*Nepal Mountain, Ama Dablam
No. 1, 1977. Sumi, 12⁷⁄₈" × 17³⁄₄".
Collection of the artist.
Photo by Paul Macapia*

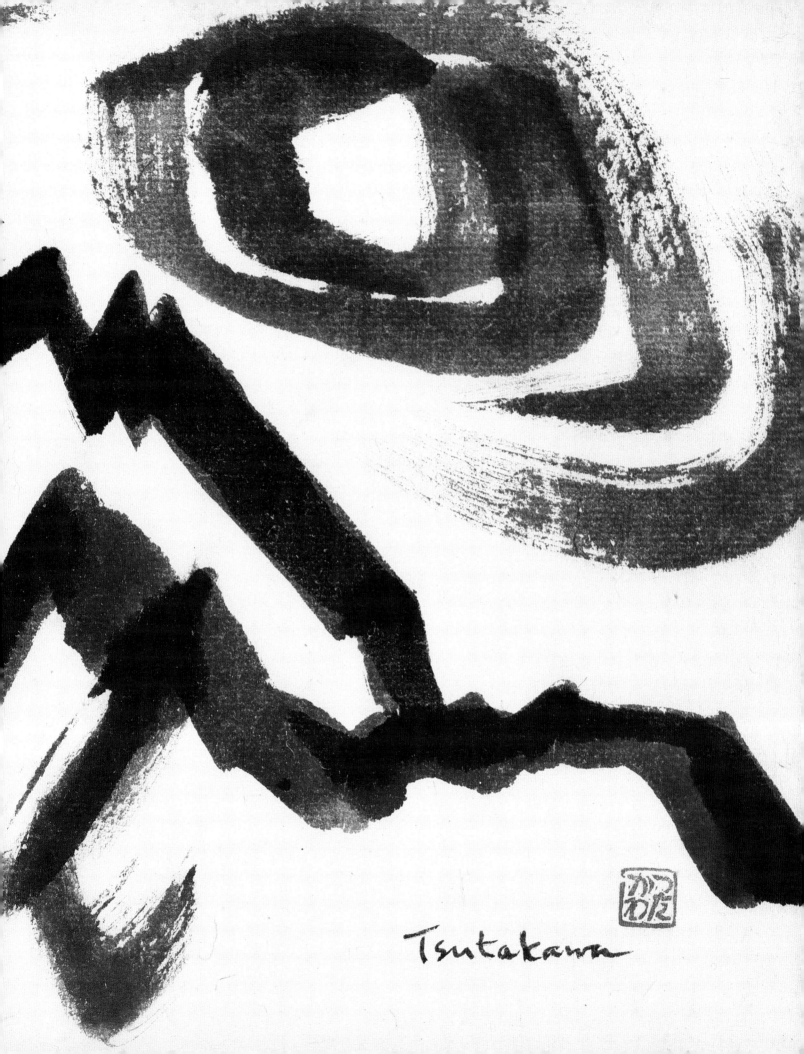

Tsutakawa

George Tsutakawa

Martha Kingsbury

With an introductory essay by Sumio Kuwabara

University of Washington Press *Seattle & London*

Bellevue Art Museum *Bellevue, Washington*

This book was published on the occasion of "Eternal Laughter: A Sixty-Year Retrospective of George Tsutakawa," organized by the Bellevue Art Museum, Bellevue, Washington, September 14 to November 2, 1990.

The publication was jointly funded by major grants from **SEAFIRST BANK** , PONCHO, the Norcliffe Foundation, an anonymous donor, the David Woods Kemper Memorial Foundation, Mr. and Mrs. Kenneth Fisher, Marshall and Helen Hatch, Mr. and Mrs. Albert S. Kerry, John and Mary Robinson, and the Joan Paterson Kerr Publication Fund.

The exhibition was made possible by generous grants from SAFECO Insurance Companies and Security Pacific Bank.

Library of Congress Cataloging-in-Publication Data

Kingsbury, Martha, 1941-
 George Tsutakawa / by Martha Kingsbury; with an introductory essay by
Sumio Kuwabara.
 p. cm.
 Published on the occasion of "Eternal Laughter: A Sixty-Year Retrospective of
George Tsutakawa," organized by the Bellevue Art Museum, September 14 to
November 2, 1990.
 Includes bibliographic references.
 ISBN 0-295-97020-0 (alk. paper). — ISBN 0-295-97021-9 (pbk. : alk paper)
 1. Tsutakawa, George—Exhibitions. I. Tsutakawa, George.
II. Kuwabara, Sumio, 1924- . III. Bellevue Art Museum (Wash.)
IV. Title
N6537.T74A4 1990
709'.2—dc20 90-37159
 CIP

The paper used in this publication meets the minimum requirements of the American National Standard for Information Sciences—Permanence of Paper for Printed Library Materials, ANSI Z39.48-1984. ∞

Printed and bound in Japan

Contents

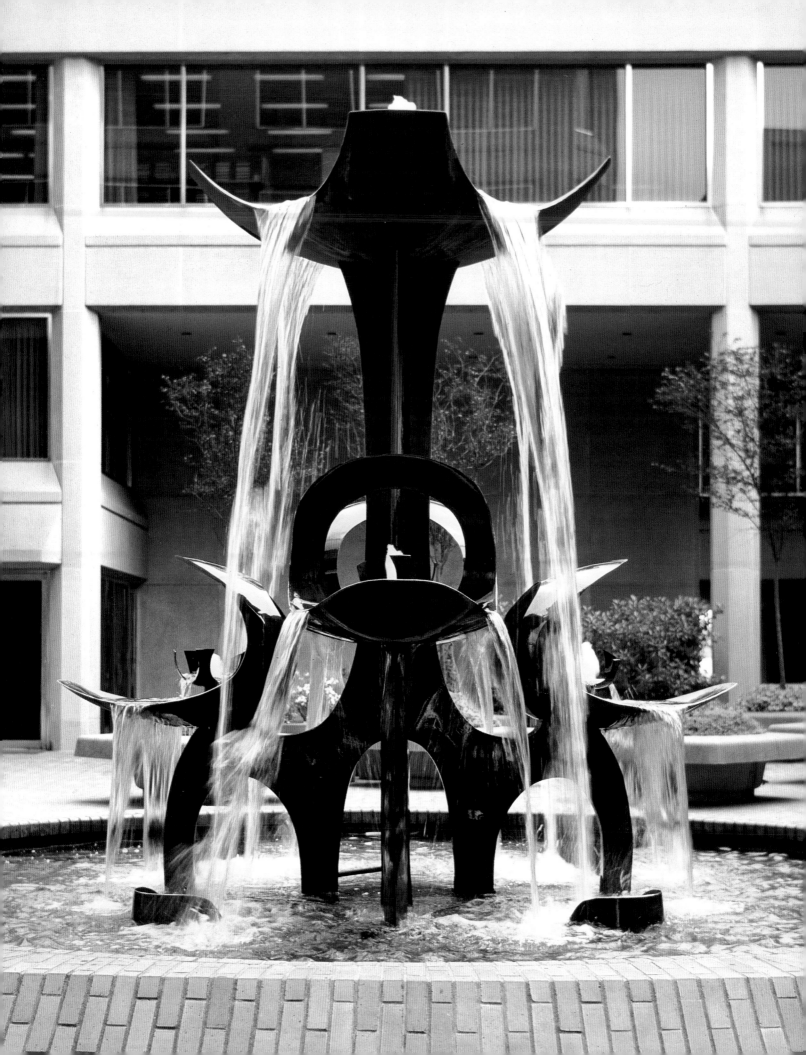

Foreword

I N 1990, the year of George Tsutakawa's eightieth birthday, the Board of Trustees of the Bellevue Art Museum is honored to present a definitive retrospective exhibition for the artist, covering sixty years of work in a wide variety of media. One of an ongoing series of solo exhibitions of this region's seasoned artists, this retrospective features a Japanese American artist of worldwide recognition. Of equal importance, the exhibition celebrates one of the most profound currents within the culture of the Pacific Northwest—the subtle bonding of aspects of the Japanese and Puget Sound aesthetic traditions into a unified expression. Among Northwest artists, Tsutakawa's work is the prime example.

The creative presence of George Tsutakawa, a favorite son of the Northwest, is reflected in his long career as painter, sculptor, fountain maker, and teacher of several generations of art students at the University of Washington. His cultural presence and that of his large family run deep in the social fabric of the Northwest through friends, colleagues, and many patrons. At the same time, Tsutakawa has maintained constant ties with Japan since an extended visit there as a youth of seventeen years.

From this almost organic connection between East and West has grown a unique art highly deserving of major recognition at the Bellevue Art Museum. The exhibition and its catalogue also reflect the viewing public's profound appreciation of Tsutakawa and of other Japanese American artists of the Northwest, as well as of the wider phenomenon of *japonisme*.

The opportunity to serve as curator of this exhibition for my personal friend, whose work I have followed and admired for thirty-four years, is a long-anticipated pleasure. For us to work in tandem on the catalogue with our colleague, Professor Martha Kingsbury, whose brilliant and sensitive essay underlines the importance of the artist to the American people, is a great honor. Together, we thank Professor Sumio Kuwabara, distinguished Japanese art critic, for joining us in this effort. We also recognize the generous contributions of Mr. Makoto Horikoshi and Mr. Masashi Takahira of the Spatial Design Consultants Company and the distinguished photographer, Mr. Osamu Murai, of Tokyo.

An astounding fact about the *oeuvre* of George Tsutakawa is the breadth of media and forms which he mastered during his career. Before he ever approached the production of fountains, around 1960, he was prolific in the creation of prints, oil and English watercolor paintings, works in *sumi* and in *gansai* and *sumi*, and sculptures in metal and wood, both relief and three-dimensional. He also produced collapsible furniture, bamboo lamps, ceramic vessels, and bronze masks. For the past thirty years he has been absorbed in the design and execution of more than sixty bronze fountains in major cities throughout the world. Examples of all of this work are included in the present exhibition and in this publication.

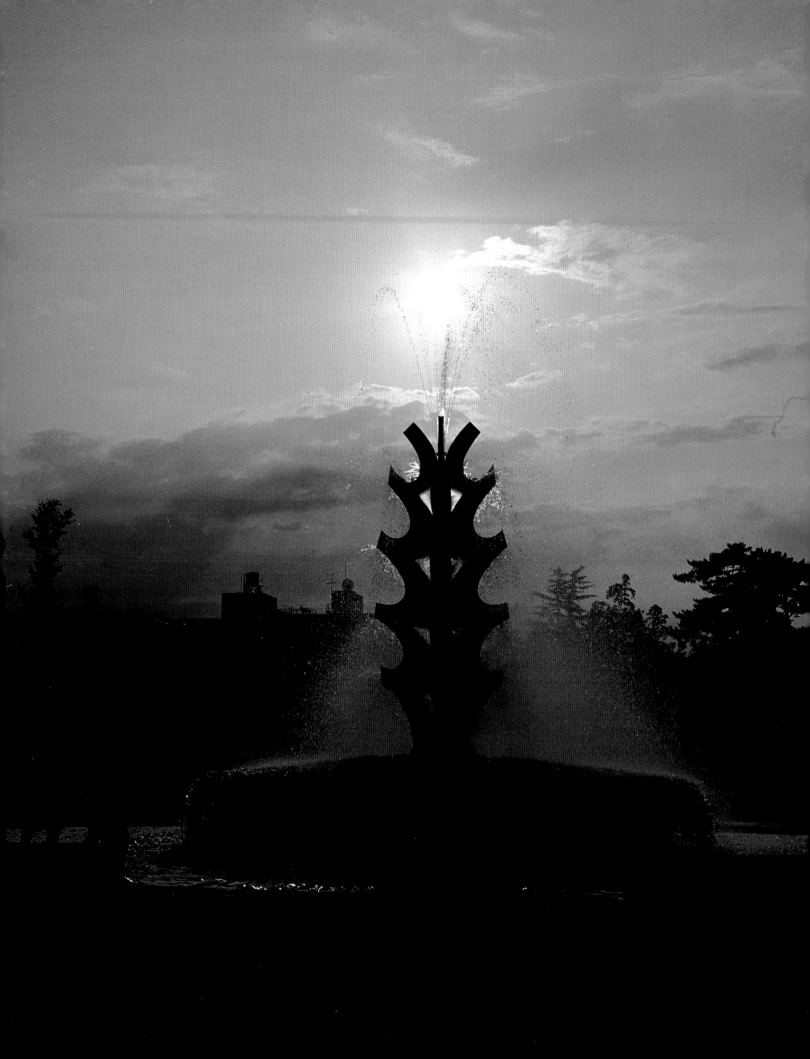

Song of the Forest, fountain, 1981. Bronze, 20'.
Tsutsujigaoka Park, Sendai, Japan. Photo by Osamu Murai

Both SAFECO and Security Pacific Bank of Washington were quick to see the importance of bringing together this material and generously funded the retrospective exhibition. Just as quick to divine the historical importance of documenting the work in this publication was an anonymous friend of the artist whose major gift set the tone for the fund-raising to come. At the same time John and Mary Robinson, friends and admirers, contributed generously and marshaled the support of Mr. and Mrs. Albert S. Kerry, Mr. and Mrs. Kenneth Fisher, Mr. and Mrs. Raleigh Baxter, Dr. and Mrs. Charles Kaplan, and David and Gail Karges. Meanwhile, gifts came from Mr. and Mrs. Robert M. Sarkis, Mr. and Mrs. Henry Trubner, Mrs. Dorothy C. Malone, Claire Mock, and Mrs. Allen B. Morgan and from Mr. James Kemper, Jr., of the David Woods Kemper Memorial Foundation. Major grants from the SEAFIRST BANK, the Norcliffe Fund, PONCHO, and Marshall and Helen Hatch assured a fitting publication. The Museum's major education program for Puget Sound schools, organized by Beverley Silver, Coordinator of Children's Education, was funded by the *Seattle Times* and by Philip and Patricia Gayton.

I wish to acknowledge the specific assistance and many generosities of several figures from the art world with whom I have worked on other occasions and whose good wishes were part of the successful dynamics of our Tsutakawa project, namely, Dr. Paul J. Karlstrom, Regional Director of the Archives of American Art, Smithsonian Institution, and Ken Levine, who have worked closely with George Tsutakawa for several years on Archives projects; Don Foster of the Foster/White Gallery, long-time representative of the artist; Marshall and Helen Hatch, staunch supporters of the art and artists of our region; and Donald R. Ellegood, Director of the University of Washington Press, and his staff, in this case particularly Naomi B. Pascal, Audrey Meyer, Julidta Tarver, Kathleen Pike Timko, and Lorna Price. Mayumi Tsutakawa, daughter of the artist, assisted with many things, including the chronology and the bibliography. Paul Macapia and his son Peter gave up their holidays to photograph the majority of the Tsutakawa works in the artist's living room, while the many grandchildren patiently waited until the last moment to trim the Christmas tree.

Last, and most warmly, on behalf of the community of the Pacific Northwest, I wish to thank George Tsutakawa for his art, and George and his talented wife, Ayame, and their remarkable family, who, as full-fledged members of our Northwest community, have gently taught us about the wonders of the Japanese culture.

Many happy returns, George!

LaMar Harrington

Director and Chief Curator
Bellevue Art Museum
March 1990

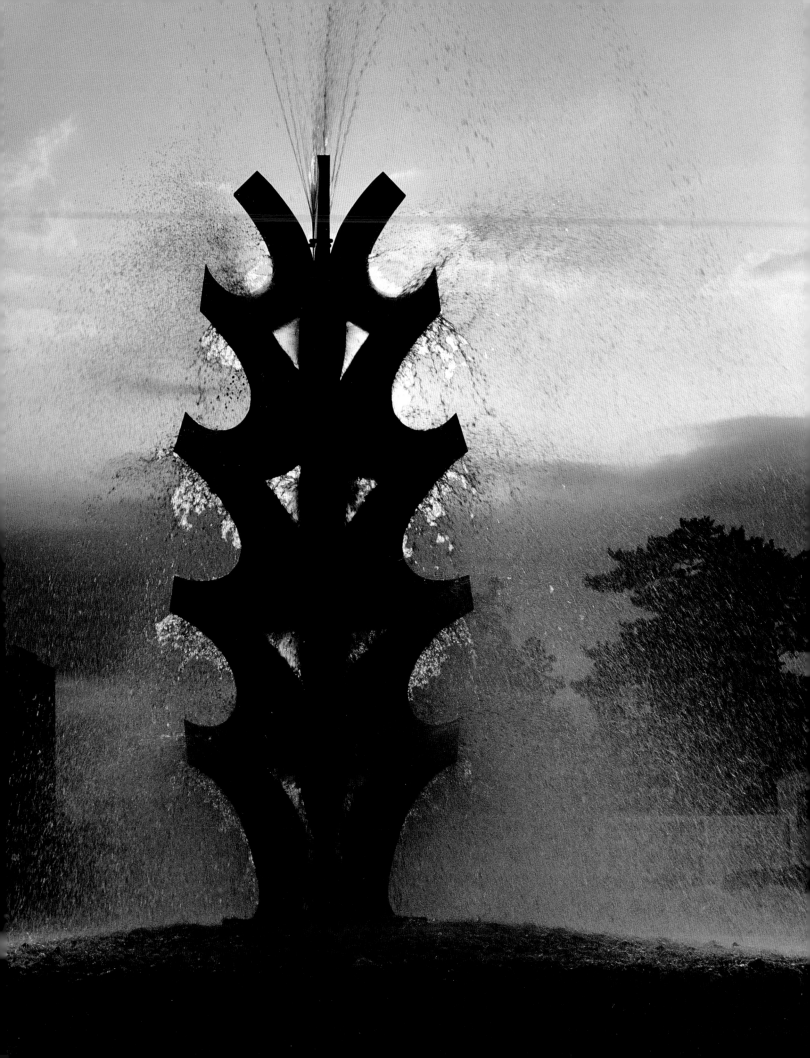

The Fountain Sculpture of George Tsutakawa

Sumio Kuwabara

Song of the Forest, fountain, 1981. Bronze, 20'. *Tsutsujigaoka Park, Sendai, Japan. Photo by Osamu Murai*

*A Personal Statement, Pacific Northwest Artists and Japan (exhibition catalogue) (Osaka: The National Museum of Art, 1982).

THE OPENING of a retrospective exhibition of the works of George Tsutakawa, one of the leading fountain sculptors in the world, to celebrate his eightieth birthday, is indeed a happy event. As one of many Japanese who hold a reverent affection for Mr. Tsutakawa's art, I would like to express my heartfelt congratulations.

Mr. Tsutakawa's art took on its present character after the end of World War II. This evolution began in earnest after his visit to Japan in 1956. Previously he had gone through what might be called a period of searching, a crucial time during which he laid the foundations for the great leaps of development he was to make after 1960.

Mr. Tsutakawa himself put it in these words:

For me, 1960 or thereabouts was a time to take another look at the philosophy and art of the Orient—particularly Japanese art—that I had become familiar with in my youth. Through my travels and my studies of traditional Japanese arts I was able to reaffirm my conviction in the Oriental view of nature which sees man as one part of nature, a part that must live in harmony with the rest of nature.

From 1960 on, I attempted to express this relationship between man and nature in my works. My *sumi-e* drawings are a direct response to nature; my fountain sculptures are an attempt to unify water—the life force of the universe that flows in an elusive cyclical course throughout eternity—with an immutable metal sculpture.*

The philosophy that man and nature are one has existed in Japan since ancient times. Underlying this philosophy is the idea that man and nature do not stand in opposition to each other. This view of the world sees man as existing encompassed by nature, as one part of the natural world, and therefore holds that man must intrinsically live as nature dictates. Perhaps this view of nature had lain dormant in the sculptor's heart, and he was able to reaffirm it upon returning to Japan in 1956.

Art is created by an individual artist, and as long as it is one person's creation, it seems hardly possible to overcome the limits inherent to that individual. To attempt to transcend such limits, it is first necessary to effect a fundamental transformation in one's customary ways of thinking. In other words, it is necessary to discard the thinking that remains tied solely to the self and to entrust that self to the workings and the order of the great natural world. Such trust could undoubtedly lead to a new and expansive vision of the world, unlike anything previously experienced. I imagine that something like this experience enabled Mr. Tsutakawa to achieve a personal revolution in his thinking.

Tsutakawa's later chance encounter with *obos,* the Tibetan rock mounds built up one stone at a time by passing pilgrims, also greatly influenced him. In 1977 Tsutakawa trekked 16,000 feet into the foothills of Mount Everest in Nepal. There he saw these *obos* at rare scenic and sacred spots along the high mountain passes. He was impressed by their appearance and by the mysterious power that emanated from them. The *obos* forms a spiritual field of attraction that instantaneously links humans with the heavens. This compelling form probably appeared to Tsutakawa as a structure that undermined the very foundations of modern sculpture, whose development had become static.

Probably just as he was drawn to *obos,* Tsutakawa was attracted by the pagodas of Japan. It is well known that Japanese pagodas, which tower above the other buildings on Buddhist temple grounds, are derived from Indian stupas. Like stupas, pagodas connote a passageway to the world of the transcendental. A pagoda is a path that leads to the heavens; by pointing the way to the world of the sublime, it serves as a medium for the salvation of human beings. Both *obos* and pagodas are embodiments of the *axis mundi* and provide the dynamics for the ascent from a lower to a higher realm. Mr. Tsutakawa's fountain sculpture is, in a way, the result of standing that *axis mundi* on the earth's surface as an eternal expression of will and making it visible through the finite forms of flowers and trees.

Water merges the infinite with the finite. It signifies the beginnings of life, and from ancient times to the present, has continued to be a symbol of regeneration and fertility. Water flows through all things on earth, sometimes appearing as a spring, a river, a lake, or an ocean, next turning into clouds or fog, then returning to earth as rain, undergoing numerous transformations as it gives and regenerates life unendingly.

As water ascends its channel within the sculpture and soars and cascades above and around it, it manifests the primeval joy and sanctity of life. The mechanism of the fountain sculpture propels water through a circuit invisible to our eyes, causing it to unfold as a brilliant metaphor of flowers and trees. Needless to say, the sacredness of the flowers and trees, which also possess symbols of regeneration, is further heightened by the sanctity of the water.

In Japan art is not considered to be created, but rather, to be born. Art comes not through the reckoning and fabrication of humans, but is born of nature: the grand system that surpasses the human dimension. The cosmic vibration that Mr. Tsutakawa's fountain sculptures possess is deeply rooted in this view of the world.

ジョージ蔦川の噴水彫刻

桑原　住雄

　噴水彫刻の世界的な第一人者ジョージ蔦川氏の80歳を記念する回顧展が開催されることは、まことに嬉しいかぎりである。蔦川氏の芸術を敬愛してきた日本人の一人として、心からお祝いを申し上げたいと思う。

　蔦川氏の芸術が今日みられるような姿になったのは、戦後に入ってからである。とりわけ1956年の日本訪問以来、それは本格的なものとなった。それ以前は、いわば模索時代と言ってよいが、それは1960年以降の大いなる発展の基礎を形成する重要な時代だったとみられる。

　かつて蔦川氏は次のように述べている。「1960年頃に私は、私が青春期になじんだ東洋の哲学や美術—とくに日本美術—に再び目を向けるようになった。私は旅行や伝統的な日本美術の研究を通じて、人間は自然の一部であり、自然と調和して生きるべきだという東洋人の自然観への私の信頼を再確認できた。

　この人間と自然との関係を、私は1960年以降の作品に映すことを試みてきた。私の墨絵は自然への直接的な感応であり、私の噴水作品は、不変の金属彫刻を、宇宙の生命力であり捉えがたく永遠にめぐり続ける水に合体させる試みである」(「パーソナル・ステートメント」展覧会カタログ、Pacific Northwest Artists and Japan, 1982, The National Museum of Art, Osaka)

　日本では、古くから、自然と人間は一つのものと考えられてきた。自然と人間とは対立するものではないという考え方がその背景にあった。人間は自然のなかに包含されているものであり、自然の一部であるから、自然の摂理に従って生きることこそ本来の人間の生き方であるという世界観である。蔦川氏が1956年の日本への旅で再発見したのは、この自然観であった。もともと氏の胸中に潜在していた自然観が、はっきりと確認されたのである。

　芸術は芸術家個人によって作られるものであるが、個人が作るものであるかぎり、個人という狭い限界を乗りこえることができない。その小さい個人の限界を乗りこえるにはどうすればいいだろうか。それにはこれまでの考え方を根本的に切りかえなければならない。すなわち、小さい個人にとらわれた考え方を捨てて、大いなる自然の道、自然の理法に身をまかせなければならない。そうすれば、これまで経験したこともない、新しい広々とした局面が見えてくるにちがいない。このようにして、蔦川氏は自己変革のきっかけをつかんだのではないかと私は想像する。

　そのころ氏が巡り会ったのがオボスである。オボスは、もう一つの世界を氏に啓示した。氏がオボスを写真で見たとき、氏に衝撃を与えたのはオボスの形体であったと同時に、その形体から発信される神秘の力だったと思う。オボスは地上の人間と天界とを一瞬にして結びつける霊魂の磁場である。それは行き詰った近代彫刻のパラダイムを根本から揺さぶるものとして氏の眼に映ったのではないだろうか。

オボスと重なるようにして氏を惹きつけたのは日本の塔であったと思う。仏教寺院の境内にそびえる塔がインドのストゥーパを原形とすることは周知のとおりである。塔は超越世界への通路を暗示している。塔は天界へ到る回路であるとともに、至高の世界をさし示すことによって、われわれ人間を救済する媒介となるのである。オボスも塔も、いずれも下から上へ向って上昇する力学をはらんだ世界軸である。その世界軸を永劫の意志として地表に立て、花や木など有限の姿で可視化したものが蔦川氏の噴水彫刻なのである。

　無限と有限とを一つに融合させるのは水である。水は原初の生命を意味する。そして太古から今日にいたるまで再生と豊饒のシンボルであり続けている。泉とか川、湖、海の姿をとる水は、地上の万物のなかを貫流し、雲や霧となったのち、やがて雨となって再び地上に還る。水は自ら生成変幻しながら生命を限りなく再生してゆくのである。

　水が彫刻の内側を昇ってノズルから噴射されるとき、そこに原初の生命の歓喜と聖性が顕現する。私たちの眼には見えない回路を通って水が上昇する噴水彫刻のメカニズムは、見事に花と木のメタファーになっている。再生のシンボリズムをもつ花と木の聖性が、水の聖性によって一層増幅されることは、もはや言うまでもあるまい。

　日本では、芸術は「作るもの」ではなく、「生まれるもの」と考えられている。芸術は人の計量によって作られるものではなく、人間の次元を越えた大いなるもの―自然によって生み出されるものなのである。蔦川氏の噴水彫刻がcosmic vibrationをもっているのは、この世界観に深く根ざしているからである。

<div align="right">（美術評論家）</div>

The Life and Work
of George Tsutakawa

Martha Kingsbury

THE ARTISTRY that George Tsutakawa achieved in his mature paintings and sculpture is grounded in the richness of his life's experiences. His art synthesizes traditions more disparate than most people ever experience and succeeds in transcending their divisive particularities. Tsutakawa's life—and therefore his art—did not unroll before him in a simple continuous line, like a red carpet leading into the future. His course was repeatedly and abruptly deflected, by rises and falls in family fortunes, by the arbitrary inequities of immigration regulations, by military and world history. He came to his Japanese schooling through the detour of being born in the United States. He came to his study of art in America through the detour of that Japanese education. He came to his life as an artist through detours in the family business and in the army. His life and art unfolded like a Japanese fan, each sharp and vivid plane sliding suddenly into view, all eventually forming a richly articulated unity. The following account of Tsutakawa's work and life is presented through six parts that reflect these changes and rhythms.

In preparing this account I was very much aided by and particularly want to thank George and Ayame Tsutakawa for all their patience, generosity, and time; Gervais Reed for his sustained and sensitive interest in the work of Tsutakawa and its Northwest context; the Archives of American Art in the Smithsonian Institution; and the joint Japan–United States Educational Commission (Fulbright Program) that enabled me to teach for a year at Hiroshima University, not far from Tsutakawa's family terrain.

Shizuo Okawahara. *Funsui Chokoku (Fountain Sculpture)*, 1988. Wall hanging, calligraphy and batik, 79" × 23".
Collection of George Tsutakawa

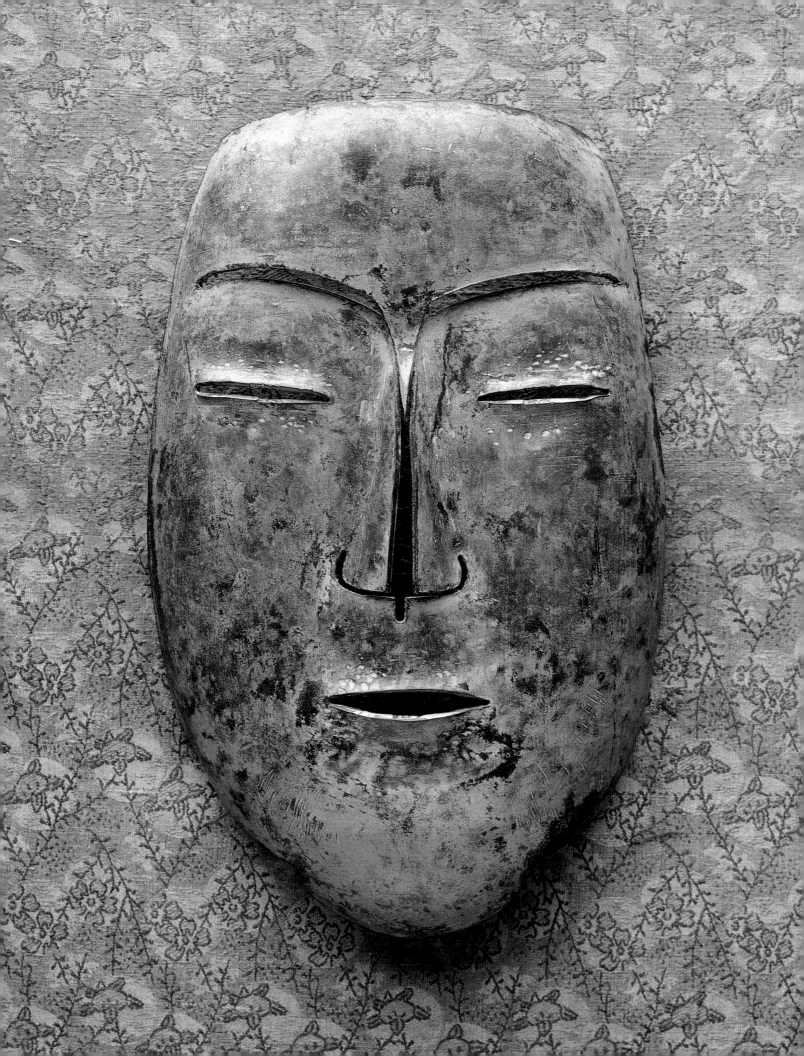

Early Years, 1910–1927

"Look at that pine tree," Redshirt said to Yoshikawa. "The trunk is perfectly straight and the top of the tree spreads out like an umbrella. It might have been painted by Turner." . . . "Imagine Raphael's Madonna standing on that rock," said Yoshikawa. "It would make a superb picture. Don't you agree?"

—Natsume Soseki, *Botchan*, 1906

"[In the 1920s] we used to go on maneuvers with the soldiers. The students—high school and college students—were all very heavy drinkers . . . They'd take to drinking and singing . . . One of the most popular songs that we always had to sing when we were drinking sake was "De-Kan-Sho." You wonder where "De-Kan-Sho" comes from? "De" is Descartes; "Kan" is Kant; and "Sho" is Schopenhauer; that's "De-Kan-Sho." Even today men know that song. It can go on and on and on. It is a very serious and very philosophical song. It tells about life . . . It's a wonderful song."

—George Tsutakawa, 1976

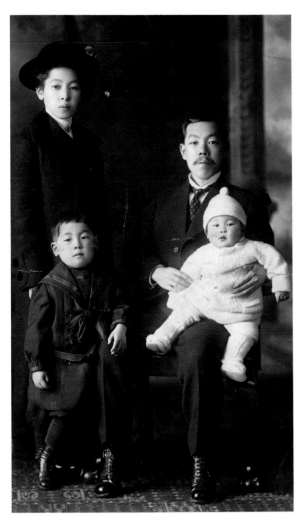

George (lower left) at age four with mother Hisa, father Shozo, and brother Henry in a 1914 portrait taken in Seattle

I N A 1906 NOVEL that quickly became a favorite and enduring classic in Japan, Natsume Soseki parodied the teachers at a provincial boys' school in western Japan. Their esthetic pretensions were a commonplace that his readers recognized with amusement. The schooling that George Tsutakawa experienced in a small coastal town of western Japan, a decade and more later, participated in the same avid cultivation of European thought and history. It was no superficial or merely amusing matter. The Hiroshima Prefecture High School in Fukuyama, which he attended from 1922 to 1927, and the local schools of the city of Fukuyama he previously attended, were modeled on the rigorous educational systems of Germany and England. Children went to school six long days a week and studied a range of compulsory subjects including much science, literature, and history. In Japan, centuries of self-imposed isolation had been followed by foreign-imposed trade relations in the mid-nineteenth century; Japan had set itself a determined project of mastering the foreigners' cultural systems in order to retain its own autonomy. By the time Tsutakawa was a student there, the diligence of many decades of effort was beginning to pay off in technology, in trade, in altered forms of literature and art. Increasing militarism was a concomitant of this history and accounted for the military training of high school and college students. "Everything was very somber, and they had a fatalistic attitude," Tsutakawa recalled. A Japanese student's life was arduous and regimented, and though Tsutakawa came to feel nostalgia for it much later, he was less than enthusiastic at the time.

Hannya, mask, 1970. Copper repoussé, 8½″ × 5½″ × 2″.
Collection of the artist. Photo by Paul Macapia

Young Tsutakawa was not entirely at ease in this schooling. To begin with, he had been born abroad in Seattle, Washington, in 1910, the fourth child and second son of his father Shozo's nine children. His name, given because he was born on Washington's birthday, linked him to his land of birth. (His older siblings had Japanese names.) At age seven, he was sent to relatives in the little castle town of Fukuyama, on the Inland Sea of western Japan. But he could speak no Japanese, and furthermore, a rich diet of milk and butter had made him chubby as no Japanese children then were. His schoolmates taunted him and called him "foreign pig." Tsutakawa determined to "forget English, learn Japanese, throw the fancy American doodads away, wear what they all wear and run around barefooted." After a year or two he was accepted.

Tsutakawa's family environment was more richly diverse than that of most of his fellow students. On the one hand, his family retained strong ties with Seattle, and they cultivated European arts, but on the other hand, the generation of his grandparents was devoted to the old traditions. His father, Shozo Tsutakawa, was a resourceful and imaginative businessman whose export-import business linked Seattle with the Japanese ports of Kobe, Osaka, and Tokyo. From 1905 his family had lived in Seattle, and George spent his earliest years in a spacious house on Federal Avenue on Capitol Hill in the fashionable Volunteer Park area. Tsutakawa retained fond memories of playing in the park and in adjacent Lakeview Cemetery, where the elaborate Victorian funerary monuments of the city's founding families graced picturesquely landscaped hillsides. He began attending Lowell Elementary School. But restrictions on citizenship of immigrant Japanese discouraged permanence, and the legal situation of East Asian immigrants deteriorated significantly after about 1910. In 1917 the seven-year-old George and one brother were sent back to Japan to live with their maternal grandmother, Mutsu Naito. Over the next few years, all the children joined this household. George's mother died in the flu epidemic of 1918, his father remarried, and this stepmother eventually joined the grandmother's household. In 1924, because of the Alien Land Law, Shozo had to relinquish ownership of his Seattle house; he deeded it to a Caucasian friend. In spite of these restrictions, Shozo's business prospered and he was frequently in the United States as well as in Japanese port cities, managing the company. Two of George's uncles remained in Seattle to run the business there. The family's American ties remained strong, even in the face of increasing obstacles. George's sister had the first piano in Fukuyama, and the family retained an interest in Western culture.

The family's cultivation of traditional Japanese practices was also exceptionally strong. It was the devotion to traditional arts of George's paternal grandfather Kiichi that apparently nearly exhausted the fortunes of this established and affluent old landlord family—and thus led indirectly to the trans-Pacific connections through which George's father struggled to rebuild the family's prosperity. George's grandfather had reputedly left the family properties in Ibara village in Okayama Prefecture and gone for several years to study in Kyoto, the ancient cultural capital of Japan. There he studied calligraphy and literature, and became a master of the tea ceremony and flower arranging, and when he returned to the family village, he brought other masters with him. Through the early decades of the Meiji restoration, and contrary to the adamant westernizing of the epoch, he had assiduously cultivated these ancient Zen arts instead of cultivating his fields. "And so one day the fields were sold, the forests lost, the mountains too, because he had to pay for all this fabulous household," explained the grandson.

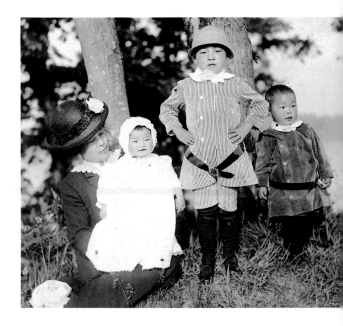

George (standing) at a 1915 outing to Mt. Baker Park in Seattle with governess, sister Sumiko, and brother Henry

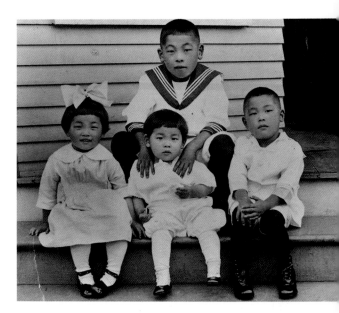

George (in back) with (from left) sisters Sumiko and Kazuko and brother Henry in a 1917 portrait taken in front of the family's Capitol Hill residence in Seattle

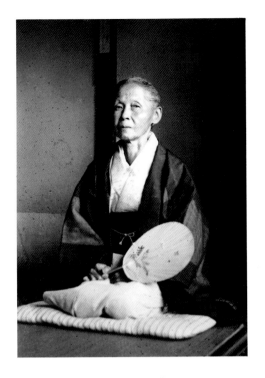

Grandmother Mutsu Naito, Fukuyama, 1921

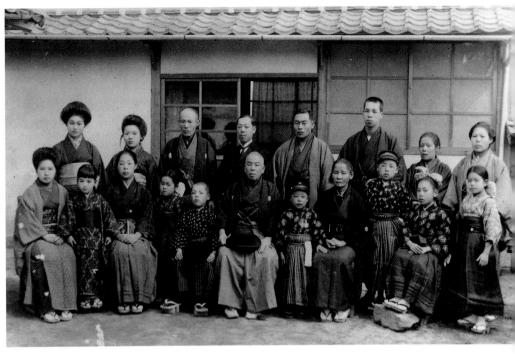

A Tsutakawa family photo taken in 1920 in Okayama.
George is the third from right in the front row

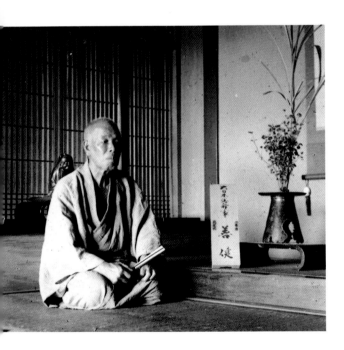

Grandfather Kiichi Tsutakawa in 1924, master of the Sa-do
tea ceremony and also of the Ikenobo flower arrangement

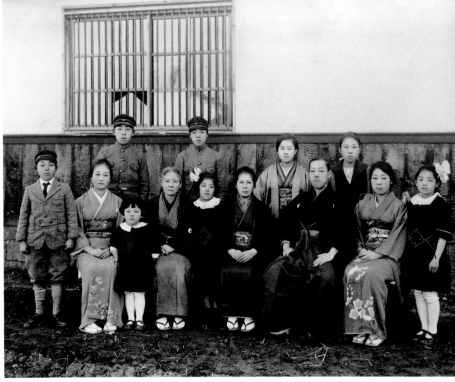

George (back row, left) in his school uniform, Fukuyama,
1925

When George was growing up in Japan, his grandfather had withdrawn into retirement in a village near Ibara. He was still devoted to practice of the traditional arts and had little use for the many children of his own nine children. George, though, was an exception; he had a special fondness for the boy. The grandparents were kind to him; four or five times a year, he would bicycle several hours to see them and often stayed a few nights with them. "As soon as I got there, Grandfather would say, 'Wash your hands! Wash your feet! Come up here and sit with me.' And he would have a tea ceremony, make tea, and make me drink it . . . He never taught me flower-arranging and calligraphy, but he was always doing it and made me watch him."

The secluded and contemplative artistry of his grandfather's life was reinforced by his maternal grandmother in the busier environment of the children's home. The grandmother, Mutsu Naito, was descended from a samurai family. She practiced the arts of tea and flower-arranging, and in addition she took the children to the lengthy performances of traditional Japanese theater, eight-hour gala outings with big packed lunches, serious plays and comic interludes, lots of coming and going. And she sent them to evening lessons with a Zen master once or twice a week: ". . . a very gentle, kindly old man. He used to tell us stories which always had to do with Confucianism, Buddhism, or Zen philosophy, but illustrated with his own paintings and drawings, and he told them so we could understand all this. He made us tea, then he showed us how to make pottery." Tsutakawa remembers this master as being "quite a recluse, but a scholar, a painter, a potter and a tea ceremony master."

Much later in his life, Tsutakawa could recognize how powerful was the example of these elderly Japanese, with their commitment to artistry as a deep and integral component of life. But the young George, however much he was drawn to these elders and their activities, did not consciously model himself on them. Their absorption in ancient traditions was nothing for a young man to emulate in 1925. Art lay elsewhere, in the bohemian subculture of Paris, in the romantic individualism of European literature, in the transforming liberty of French modernism. Even in Fukuyama, "a very, very old town with a castle in the middle, a beautiful picturesque old city . . . there was a small group of painters who had studied in Tokyo, and they were telling us about Picasso, Matisse, and showing reproductions of their works. Now this was in 1925 in Japan . . . in a little hick town." Tsutakawa decided to become an artist—whatever that might mean.

T HE FIRST THING it meant was that George Tsutakawa had had enough of school. After five years of indifferent attendance at the high school, he had not accumulated enough credits to graduate. At seventeen, he quit and for several months worked with carpenters building a house for his father in the Kobe area. A contractor in Fukuyama prepared all the lumber there. Then Tsutakawa sailed with the contractor and his family, on a small, cargo-carrying sailboat, up through the Inland Sea to the building site. The beauty of the islands and sea enthralled him. The house had western features in the kitchen and use of glass, but its structure was fundamentally Japanese, with traditional post and beam construction, and walls of mud, lime, and straw held by a woven inner structure of bamboo.

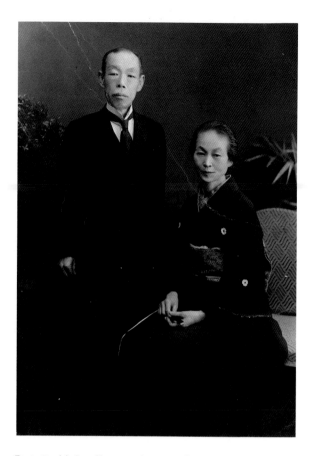

Portrait of father Shozo and stepmother Koteru, taken in 1948, was later sent to George by his stepmother after his father's death, inscribed with a haiku asking that the photo be saved as a fond remembrance

The second thing his artistic declaration meant was that he became a source of shame to the family. "When the house was built, my father got me a ticket, put me on a steamship, and said, 'You go back to Seattle.' And I did, alone." For the second time, Tsutakawa was exiled to a land whose language he did not speak.

As before, there was family to receive him; this time, George was to assist his uncles in Seattle. Still, the abruptness of these trans-Pacific changes would be hard to exaggerate. When seven-year-old George departed Seattle in 1917, he left a mother whom he never saw again. When seventeen-year-old George returned to Seattle in 1927, he left a father from whom he was deeply estranged. He never saw his father again, nor did they communicate for twenty years.

Two years after his return to Seattle, Tsutakawa did a charcoal portrait of his grandfather, working from a photograph. It is the earliest work he bothered to save, and he has it still, in his own bedroom. A gentleness, a contemplative cast, and perhaps some melancholy are evident in this portrait that links the artist to his Japanese youth. But it is not at all done in a Japanese manner; rather, it is a thoroughly western charcoal portrait, conventional and competent in modeling, explicit in detail, a work by the American student George.

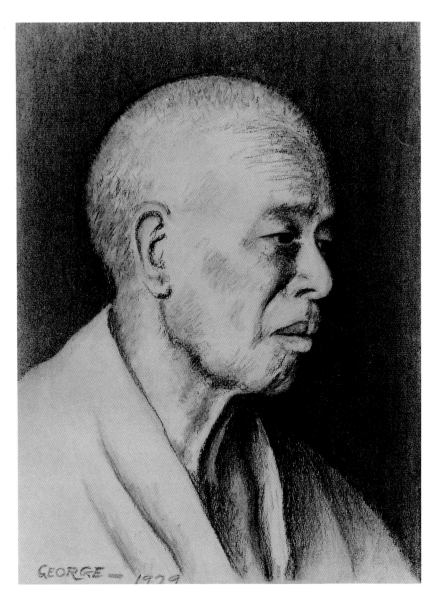

Portrait of Grandfather, 1929. Charcoal, 16¼″ × 12⅝″.
Collection of the artist. Photo by Paul Macapia

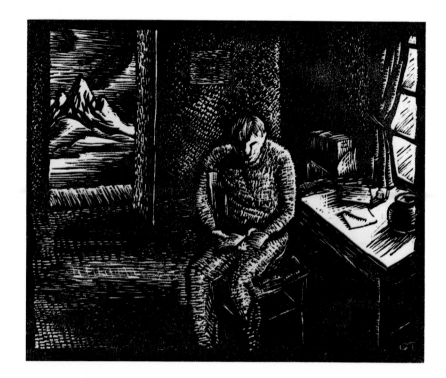

Self Portrait (Man Reading in Room), 1932. Linocut print, 4³⁄₈" × 5³⁄₈". Collection of the artist. Photo by Paul Macapia

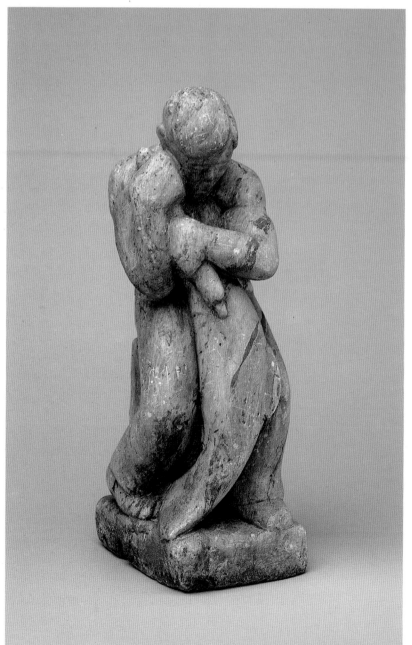

Fisherman (Self Portrait), 1935. Soapstone, 14¹⁄₂" × 5" × 6¹⁄₈". Collection of the artist. Photo by Paul Macapia

The Art Student, 1926–1937

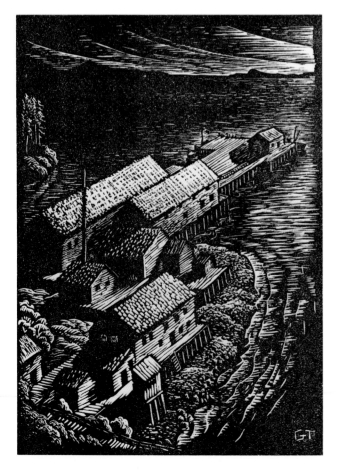

Fiord No. 2, 1932. Linocut print, 7¼″ × 5¼″.
Collection of the artist. Photo by Paul Macapia

The wide circle of the ocean's horizon is around me, a huge zero, the symbol of my momentary nowhere.

—Rockwell Kent, *N by E*, 1930

Those were wonderful days, you know, during the depression. Nobody had money. I used to go to Alaska and work in the salmon cannery and work for a whole season and came home with 150 dollars. That paid for my tuition, which was only 23 dollars a quarter, for my books and for street car fare; hot lunch was 9 or 10 cents. It paid for just about everything. Wonderful times!

—George Tsutakawa, 1976

T HE TENDER, reticent portrait of his grandfather was Tsutakawa's homage to a past he had left behind, to venerable traditions and the elders who had exemplified an ancient form of life through art. Returning to Seattle, Tsutakawa lived with his uncles and assisted them with the family business, while attending high school and college. With diligence and determination, he made himself into an American art student. Over the following decade, Tsutakawa was increasingly involved with printmaking and with sculpture. In a characteristic linoleum block print, he constructed an intimate image of a solitary, reflective figure. The man is situated somewhat apart from the vastness of distant mountains glimpsed through an open door of the simple room in which he reads alone. The subject is still and contemplative, but the sharp contrast of black and white and the rhythmic patterns of the cutting create patterns of energy throughout. This is a kind of self-portrait, Tsutakawa remarks, representing how his life was during summers he worked in the Alaska canneries.

In one of several stone sculptures from the mid-1930s, Tsutakawa addressed a different aspect of those summers. Though only 14 1/2 inches tall, *Fisherman (Self Portrait)* is a blocky, massively conceived work, full of the compressed energies of the physical labor it depicts—of fisherman against the dead weight of salmon to be heaved out of the holds. It, too, evokes a strong sense of the artist, who has also called it a self-portrait. When the catch was good the work was endless, through the long, long days of brightening, then weakening northern daylight. Other summers there was little work and plenty of time for drawing and watercolors, and time also for visiting the Indian villages, especially on the way up and back down the Inland Passage. In the villages he met the carvers, who still made objects for themselves as well as for tourists. He was deeply impressed by the expansive reliefs on ceremonial houses, with their ample forms, taut contours, and enormous eyes.

Union Bay Cannery, Alaska, 1932. Linocut print, 8¾″ × 6½″.
Collection of the artist. Photo by Paul Macapia

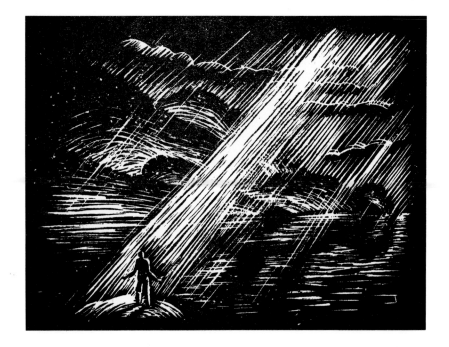

Inspiration, 1932. Linocut print, 3⅛″ × 4⅛″.
Collection of the artist. Photo by Paul Macapia

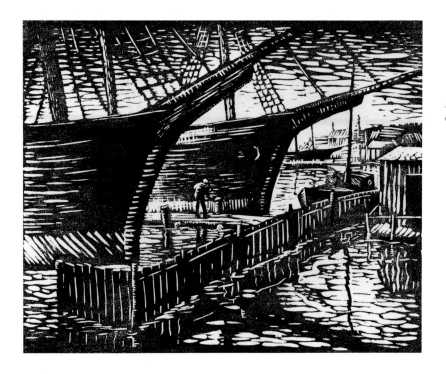

Lake Union, 1932. Linocut print, 6½″ × 8½″.
Collection of the artist. Photo by Paul Macapia

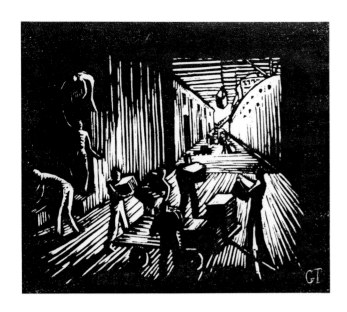

Longshore, Union Bay, 1931. Linocut print, 5¾" × 6¾".
Collection of the artist

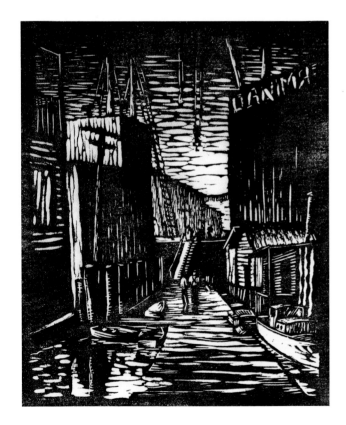

Both printmaking and sculpture involved a forceful engagement with materials, one quite different from the delicacy of those arts his grandparents and teacher in Japan had practiced. Not only was the physical engagement with these western media different in character from Japanese media; so also was the sense of art's origin and its purposiveness. Art in the west was believed to arise out of one's uniquely individual creativity, much more—and out of one's assimilation into a methodically refined context of understanding, much less—than in Japan. Individual creativity in the west was to be discovered through solitude, measured against the vastness of nature, participating in but also pitted against the historical continuities of culture. Art was regarded as a kind of extrusion, squeezed forth from the cauldron within (not at all like the matrix of life, which art was for Tsutakawa's grandfather). Art in the west had become, increasingly over two centuries and more, an endeavor identified with youth—an adventure of the restless and rebellious, the undertaking of an avant garde. Experiment, exploration, adventure were the prerogatives of youth—and of art. Hardship, self-doubt, uncertainty were the concomitants, the proving ground.

The truth of one's self and one's art was sought by impoverished foreigners who migrated to Paris and whose adventures were found in the flux of its urban density. For example, Constantin Brancusi of Romania, whose work Tsutakawa admired, lived for decades in the Impasse Ronsin. The myth of a kind of peasant saint grew up around him, though for Tsutakawa and many Americans, the rugged simplicity and radical humility of his earthbound sculpture spoke for itself. And the truths of self and art were sought by others through the vastness of wilderness forests and the trackless mists of northern seas—Rockwell Kent, for example, whose work Tsutakawa also admired. Kent's book *N by E* told of his journey from Nova Scotia to Greenland, with two other men in a 33-foot cutter, "of shipwreck there and of what, if anything, happened afterwards," as he wrote in the introduction. The black and white illustrations with which Rockwell Kent profusely illustrated his own and many others' books were endlessly varied and always dramatic evocations of "man in nature." Light-shot skies, night seas, desolate coasts, and exalted straining figures were artfully compressed into vivid Art Deco vignettes. The young Tsutakawa admired these, too. "Oh yes!" he exclaims at the memory, "He was my master then, and I still have his books from then." In the commercial bustle and ethnic mix of a Pacific port, and in the solitude of Northwest forests, Tsutakawa sought similar paths toward individual creativity.

Tsutakawa's admiration for the work of Constantin Brancusi or Rockwell Kent embodied even more than a changed relation to materials, more than a different sense of how art arises; their sculpture and graphic work also exemplify the west's values of permanence and public access as important goals of art. The endurance through time and the accessibility to great numbers of people, which sculptors, illustrators, and printmakers often seek, were deeply congenial to George Tsutakawa. These are values very much at odds with his grandfather's sense of art as a matrix that would give form to life, and sustain it, through the perpetually renewed private enactments of artistic practice. They are also values difficult to reconcile with the deeply personal element that western artists sought as the wellspring of their art. Indeed, many western artists sacrificed the accessible and permanent to the private and transient. Tsutakawa already had focused on prints and sculpture in the 1930s and never relinquished the values they served. And Tsutakawa eventually—by his fifties—transcended the personal in preference for the public and permanent, but not without first having undertaken a through exploration of the labyrinthine byways of his individual identity.

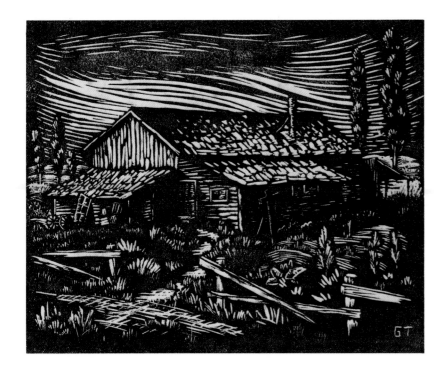

Nakai's Farm House (Auburn, Washington), 1934.
Linocut print, 6″×7½″. *Collection of the artist*

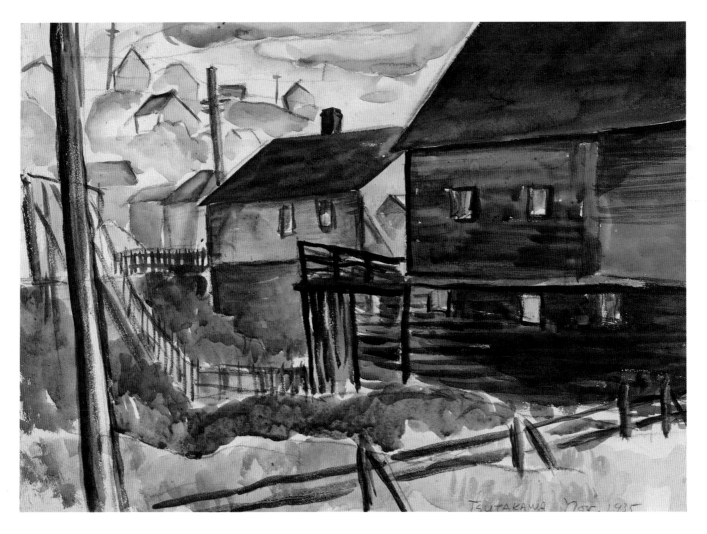

Backyard, Jackson Street, 1935. Watercolor, 15″×19¾″.
Collection of the artist. Photo by Paul Macapia

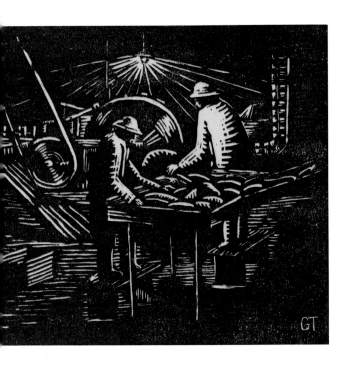

"Iron Chink" or Slimer (Union Bay Cannery, Alaska), 1932.
Linocut print, 6″ × 6½″. *Collection of the artist*

N HIS RETURN to Seattle at age seventeen, Tsutakawa set about reinventing himself in a changed context. He clearly chose to construct himself as an American and an art student. He had forgotten English, and languages proved more difficult at seventeen than at seven years of age. A grade school class in English for Asians born into American citizenship constituted a first, ineffectual effort. But the students all talked Japanese together instead of learning English, and furthermore, he remembers, "We were smoking and doing all sorts of bad things." Within months, he was sent on to Broadway High School, where the literature and history courses in English were still very difficult for him. He made friends. One, Bill Gamble, became an artist and teacher at Michigan State University in East Lansing, and later would keep Tsutakawa's work for him through World War II, when West Coast Japanese were interned and lost their property. Another was Henry Borzo, "a skinny, red-headed American boy, you know, but he was a very unusual fellow. He always sat next to me because he knew that I couldn't speak English; he knew I couldn't read the books. So he always sat next to me, especially in a civics or a history course." Borzo was a thirteen-year-old freshman when Tsutakawa was eighteen; his Dutch father had been a painter, and he was especially drawn to the visually expressive and English-deficient older youth. They remained friends through high school and the university, and for many decades afterward, when Borzo was a history professor at the University of Iowa.

Eventually Tsutakawa achieved a better command of English through the detour of French, a language he found he could learn much more easily: "In those days everyone who wanted to become an artist had to go to Paris—if you wanted to be somebody in art . . . so I said this is what I want because I'm going to Paris anyhow. So I studied French very, very avidly for a couple of years, and the English started to come to me." But though Paris was his distant goal, for the present he was in the United States. His high school art teachers encouraged him strongly. They also convinced him that the diversified program of the University of Washington's art department would offer him the best opportunity in the city for further study. This, then, became a real incentive to master English, and Tsutakawa found himself hanging on through the whole course of study, "while all my other fellow countrymen were dropping out one after another—going to work in a garage or farm or doing this and that."

An exception was Shiro Miyazaki, who became a very close friend. Miyazaki's father was a correspondent in the United States for a Japanese newspaper, and Shiro was interested in art, in writing, and in intellectual and social issues. It was also important to Tsutakawa to find artists already established within the Japanese community, and working in a western manner. "I was just trying to get my bearing on the new situation," he explains. "Naturally I was drawn to the Japanese community, which was around Main Street and Jackson Street, anywhere from the waterfront up to about Twelfth Avenue . . . And there was a concentration of the Chinese and Japanese merchants—small businesses, grocery stores, beer parlors, little hotels, fish markets and things like that. In about the center of this so-called Japanese town, on the hillside, there was . . . a small sign shop, the name was Noto Sign Shop. And this little shop was owned and operated by Kenjiro Nomura and Kamekichi Tokita, who painted signs for all these Japanese and Chinese businesses around that part of the town. And they did beau-

tiful work, these gold-leafed names of little banks . . . but they both had great hobbies; in fact, they were professional painters." Tokita and Nomura both painted in oil, urban subjects like those of the American Scene painters of the 1930s and the Ash Can School before them. They exhibited regularly at the Northwest Annual and were members of the loosely affiliated Group of Twelve painters, who in 1937 published their own works, a first in Seattle. For Tsutakawa, it was "a very fascinating and wonderful experience to go to the Northwest Annual, see Nomura and Tokita's paintings as well as getting to know these artists in their own shop. So I used to drop by after school or weekends . . . Miyazaki and I used to go to visit these sign painters. And we'd sit there and talk about art . . . and they were doing some very fine work."

Meanwhile, Tsutakawa had plenty of time for art courses at Broadway High School and was increasingly preoccupied with them; his math and science courses were easy since he retained most of the material he had learned in Hiroshima. Two art teachers, Hannah Jones and Matilda Piper, encouraged him and other students such as Andrew Chinn and Fay Chong. Chong, like Tsutakawa, also became a well-known artist in Seattle. These serious and careful older students were given great freedom to follow their own interests. Miss Jones introduced Tsutakawa to block print making, first linoleum and later wood. She sent him to the Northwest Printmakers, a vigorous group who exhibited their own work and significant loan shows from other parts of the country, usually in the Henry Gallery at the University of Washington. Intimidated, Tsutakawa was nevertheless persuaded to submit his work, taking the streetcar from Capitol Hill, where he lived, studied, and worked, across the bridges under the steep north side of the hill, and on out to where the university climbed up the wooded slopes of further hills. He was exhilarated that professional artists accepted his work, and he showed there regularly through the years from 1930 on. In 1932 he was gratified to find his block print *Iwashi*, a still-life of herring on a plate, reproduced in *Scholastic Magazine*'s eighth student-work issue. His print received the fifty-dollar first prize, the Milton Bradley Block Print Award. It was encouraging, too, that his friend Shiro Miyazaki was pictured along with Tsutakawa and others in the photo pages of award winners. And by a coincidence that became meaningful later, so was the young Morris Graves, then in Beaumont, Texas, who would shortly become an important artist friend in Seattle.

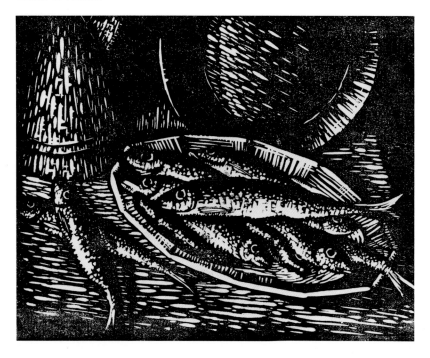

Iwashi, 1932. Linocut print, 8½" × 10¾".
Collection of the artist. Photo by Paul Macapia

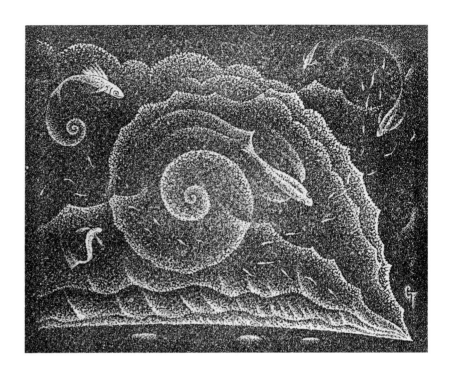

Phosphorescent Fantasy, 1932. Linocut print, 7" × 8¾".
Collection of the artist. Photo by Paul Macapia

Through his prints, Tsutakawa explored the variety of vernacular subjects that Social Realist artists increasingly turned to in the decades between the wars. The clutter of docks and harbors, the simple lines of big ships, were repeated subjects. Very steep perspectives and simplified contrasts of black and white gave some works a strong drama. Others were enriched by the texture of buttery cuts out of the soft linoleum block. The cannery work buildings were described from a high point of view that emphasized their narrow hold on the land's ragged edge, squeezed up against the docks and the sea. A more customary level view describes distant mountains in Alaska and farms and forest glens closer to Seattle. To describe the pattern of phosphorescence in the wake of the transport ship to Alaska, he devised a minutely stippled handling so carefully controlled that an Art Deco clarity and elegance resulted.

By 1932, when many of these prints were done, Tsutakawa was ready to move on to the university. He was an art major throughout his student years, little drawn toward anything else. He eventually accumulated more than enough credits to graduate in either painting or sculpture. Ceramics interested him a great deal at first, but sculpture soon became his real focus, and Dudley Pratt his main teacher.

Dudley Pratt had trained at Yale, the Boston Museum School, and the Pennsylvania Academy, and he studied in Paris with Antoine Bourdelle just before coming to teach in Seattle in 1925. Between then and his leaving in 1952, Pratt executed a great many public and private commissions in the area—for the city police building and for the university's medical school, for example. Part of Tsutakawa's apprenticeship was to help in all ways with preparatory stages of these commissions. Both carving in stone and casting metal interested Pratt, so the apprenticeship was diverse. And Pratt was interested in local materials, new processes. He built a tiny trailer that his model-T Ford could haul up into the Cascade Mountains and gathered a few students for day trips that began at 5:00 A.M. The goal was to climb up to old talc mines, from which good soapstone could be extracted and carried back down to the workshops. But the tires frequently blew out under the strain, and Tsutakawa remembers the trips as a comedy of repeatedly unloading and reloading the stone in order to patch the tires along the pitted road.

Pratt experimented with firing the soapstone, too; Tsutakawa observed, "It kind of crackled, and chipped, and these little crevices appeared, and it turned brownish, a metallic brownish color."

In stone carvings, both representational and abstract, including *Fisherman (Self Portrait)*, Tsutakawa sought the fiercely compact massiveness possessed by many of Pratt's works. It was a common style for many public works then, conveying to the viewers of World's Fairs or government buildings the qualities of power, simplicity, and resounding certainty. In relief carving, and in terra-cotta work too, this bulky clarity was sought by Pratt and later by Tsutakawa. In other instances, Pratt worked quite differently, toward an attenuated grace and taut thin elegance that might now be called Art Deco, as in the swooping arc of a seagull. This kind of work was technically beyond Tsutakawa then, but its airborne grace and rhythmic movement were surely an important precedent for him, when he decided much later to leave behind the earthbound metaphors in his own work.

Another sculptor who became important for Tsutakawa in the 1930s was Dudley Carter. He was a timber cruiser for one of the lumber companies and had a work yard outside the city, where some of the finest and biggest logs were shunted aside for his own use. He carved figures similar in bulk and scale to other public sculpture of the time, but with an unusual rawness of material quality. The ragged textures of the cedar and of axed surfaces were left visible. It was another example, for Tsutakawa, of the important role of materials as integral to the work. Carter also employed Indian motifs in his work on occasion, reinforcing the impact of the Indian works Tsutakawa had seen in Alaska.

Tsutakawa also studied with the flamboyantly Continental sculptor Alexander Archipenko, who taught at the University of Washington during the summers of 1935 and 1936. On the basis of his early Cubist works, Archipenko had developed a rich variety, both representational and abstract. A lively counterplay of contours and masses was always present, and sometimes unexpected hollows and voids were played off against the solid materials. Tsutakawa worked under Archipenko alongside the graduate students: "I learned so much from him, so much about form, sculptural form. And space! The whole idea of space in sculpture. He was one of my masters." The suave and gracefully integrated curvatures of Tsutakawa's terra-cotta figures, and of some near-abstract experiments, resulted from this stimulus.

This heightened consciousness of space as an esthetic element with its own integrity found reinforcement through a growing interest in the distorted spaces of Surrealist painting, and, in contrast, through acquaintance with architecture students at the university, who were required to take joint courses in painting and sculpture along with the art students. Minoru Yamasaki was a fellow student during Tsutakawa's first two years at the university, along with other future architects such as Victor Steinbrueck and Paul Kirk, who remained friends with Tsutakawa through the years.

Meanwhile, Tsutakawa was broadening his competence in other directions. He became skilled at English watercolor under Ray Hill, "a good craftsman [who] had a very good sense of composition." He learned the rudiments of fresco from Ambrose Patterson, who had gone to Mexico in 1934 to study with muralists there, in particular Pablo O'Higgins. A strong sense of objects and of public access continued to draw Tsutakawa. He made studies for murals. He translated the formalisms of Cubism onto a wooden bowl in whose shallow cavity the jaunty zigzags of trees and a strolling man played witty games with the format.

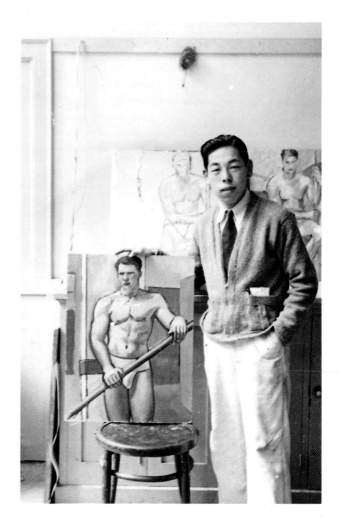

George as an art student at the University of Washington in 1935

By 1936, the time was ripe for his trip to Paris. Tsutakawa had the money saved; he had picked out a steamer line that would take him through the Panama Canal and on to Europe. But when one of his uncles had a stroke, he was suddenly pulled back into the family business, shouldering new responsibilities and turning once more from his chosen path. He took another year at the university, deferring his degree until well past the required credits and extending his immersion in art into 1937. Then his student days ended once for all, and the claims of family and commerce seemed to take over.

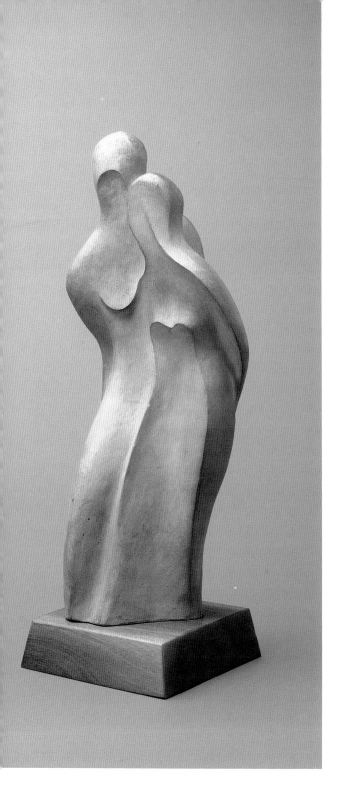

Two Sisters, 1936. Terra cotta, 19½″ × 7″ × 6″.
Collection of the artist. Photo by Paul Macapia

Three Sisters, 1936. 18½″ × 4½″ × 7″. Collection of Mr. and Mrs.
Johsel Namkung, Seattle. Photo by Paul Macapia

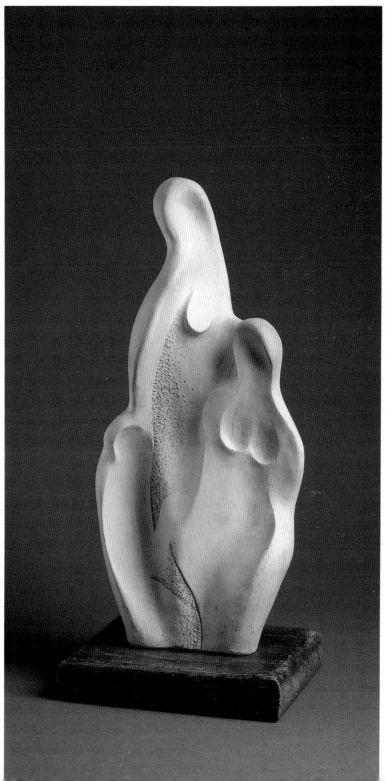

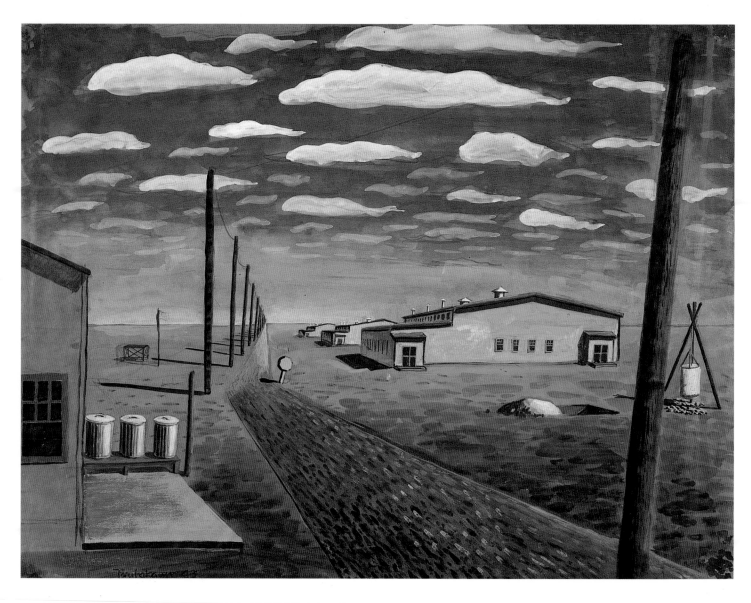

Camp Fannin, 1943. Oil, 16⁵⁄₁₆" × 21³⁄₄".
Collection of the artist. Photo by Paul Macapia

The Citizen: "Sunday Painter" and Soldier, 1937–1946

My desire in painting is to avoid the conventional art rules, so that I can be free to paint and approach Nature creatively. I have gradually and almost unconsciously been influenced by the work of early Japanese painters. Now realizing this influence, I am consciously trying to utilize those qualities that I want, such as color, line and simplicity of conception, in my own style of painting. Due to the great difference between the Western style of painting and the Japanese, the problem is a very difficult one.

—Kenjiro Nomura, 1937

"You, Mr. Judge . . . was it a just thing to ruin a hundred thousand lives and homes and farms and businesses and dreams and hopes because the hundred thousand were a hundred thousand Japanese . . . and, if so, how about the Germans and Italians that must be just as questionable as the Japanese or we wouldn't be fighting Germany and Italy? Round them up. Take away their homes and cars and beer and spaghetti and throw them in a camp and what do you think they'll say when you try to draft them into your army of the country that is for life, liberty, and the pursuit of happiness?"

—John Okada, *No-No Boy*, 1957

T SUTAKAWA'S FATHER'S COMPANY dealt in all manner of export and import goods—food, clothing, art goods, scrap metal, lumber. The store that George managed for the company was a retail outlet at the important crossroads of Jackson Street and Rainier Avenue South. This was where Jackson Street climbed up from the International District and Japan Town from its origin just below them in the Pioneer Square area, with its train yards and depots abutting the docks and the nineteenth-century commercial center of town. "We had a grocery store, fresh flowers, vegetables, fruits, and fish market, Japanese and American food, and quite a busy place," Tsutakawa recalls. Thoughts of Paris dissipated as he became absorbed into the bustle of business and into the small but diversifying world of Seattle artists.

Tsutakawa's life as an artist was redirected away from the university, with its Eastern-trained and European-traveled faculty, its designers and educators from Columbia University Teacher's College, its pedagogical interests in fine arts in education, and in art for increasing numbers of people. He became more firmly attached to the Asian artists downtown, such as Tokita and Nomura, with whom he had always maintained important ties. And he came to know others closer to his own age, who were still, like himself, feeling their way through a variety of choices and directions in art.

In 1937, the same year Tsutakawa left the university environment, twelve Seattle painters reproduced their work and tried to formulate their artistic goals in a small publication by Frank McCaffrey's Dogwood Press, *Some Work of the Group of Twelve.* Two of them taught at the university, but in these years of the Depression, there was an increasing gap between the accredited and salaried academic art teachers and the variously trained and resourceful artists, whose artistry was mostly certified only by their own commitment, their joint exhibitions, and sometimes a passing notice in the local papers. One of the greatest benefits of the WPA and other government art programs during the Depression, one cited again and again by artists, was its certification of the independent artist as a worthy practitioner within American society. A number of the downtown painters were on the WPA rolls in the late 1930s—Morris Graves, even Mark Tobey briefly.

Tsutakawa's store sometimes cashed the government checks of the WPA artists or extended them credit. The store was a meeting place for artists, and he was, to a degree, one of them. On the other hand, he was also running a business that he remembers as having more than ten employees. He was not certified an artist, by either the university or government programs; and he came to think of himself as a Sunday painter. In fact he dropped sculpture and other physically rigorous ambitions, and became instead a painter and friend of painters.

Among the artists Tsutakawa became closer to at this time were several who would soon be regarded both locally and nationally as part of a Northwest School. Mark Tobey, Morris Graves, Kenneth Callahan, William Cumming, and Guy Anderson were among the best known. The year after Tsutakawa left the university was crucial for them. Tobey returned to Seattle in 1938 after an absence of many years of traveling in Europe and teaching in a progressive school in England. Graves was coming into an innovative and productive period after several years of wandering and experiment. Some among this group had an unusual interest in Asian art. Callahan worked at the Seattle Art Museum handling Dr. Richard Fuller's extensive collections of Asian objects and pictorial arts. Tobey and Graves had each been to Asia. Tobey had lived in both China and Japan, studying calligraphy, *sumi* painting, and Zen philosophy. Graves had been in the Merchant Marine. Both were strongly drawn to water-base media and to paper as a support; increasingly by the late 1930s, the work of each was moving toward the scale and delicacy of Asian art. They were appreciative of and inquisitive about Tsutakawa's heritage, showing an interest that was unprecedented in his experience of westerners. He, in turn, was a kind of go-between for them and other Asian artists, who were too self-effacing, too intimidated, to reach out or respond to established Caucasian artists. "Mark Tobey wanted to talk to Nomura and Tokita, but they always shut up when they're confronted with a great artist. Because he was regarded as so superior, they were modest . . . They were immigrants . . . There was a very strong feeling about this . . . They have to contain themselves."

However great the relish of these western artists for things Japanese, it occurred in a very different context from the traditions of Tsutakawa's childhood in Japan. There, a single painting appropriate to an occasion or to the season had been respectfully hung in the *tokonoma,* an alcove designated for that purpose. In contrast, Tobey's objects participated in a dense exotic accumulation within which the sudden treasure or the unexpected juxtaposi-

tion created surprise and wonderment. Tobey lived in a clutter of musical instruments and notations, his own and others' art works, and collected objects. "He was a great collector of odd things, especially Asian things, and he would pick it up and show it to me . . . 'Well, look at the color, look at the texture and look at the form.'" Even more eccentric, Morris Graves then "had an old condemned house up on the hill above a store, just off Twelfth Avenue on Yesler. It was a great big old abandoned house, no water, no electricity, no nothing. And this bunch of artists just took it over. Inside there was a huge living room, and they covered the floor with sand and gravel and made a fire there." It was in an atmosphere more like European bohemianism that Asian artifacts were studied with such relish.

In particular, it was a bohemianism with distinct elements of Dada and Surrealism that these young artists were creating out of the imposed limitations of a provincial Depression outpost. Tobey deployed enigmatic figures in eerie gray landscapes and experimented with tangled luminous forms on the edge of abstraction, vaporizations of the material into the spiritual or psychological. Graves was becoming friends with the equally eccentric John Cage, musician-experimenter who came to teach at Seattle's Cornish School in 1938. Graves himself was exhibiting flamboyant and provocative behavior of a Dada cast that seemed linked also to Zen. And Graves was painting much more in tempera on paper by 1938. His works were weird evocations of unidentifiable organisms floating in dark, eerie spaces and carrying provocative titles, like *Message;* or he depicted ceremonial chalices or urns in equally mysterious fogs and tidal flats, and bearing portentous titles such as *Burial of the New Law.* Tsutakawa recalls that Mark Tobey was also doing big, spatial, somewhat Surrealistic paintings. Another friend of Tsutakawa then was Malcolm Roberts, who was "already doing Surrealistic paintings, very beautiful things . . . His paintings were a little more like a Chirico, but much more refined . . . He would bring [them] in to this little room and we sat and talked about it."

The spatial aspects of the new paintings interested Tsutakawa most. His early works had always been grounded in clearly constructed perspective systems, and though the point of view varied from the simple horizontal view to the steep and dramatic, it was always clearly coherent. In *Terrestrial Rhythms,* a major oil painting of 1940, he took the desolate coulee geology of central Washington as the starting point for a work in which space is fluid and mutable. The scale is uncertain, as in so many Surrealist works, and as in that genuinely strange and uninhabited terrain itself. What the arid glaring landscape of Spain was for Miró and Picasso, the basalt cliffs and blind dry coulees were for Tsutakawa. With the painting's high horizon and pale coloration, it almost seems that earth and atmosphere may dissolve and intermingle, like the transformations of dreams. "With a bunch of painters, we used to take a trip back to east of the mountains, around Dry Falls and Wenatchee and Grand Coulee Dam, that country. Somehow I just loved that country. And then we did watercolor and oil paintings, quite a few of them, in those days. And we'd try to finish one or two up for the Northwest Annual, hoping they'll be accepted."

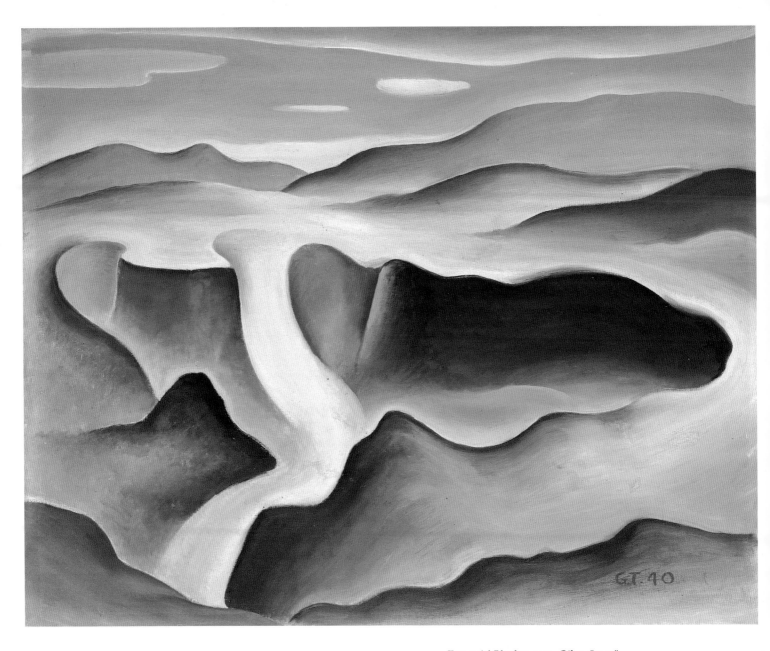

Terrestrial Rhythm, 1940. Oil, 34″ × 43″.
Collection of the artist. Photo by Paul Macapia

One friend was lost in these years, perhaps his dearest, Shiro Miyazaki. Tsutakawa relates that he "used to come to my house . . . And we spent many, many days, hours, together, and we went sketching together. And we had many paintings that were done together." But Miyazaki had become increasingly involved in labor organizing and in working for the Communist party. His art, too, became devoted to the cause; he was repeatedly arrested and in financial difficulties; his father disowned him. In the mid-1930s he moved to California, leaving much of his work with Tsutakawa. Tsutakawa sent him money. From exhaustion, from tuberculosis, from other diseases, Miyazaki died in 1940. For Tsutakawa, he was triply lost—lost to art through his turning to political organizing, then lost to Seattle by moving, and finally lost through death.

Tsutakawa had come to be adamantly opposed to any instrumental use of art, for any ideological purpose. Like the Group of Twelve, and like the reclusive Chinese and Japanese practitioners of art as an element of the contemplative life, Tsutakawa held it to be apart from commerce or politics. Art was to be concerned with harmony or with personal expression. "To me, whether he was a Communist or imperialist or capitalist artist, if he's a good artist, he's a good artist." Some of the Seattle painters with whom he associated were of the same mind. Tobey, who was a member of the Bahai faith, and Graves, who was incarcerated during World War II for refusing the draft, were both developing a consciously antinationalistic pacifism by around 1940, as was Guy Anderson.

Perhaps Tsutakawa's modest level of artistry, as a self-styled Sunday painter, might have continued indefinitely. In 1940, he went to San Francisco to the Golden Gate International Exposition, for which his old friend and mentor Dudley Carter had completed a big wood totem pole. The murals in the Coit Tower on Telegraph Hill excited Tsutakawa; they were dense with the vivid colors and vigorous subjects of California life and history. In addition, they were public. But he felt he had relinquished those media and purposes, his art was private expression. It did not represent the histories of any peoples, and then, as later, he "was very delighted, that they didn't identify me as an Asian artist or American artist." This comfortable anonymity was soon denied him, though; and the harshest requirement to consider who he was, to others in society and to himself, was impressed upon him.

About the same time as the Exposition, Tsutakawa made one of his annual autumn trips over the Cascade Mountains to the dry plateau country of the Columbia River. He stopped his car on a promontory looking out over deep golden wheat, in the area near Cle Elum and Ellensburg, and got out his camera to take a picture. A state highway patrolman pulled over behind him, got out of his car, wanted to see Tsutakawa's identification papers—more than just his driver's license. The patrolman went back to his car and spent a long time on his radio. Tsutakawa waited, puzzled, then apprehensive. The officer returned eventually and told him he was free to go on. But by now he knew all about Tsutakawa, who he was, his business, that he was a Sunday painter. "Be careful," he said, "We have our eye on you."

P EARL HARBOR abruptly changed the tenor of all Americans' lives, and those of West Coast Americans of Japanese origin in particular. An inevitable dread gripped the Coast, a fear of Japanese submarines, for example—Puget Sound and the islands from Tacoma up past Seattle to Bellingham constituted an endless labyrinth of interlaced passageways. Japanese Americans found themselves abruptly deprived of their civil rights and property and shipped to detention camps in "safe" inland areas. As Tsutakawa's father lived primarily in Japan and was not a citizen, the family business was regarded as alien property. "Tsutakawa Company was confiscated . . . We lost everything. That was a big company, warehouse full of merchandise and half a dozen trucks, big company in those days." The families of both his uncles (Jin and George) were sent to Minidoka, Idaho; his sister Sadako and her family were in the Tule Lake, California, camp. For Nisei (second-generation) young men with citizenship, the decision to resist or accept the draft under these conditions was often harrowing. "It was a great mental and—what do you call?—physical as well, difficulty for all the Japanese people, especially Nisei like myself."

For George Tsutakawa, the war years enforced a reexamination and re-affirmation of his identity as a Japanese and, eventually, as an artist. The crises were related, as his artistry became first a field for self-examination, then an arena in which to synthesize his heritages, and finally a means of transcending the self.

Tsutakawa was inducted into the U.S. Army soon after Pearl Harbor, in early 1942. He remembers being taken with other Nisei from the Seattle area to Monterey, California, and then sent with the same men on a troop train with "orders to keep the blinds down, so we can't see outside . . . I think we were all suspected, you know, still suspected of espionage or some sub-versive act . . . Of course we didn't know where we were going, and there was a rumor that we were going to be imprisoned or enslaved or something like that." He said that they felt treated more like prisoners than inductees until they reached Camp Robinson, Arkansas, near Little Rock. There, they found, they were treated like everyone else, assigned in small groups among the other units, and to people in the area were indistinguishable from Chinese or other Asians.

Tsutakawa visited his family on his furloughs and found them not really so demoralized as one might have anticipated. He observed that the hard-working interned Japanese found that, for four years, they had nothing to do. Farm projects took some energy but, isolated as they were, they turned to their cultural resources for enrichment and continuity. A young woman from Sacramento whose family was in camp with his sister was among those whose understanding of traditional arts was strengthened during this time. She stood out as a performer of Japanese dance and *koto* music. The soldier Tsutakawa met the interned Ayame Iwasa in the detention camp, and they married two years after the war.

But this community identity could only be visited, not shared directly, by a young man in the army. Tsutakawa, in contrast, was pressed to come forth as an individual, to mediate between Japanese and Caucasian, much as he had tried to do between artists' groups in Seattle. One uncle, George, was evidently more suspect than others and was sent with other Japanese nationals to a higher-security camp in the southwest, from which he strug-gled, with deepening bitterness, to be returned to Japan. And he wrote Tsutakawa "many, many letters, asking me, as a member of the United States Armed Forces, if I could be of some assistance in persuading the American military government to free him . . . He kept writing to me and he wanted me to come to the camp and talk to the camp commander." So Tsutakawa got a furlough and took the trains to try. "And then this was just a desert; there was *nothing* there . . . one small town, maybe half a block long, one laundry, one beer parlor, one small hotel . . . and went out to this camp, which is way out in the desert—nothing! Barbed-wire, you know, and guarded . . . go through two, three gates and be interrogated and had to show all my credentials . . . And we had conversation, limited time, with a guard watching you all the time . . . And we had conversation but there was nothing much I could do." Inevitably, he felt keenly the vulnerability and separateness of his Japanese identity. (His uncle and family were even-tually repatriated to Japan through India.)

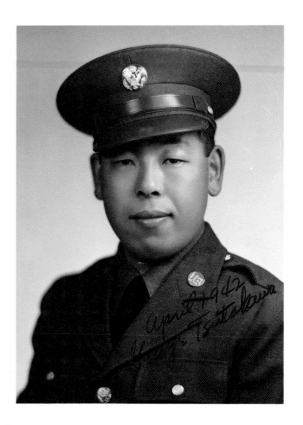

George in 1944, a United States Army sergeant

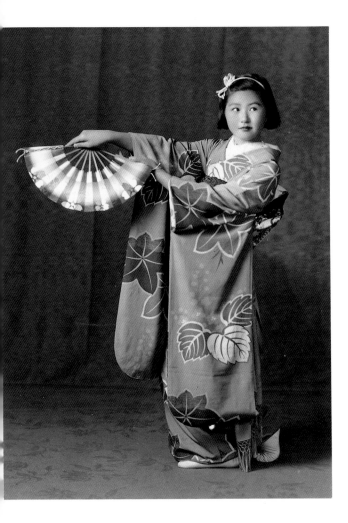

Tsutakawa remembers with special vividness an incident that occurred on the train as he went to find his uncle: "I was still kind of scared myself, and then traveling . . . in a strange territory where I have never been before, just for this purpose . . . After we passed through Oklahoma City, as I was sitting there, a gentleman, a very tall, handsome, bewhiskered gentleman, in sort of a Southern style . . . came and sat next to me. And I didn't say anything; I just sat looking out. And he just sat there for a long time and he was reading a paper or something like that. But somehow, eventually, he started a conversation with me. He was a very kindly man, you see." The passenger then inquired where the soldier was from, where he was going—and then whether he was Japanese. Tsutakawa balked at the direct question: "And at that time, somehow, I didn't want to say I was Japanese so, 'No,' I said, 'I'm Korean.'" The man seemed knowing, even sympathetic, and said he had been much in Korea and Japan. "And I think he suspected, he knew already that I was not Korean . . . He really didn't pursue this any more. And then he got off the train, he said, 'Well, good luck, soldier.' And then after that, there was a lot of hard thinking and soul-searching . . . So after that experience, I decided that I would never lie about my birth, my origin, any more; I should be always honest and say who I am."

Most of the few paintings or drawings that Tsutakawa saved from the war years are closely related to his experiences then and to his sense of self. *Camp Fannin* is a tempera painting from 1943, in which the deep perspective and small scale of distant forms convey the utter flatness and near hallucinatory emptiness of his new post. Sketchbook pages record the bleak comedy of the helplessness he experienced in the army general hospital ward when he was there for minor surgery, and as he saw it in others; with spare pen lines he invented near-caricatures of the tension and discomfort.

Ayame Iwasa at fifteen was an outstanding performer of Japanese classical dance in the Bando-ryu style (1939 photo)

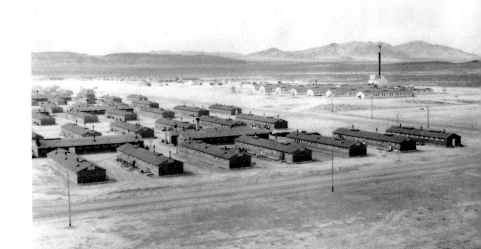

Tule Lake war relocation camp in the northern California desert, where Ayame and her family were interned for four years

In a little oil of the same year, *Boy Playing Ball,* Surrealist forms like those of Arp or Miró appear within the flatness. As in Surrealism, the figure has no definitive setting but seems to generate or be generated by some organic ambience. The most complex and also most personal of these works is another related oil that Tsutakawa designates a self-portrait. As he explains it, his Self is dispersed among several elements: a figuration of sculptural clarity in the center, with a hole in its own center; its shadow, through which it watches its central self; and a cell of life, a displaced energy and organicism, isolated at lower right. The central emptied manikin is attached by a great spring to some unknown destiny toward the far diminishing horizon, and all is set in a brightly simplified pattern of shapes and colors, again like the happiest experiments of some of the Surrealists. Like Surrealist work, it is less happy and more disturbing after a first impression. There is a sense of the self as possibly empty, watching itself from outside and drained of its life force. The work was very likely done in 1943 at the point when some of Tsutakawa's unit had been shipped out, and the air was full of rumors and tension.

Boy Playing Ball, 1943. Oil, 13″ × 15¼″.
Collection of the artist. Photo by Paul Macapia

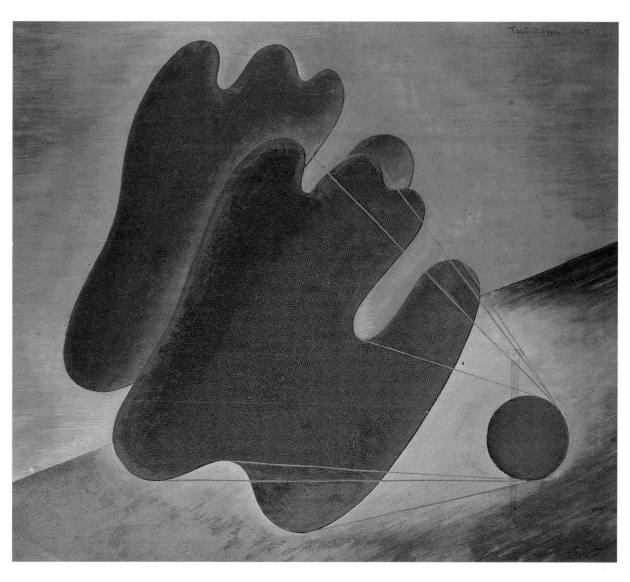

Tsutakawa's self-scrutiny came to a climax by these difficult individual incidents and by particular works of his own. His realignment to art, though, was also to a very different, pervasive, and free-wheeling activity that only sometimes participated in the rigor of self-examination. He recalls: "I started basic training like anybody else, running around with a rifle and doing the calisthenics and target practice and all that. But anyway, after about a month of this training, I was called by the camp commander . . . 'I hear you're an artist.' 'Yessir!' So he says, 'Well, how would you like to paint my portrait?' Well, I had to kind of brush up and try to remember what Isaacs [a University of Washington professor] told me in his portrait painting class." After the commander, there were other officers who wanted portraits, "so then they treated me so well, just like an officer, and I'd go to the officer's mess hall and eat the best steaks and made friends . . . yeah, and then they say, 'Well, how about decorating the officers' club?' Now this time they're talking about a big mural. I had never painted a mural in my life, actually, but I said, 'Sure, yes sir.'" Even the USO put in its claim to the artist's skill. Tsutakawa painted several murals of subjects that were requested—"usually people, and sometimes it had to do with weapons—oh anything, all crazy things, nothing serious," he claims, and he didn't take it seriously. But he found he could be loose, easy, and prolific in these situations.

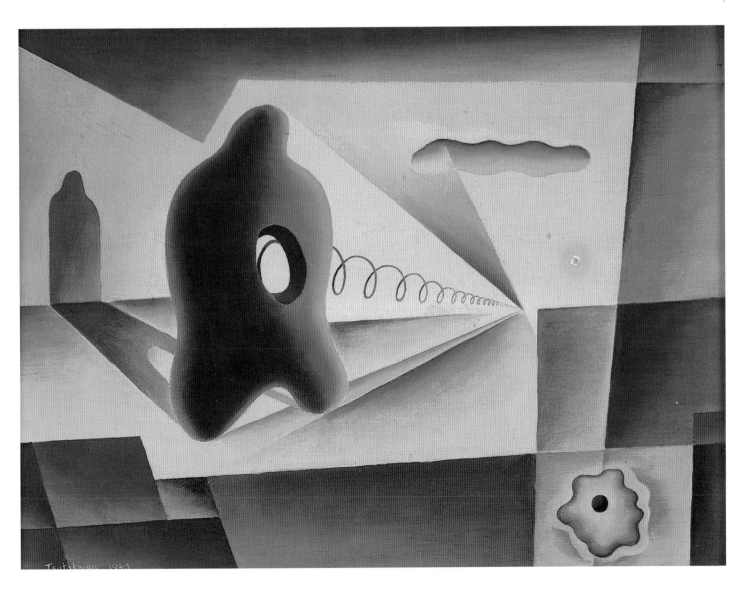

Self Portrait, 1943. Oil, 11¼" × 15¼".
Collection of the artist. Photo by Paul Macapia

On weekends Tsutakawa and friends went in to Little Rock, to Negro jazz and dance clubs where whites went to watch from the balcony. Asians were considered whites in this context, and Tsutakawa learned new aspects of race relations in America from this experience of the South. He also learned a sense of ethnic culture from an outsider's viewpoint, watching and making a number of works in pastel. These employed a Cubist-derived patterning of sharp angles and simplified brightly colored forms, to capture the dancers, the musicians, the vivid ambience, of the jazz club. "I was fascinated and drawn by the Negro culture, and especially their religious ceremonies."

He also became friends with a painter and printmaker in Little Rock, Tom Robinson. The Robinson family gave Tsutakawa a "big room with a screen porch where I could go and sleep in this luxurious bed with a canopy, real Southern style . . . I was having a great time . . . unbelievable!" In a revealing transposition, he found himself on the white-majority side of the color line: "In those days I had very interesting experiences. I soon found out that I had to have no fear of my freedom and movement in the city . . . and I used to explore and wander around downtown in Little Rock."

The mural painting continued when the unit moved from Camp Robinson, Arkansas, to Camp Fannin, Texas. Tsutakawa termed himself the camp commander's "pet artist . . . always riding the jeep, going around and inspecting bivouac and maneuvering areas—make sketches and maps and do little things like that for the commander. And that life was fine, too." He

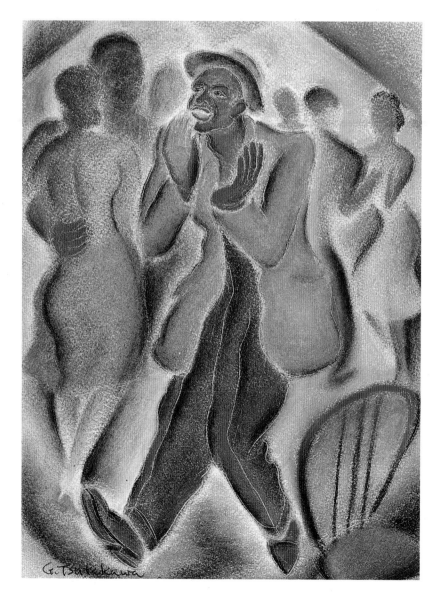

Zoot Suiter, 1942. Pastel, 11½" × 8⅞".
Collection of the artist. Photo by Paul Macapia

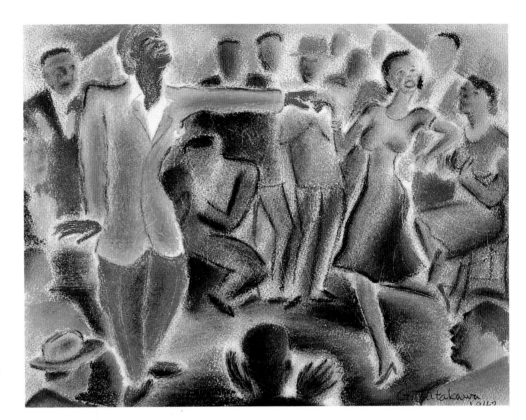

Couple Dancing, 1942. Pastel, 8⅞" × 11½".
Collection of the artist. Photo by Paul Macapia

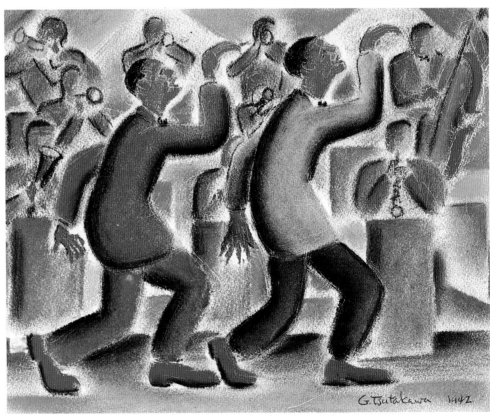

An Impression of the South, 1942. Pastel, 8⅞" × 11½".
Collection of the artist. Photo by Paul Macapia

was soon sent on to Camp Shelby, Mississippi, where, he recalls, "the all-Japanese combat teams were being organized for active duty in Italy . . . the very famous outfit which is one of the most decorated outfits in the U.S. Army . . . Well, I was in that outfit briefly." But the commander's pet artist was in no shape for grueling jungle training, and besides, he was ten years older than most recruits. It was at this post that Tsutakawa landed in the hospital and underwent surgery for a worsening medical condition. When he was well, the unit had gone. Furthermore, the army had discovered better use for his years in Japan and his university training; he was next sent to Fort Snelling, Minnesota, where he spent the rest of the war teaching the Japanese language to officers.

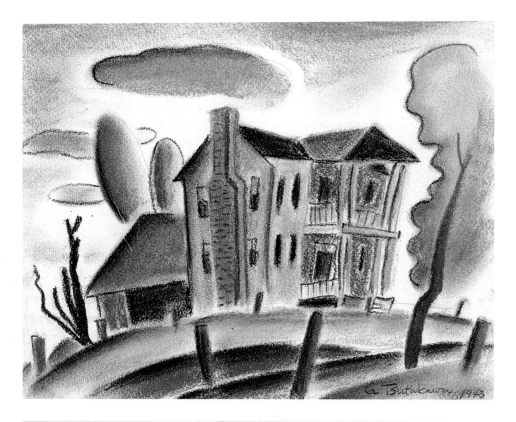

Southern Mansion, 1942. Pastel, 8⅞″ × 11½″.
Collection of the artist. Photo by Paul Macapia

East of Little Rock, 1942. Pastel, 8⅞″ × 11½″.
Collection of the artist. Photo by Paul Macapia

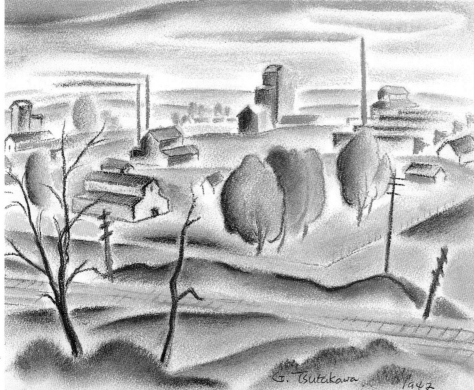

Though there was no more such prolific work as commander's artist, Tsutakawa's art benefited in a different way from the new location and the easily available furloughs and travel. He became well acquainted with the collections of the Minneapolis Art Institute. He went to Chicago frequently, spending days in the Art Institute and responding intensely to the Van Goghs. For him, they resonated with his experience of the central Washington wheatland's brilliant gold and endless blue. He made his first visits to Boston and, most importantly, to New York City, in the spring of 1943. The galleries on Fifty-seventh Street did not intimidate him then as they might have done earlier. A big Kandinsky show at what became the Guggenheim Museum made a deep impact. The Museum of Modern Art had many affirming works: Miró, Brancusi. The Buchholz Gallery had an exhibition that especially impressed him—forty watercolors and drawings by Henry Moore, the first extensive showing in the United States of any work by this noted sculptor. Tsutakawa undoubtedly found the works deeply sympathetic, for they depicted sculpturesque figures of that bony, eroded character already associated with Moore's three-dimensional work, and their hollows, holes, and suave contours would have been familiar from Tsutakawa's own work under Archipenko. The figures were set into deep landscapes of curvilinear land forms simplified to eerie grayness and rolling with an organic energy of their own. They recalled Tsutakawa's sense of the central Washington land forms, and they surely confirmed his satisfaction with his own self-portrait of that same year.

Fort Snelling Winter, 1949. Oil, 23" × 29".
Collection of the artist. Photo by Paul Macapia

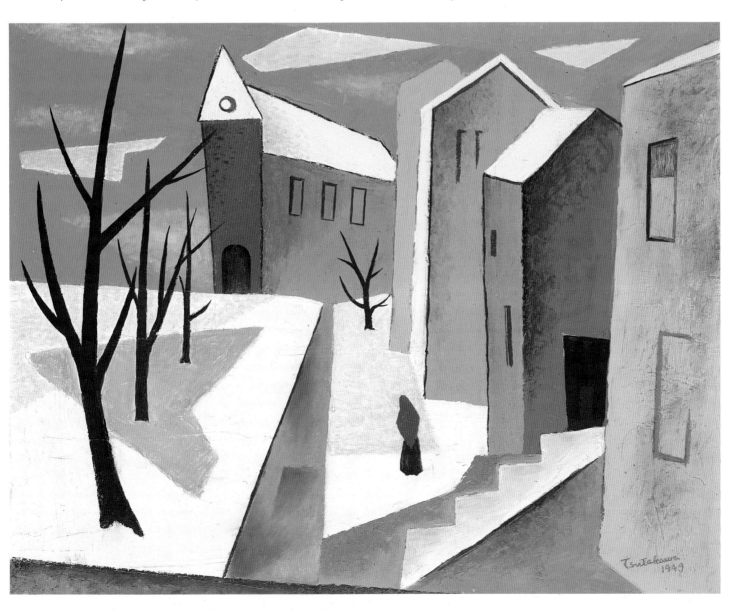

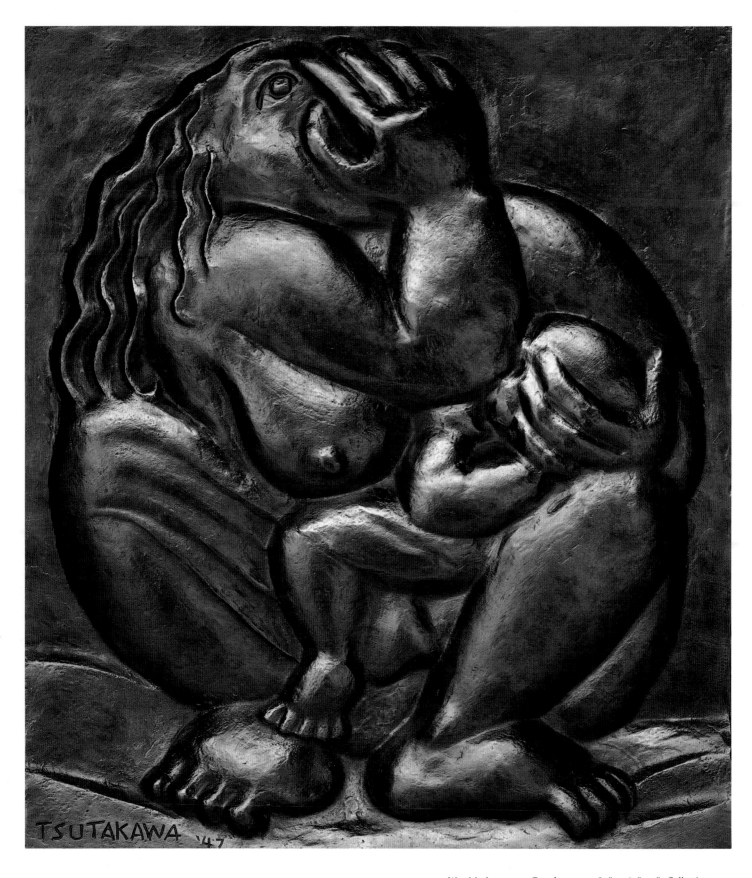

War Mother, 1947. Cast bronze, 18¼″ × 16½″ × 2″. *Collection of Mrs. P. Locke Newman, Seattle. Photo by Paul Macapia*

Artist-Experimenter, 1946–1955

. . . the total space—and everything in it, including time, and light, and movement, rhythm, and scale. I mean, size, volume, weight, and vibration; we [artists] were always talking about this.

—George Tsutakawa, 1983

WHEN TSUTAKAWA returned to Seattle after more than four years in the army, he did not reenter his old life of managing the market and of friendship with the downtown artists. Of course, Seattle itself had changed; Tokita and Nomura, those older painters who had encouraged him for so long by their work and awards and companionship, were no longer accessible. "I was in the army and we kind of lost contact . . . And then when I came back from the war and they came back from internment camp to Seattle, everything was all torn up; it was not like the old days anymore. We had a heck of a time trying to locate them, because they had lost their place, residence, homes, business, everything was really dislocated. So it took some time before we got together again."

Tsutakawa himself had changed. The war years were his *Wanderjahre,* his alternative to the European sojourn that never materialized. They had freed him from the family's commerce and given him opportunity to roam through major museums at leisure and to know a larger world of galleries and contemporary art than Seattle provided. He had explored the other cultures that opportunity brought his way. He had gained much creative facility during years of permissive experimentation and freedom from academic constraints. The army was the last of the detours through which Tsutakawa came into his full life as an artist. When he returned to Seattle in 1946, at thirty-six years of age, he was prepared to undertake the work of consolidation that would make a whole and focused art from the radically diverse cultural components of his experience. In the following decade he became much more productive, renewed his work in sculpture and his association with architects, and expanded the range of his art's forms and purposes. He constructed a work life and family life of deep commitment.

"First what I did was to really decide that I wanted to pursue art. So I went back to graduate school with GI education funds." Tsutakawa returned to the University of Washington as a graduate student in art. His training and his maturity led to his teaching Japanese there in the Far East Department; soon he was asked to teach as well as study in the Art Department.

It was the culmination of a long struggle against the dictates of a distant culture and father—a culture and father whose very remoteness made them harder to grapple with. Though he had felt essentially disinherited from the time his father had broken off with him, twenty years earlier, Tsutakawa declared himself again: "In those days most sons did what their father or the ancestors prescribed . . . But in the history of any country—China, Japan— there have always been a few rebellious sons who didn't go along with the father's wishes . . . I found out that my father was getting old and ailing and that he was retired in the old country home. I wrote him a letter in Japanese—the best Japanese I could—and told him what I was doing: that I had been hired by the University Art School to teach part-time in the art department. About a month later a letter came from my father—a very wonderful letter—actually, in effect, forgiving me, and saying, 'All right, you're on your own; you do your own stuff.' I'll never forget that. I'm glad that he lived long enough to find out that I was wholeheartedly making art my life's work."

WELL BEFORE the happy outcome of the return to art and his reconciliation with his father, Tsutakawa had determined on another major change: he wanted to marry Ayame Iwasa. Like Tsutakawa, Ayame had been born in the United States. From the age of thirteen months to thirteen years, she had lived in Japan in a village not far from Okayama City, adjacent to Fukuyama where George had lived. Her upbringing, like his, had been richly traditional, and she was especially accomplished in Japanese music and dance. She had returned to the United States in the late 1930s and lived for five years in Sacramento, where she continued her studies. Her mother and stepfather operated a number of businesses, among them a liquor distributorship. After Pearl Harbor, she had even more time to focus on traditional arts and participated in the weekly performances with which the interned civilians sustained themselves. She might have returned to Japan after the war, to study and possibly to stay, had not meeting George changed her plans.

The Tule Lake camp was a high-security relocation camp that included many loyal to Japan. Ayame's stepfather, like many other older Japanese, believed resolutely in Japan's triumph in the Pacific. Short-wave radios in the camp picked up Japanese broadcasts confirming their view. Ayame's older brother, who had stayed in Japan to complete his studies, had been caught there by the war and inducted into the Japanese army. When George, visiting Tule Lake on furlough in early summer of 1945, declared that Japan would soon lose the war, Ayame's stepfather became angry. Two months later, Japan lost. The camp gates were opened, and the interned Japanese were sent out to remake their lives as best they could. Ayame's family returned to Sacramento, where they learned through the Red Cross that the end of the war was for them additionally tragic: her brother had been sent to Hiroshima two weeks before August 6 and died in that unprecedented holocaust. The conflict of loyalties seemed unbridgeable; when George proposed marriage, Ayame refused him.

He wrote, and waited, and persuaded, for a year and a half, and finally they were married in January, 1947. Ayame provided their life with a context rich with understanding of Japanese traditions. They made a new Japanese American household for themselves, moving from extremely humble to increasingly comfortable quarters over the next decade as their family grew.

(Gerard was born in late 1947, Mayumi in 1949, Deems in 1951, and Marcus in 1954.) Tsutakawa's home-made Christmas cards of that decade were compressed vignettes of the harmonious life of art and family. Each year, in block prints or drawings, he invented some lively modernist image of his family; in 1949 Gerard was a frolicking organic splash and Mayumi (about to be born) was depicted as a Miró-like creature descending from the upper corner. In later years a matrix of cubist loops and bifurcated patterns would hold the family cats and George's home-made furniture along with the parents and children.

THESE CARDS were the whimsical by-products of more ambitious art in which Tsutakawa's new concerns were evident. For example, in 1947 he undertook a true fresco, working into the wet plaster, under the direction of Ambrose Patterson. This was no longer some trivial matter for an officers' club, and the free-standing panel's dimensions, 4 by 5 feet, were large enough for a sense of the amplitude of the work entitled *Dancing Figures* that he constructed. The looping lines that brought the figures into interlaced complex relations became the basis for independent color areas and for a Cubist sense of transparency and overlap.

Dancers, 1947. Oil, 21" × 27".
Collection of the artist. Photo by Paul Macapia

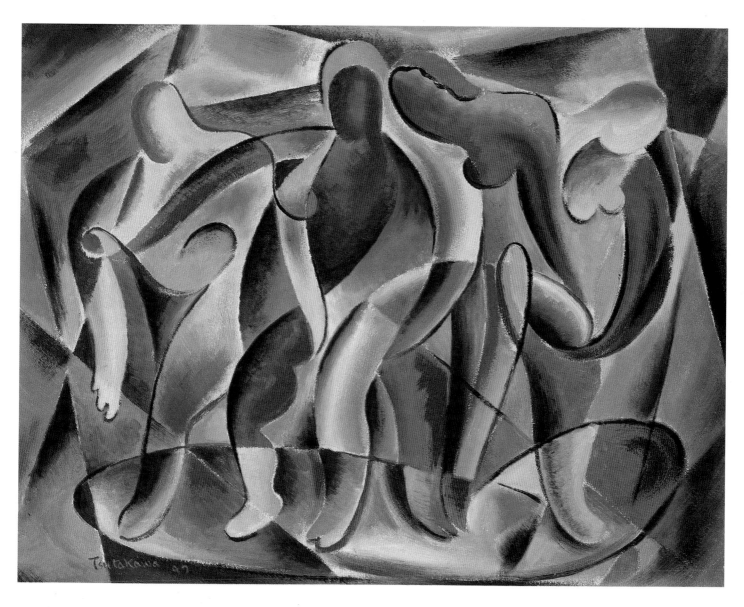

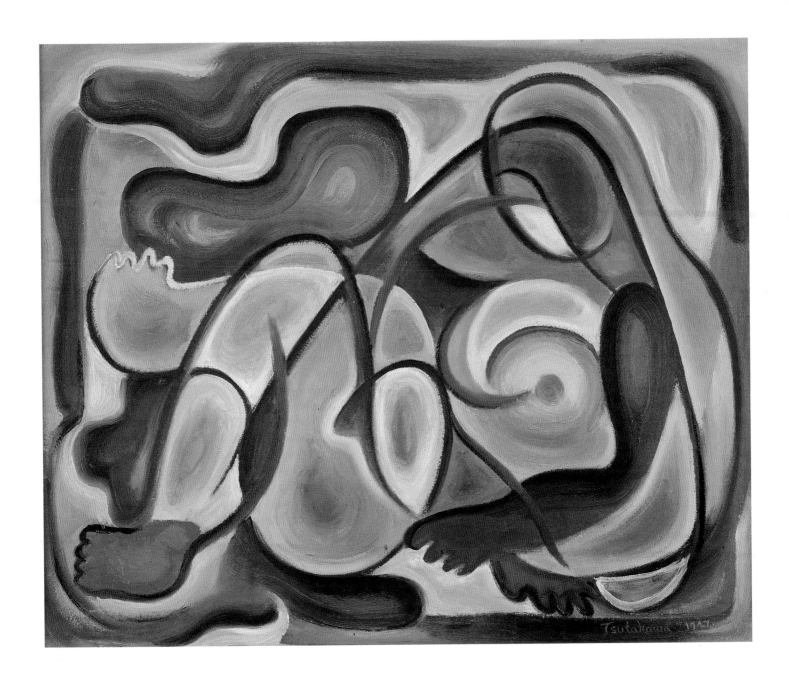

Reclining Nude, 1947. Oil, 24¾" × 30½".
Collection of the artist. Photo by Paul Macapia

In other works of about the same time, similar Cubist-like constructions were pursued—for example, in an oil painting of a robust woman reclining on her elbow. The full palette of colors and the tendency toward bright pastels, then, have some similarity to his earlier pastels of the Black jazz musicians; and so does the creation of permeating lively rhythm. But the figures are most often generalized females and the rhythms correspondingly more fluid, less syncopated and angular in these works after the war. The figures' amplitude and energy suggest fecundity and a positive life force, and they coincide with the first decade of the artist's marriage and the births of his four children.*

*Tsutakawa's looping figuration of these years has obvious similarities to Archipenko drawings of later years (e.g., figures 26 and 27 of 1962 in Giovanni Sangiorgi et al., *Alexander Archipenko* [Rome: Ente Premi Roma, 1963]), and very likely this similarity is rooted in earlier interchange. Archipenko's influence was reaffirmed when he returned to the University of Washington for a summer workshop in 1952. There also are striking similarities between Tsutakawa's cedar relief of 1953, *Daydream,* and Archipenko's *Angelica* (much smaller, of gilded bronze) of 1925. Both are shallow reliefs of fragmentary female forms, reclining torsos with heads to the right and abbreviated indications of limbs. In both, the truncated or missing limbs are indicated in witty and unexpected ways—in Tsutakawa's, a hand on the figure's hip refers to an arm that is not there (see fig. 113 in Donald H. Karshan, *Archipenko: International Visionary* [Washington, D.C.: National Collection of Fine Arts, 1969]).

†Tsutakawa's 1947 relief of *Mother and Child* or *War Mother* also suggests the possibility that it was stimulated by a José de Creeft work of similar size and subject, *Maternity* (1918; Metropolitan Museum of Art, New York). The de Creeft free-standing granite sculpture depicts a baby's head cradled by the turned head, shoulders, arms, and hands of the mother. It won first prize in an Artists for Victory competition in 1942, and it was widely reproduced in 1942–43. Tsutakawa's awareness of de Creeft may also have been stimulated by the Seattle Art Museum's 1940 acquisition of de Creeft's 1938 *Cactus,* carved of greenstone. (Both are illustrated in Jules Campos, *The Sculpture of José de Creeft* [New York: Kennedy Graphics, 1972].)

A more emotional work from 1947 was a plaster relief that Tsutakawa has sometimes called *Mother and Child* or *Madonna and Child.* Even more than the mural, it was probably rooted in his new sense of life, and also like the mural, it was directed by a desire that art be public. The massively robust figure types and their compression within a constraining format were very much in the old mode of so much prewar public sculpture—what he called "World's Fair sculpture." The subject, though, is postwar, for the very great compression all bears on the protection of the infant, and the woman's head and one visible eye are strained upward almost violently. Like Käthe Kollwitz's works after an earlier war, the relief is about terror and helplessness. Specifically, he has said, it was about the atomic bomb, and he had originally called it *War Mother.†* (In the 1980s he had a small edition of bronzes cast from the 1947 plaster; one is now in the Fukuyama Fine Art Museum.)

Returning to the University of Washington Art Department in 1947, Tsutakawa resumed working in a disciplined and orderly environment congenial to his own diligence, which his Japanese schooling had supported and later schooling had encouraged. But he returned with a new sense of freedom and interests, drawn from his years of independent work and his term in the army. He found himself isolated by his interest in public art. "I had already, like most of the art students, studied Mexican murals . . . so I was kind of fascinated . . . So I brought this up [at faculty meetings] . . . 'We should train our students to do large things, and sculpture and painting both.' I did say that. But no one was interested . . . no interest whatsoever . . . I was really shouted down." On another front, Tsutakawa tried to facilitate participation in the university programs by the downtown artists whom he had come to know before the war. Here, too, he had no success; the gulf between town and gown seemed actually to be widening, now that the government programs of the 1930s had been abandoned. Though Mark Tobey and Kenneth Callahan were well established nationally by the late 1940s, little more came to pass than one seminar talk by Callahan.

In spite of these limitations, his teaching and his students quickly became very important to Tsutakawa, and his continuing connections to former students provided him much gratification. Teaching was an arena for the collaborative and public tendencies that were increasingly preoccupying him. Through his teaching he came into a structured collaboration that, like his apprenticeship earlier with sculptor Dudley Pratt, prepared him to work with engineers, architects, and designers in increasingly complex situations from the late 1950s on. That collaboration, for about ten years beginning in 1950, was found through his teaching part time in the School of Architecture. He had been good friends with architecture students earlier, when they were sent to take courses in the Art Department; now he felt comfortable when he was sent to teach drawing and sculpture in the architecture program. He was part of a team of instructors in a year-long course that constituted the whole of first-year students' programs. "There were actually two or three artists too, who took part from the art school. And then all the rest of them were architects, but some architectural draftsmen, some theorists, some historians, some practitioners, professional architects. They were all thrown together to teach about 150 students." Tsutakawa remembers the course as "a highly integrated architectural design education for the beginners . . . to integrate all these arts together in this one big course."

The impetus behind the course was very much the example of the Bauhaus, and of its American offshots and reincarnations that flourished in these years in Cambridge, Massachusetts, and Chicago, for example. "For ten years, therefore, I got to know all the instructors, all their methods, and their philosophy and attitude . . . It was a very good ten years for me." It was in these years that there was so much talk of "the total space—and everything in it, including time, and light, and movement, rhythm, and scale . . . We were always very concerned about this Bauhaus Theory." Tsutakawa recalls that the Bauhaus influence was pervasive then throughout much of the art world, and that he himself was strongly influenced by the Bauhaus understanding of art as "a very total thing." Later he felt that the Bauhaus emphasis on form, space, and relationships had led to formalist art that lacked this sense of totality and that was no more than extensions of Bauhaus design exercises. He remarked that such work had "no form, there's no message . . . It's so detached. I don't see the relationship to man and his living and his thinking." He felt that perhaps "the whole world, all the people engaged in the business of art, just took it too seriously," and he hung on tenaciously to his own understanding of art as a total and personal matter, related to living and thinking.

In the late 1940s, Tsutakawa designed and made a number of chairs, tables, and lamps. They were fully compatible with a modernist esthetic in their simple vernacular materials—plywood, bamboo, paper, and Fibreglas—as well as in their modest functional effectiveness, and in their delightfully free and abstract forms, derived from the materials and tools rather than from traditional canons of form. The furniture was constructed of notched and fitted planes that went together quickly without nails or other intermediary joints. Their shapes were tautly arched in their vertical supports and fluidly organic, like an Arp or Miró or Calder construction, in the upper portions. The light fixtures and lamps were variously constructed using thinner bamboo for supports and large bamboo sections as cylinders holding the light source. Sections of the cylinder walls were cut away in Arp-like organic shapes and filled with translucent paper or plastic. These strongly sculptural abstract forms would be seen to relate to cylindrical and symmetrical sculpture Tsutakawa executed much later. Perhaps the interplay of matter with light anticipates this later counterpoint of metal and water.

While the furniture and lamps might seem elegant exemplars of Bauhaus-influenced design, they also grew organically, so to speak, from his own domestic life. They were made for use and were heavily used in the first years of his marriage, when he and Ayame had little money and very few possessions (they continue to use the lamps today). Soon he was making lamps for sale too, though he sold very few, and he considered making the furniture commercially but found that the complexities of obtaining patents made this impractical.

Japan was another factor in these functional works. They are very innovative and quite unlike Japanese lanterns in form (much farther from them, for example, than Isamu Noguchi's lamps of about the same time); yet the varied use of bamboo and the avoidance of weight and ponderous form reflect Japanese formal values.* The prewar talk among the artists downtown surely helped stimulate these attitudes—for example, conversation with George Nakashima, who was an acquaintance of Tsutakawa and a good friend of Morris Graves. Nakashima, trained in architecture and design, spent several years in many parts of Asia and had apprenticed himself to a study of traditional carpentry in Japan. On his return to Seattle in the late

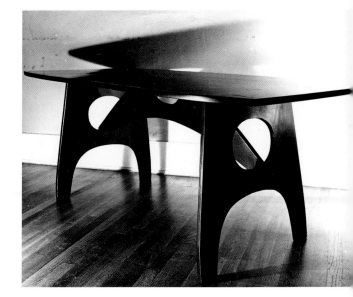

A 1954 table of wood and black lacquer constructed without nails

*Certain parallels between Tsutakawa's and Noguchi's work in the 1940s and 1950s have raised questions of influence and connections. These are discussed further in References and Remarks.

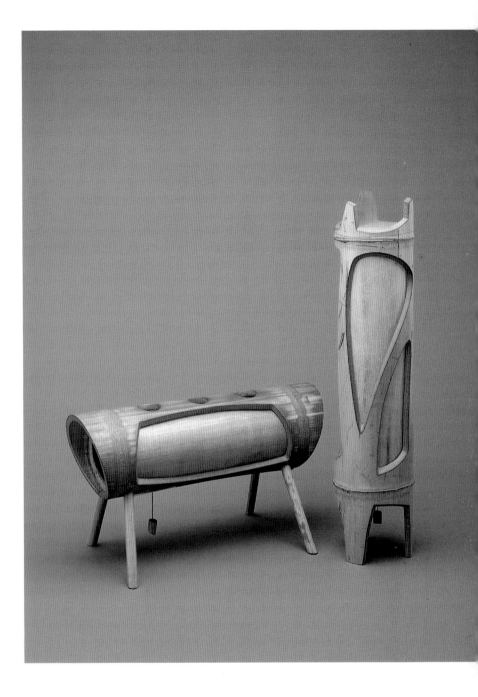

Lamps, 1952. Bamboo, 10" × 17" × 5½"; 22" × 5".
Collection of the artist. Photo by Paul Macapia

1930s, he began making furniture, advised Graves about the house Graves was building, and wrote in a 1941 article in *Arts and Architecture* that "form should grow" from the natural properties of materials and as one understands them through working with them.

Tsutakawa was also encouraged in this direction by Paul Bonifas, a Swiss potter who began teaching in the University of Washington Art Department about the same time as Tsutakawa. The vigor of his work and the crisp refinement of his forms made Bonifas admired by, for example, Amédée Ozenfant, who wrote of him in *Foundations of Modern Art*. Bonifas loved to talk and philosophize about art, and Tsutakawa benefited both from the talk and from studying ceramics with him. Some of Tsutakawa's lamps were included in a two-person exhibition at the Studio Gallery in Seattle, in 1947, where Bonifas was enthusiastic about them.

While extending his work into new media, Tsutakawa also returned during these years to a variety of sculptural works, and to painting. He made terra-cotta reliefs similar in manner to *Mother and Child* in their massive sense of form and their potentially public character. *Transfusion* was a large relief (about 3 by 4 feet) constructed by abutting four panels. Its forms described limbs and the apparatus of medical advances, and very likely it was related to Dudley Pratt's work of the late 1940s for reliefs at the University's medical school. (It hung for years in the university's School of Art until it was stolen in 1963.)

Tsutakawa also made a number of reliefs from cedar, both planks and enormous burls, whose complex textures tended toward a self-enclosed bulkiness (somewhat akin to reliefs in plaster). Most of these works were figurative. While the material was worked with a rough vigor (perhaps encouraged by Dudley Carter and by Northwest Coast Indian examples), the figures themselves were usually contemplative, at rest, and suggestive of a remote stillness. *Pre-Eve, Hermit, Daydream,* and a relief of Ayame playing the Japanese *biwa* are among them. An exception to their stillness is an untitled sculpture, an enormous big-eyed head, surrounded with the figure's own arms, which bulges forth from a cedar burl. Its nearly comic aggression has the startling force of the wood guardian figures in Japanese temple grounds.

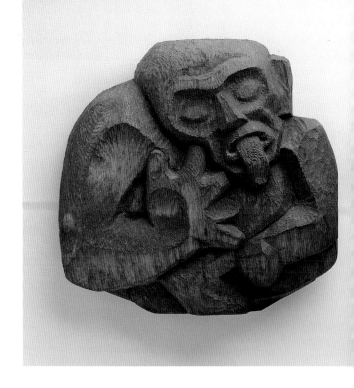

Welcome Monkey, 1947. Cedar burl, 18½" × 19½" × 4½". Collection of the artist. Photo by Paul Macapia

Daydream, 1953. Cedar burl relief, 17¾" × 28" × 2¼". Collection of the artist. Photo by Paul Macapia

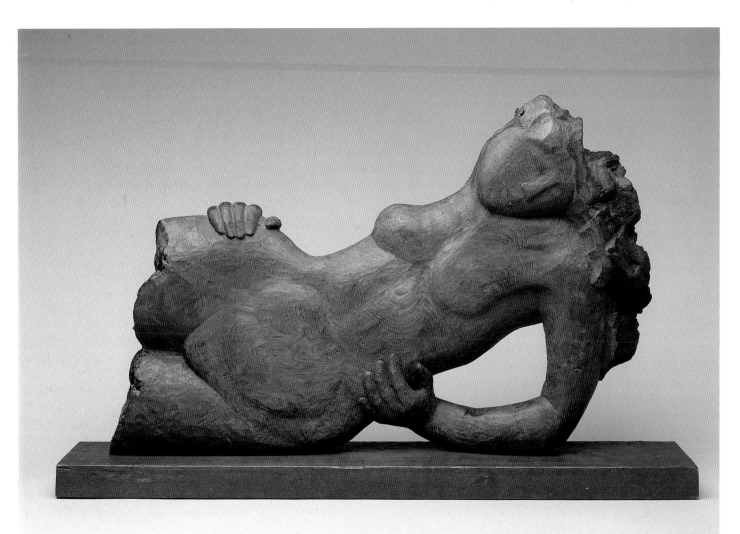

Pre-Eve, 1950. Cedar burl relief, 32″ × 14½″ × 2″.
Collection of the artist. Photo by Paul Macapia

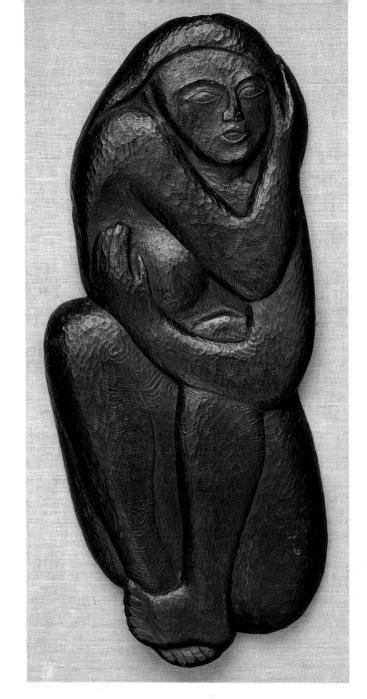

Hermit, 1948. Cedar burl relief, 18″ × 42″. *Collection of Mrs.
Anci Koppel, Seattle*

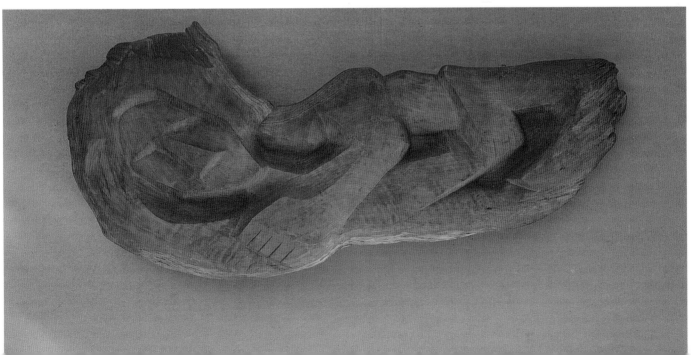

Tsutakawa used plaster again for a hollow cylindrical sculpture of 1951. The walls of the vertical cylinder are pierced with openings of varied organic shapes. On one hand, this is a development out of the bamboo lamps toward equally nonrepresentational independent sculpture. On the other hand, it recalls Henry Moore's pierced and eroded figures and the "helmet" heads and other cylindrical enclosures, which he was executing in both drawings and sculpture during the late 1940s. While there is absolutely no figurative reference in the Tsutakawa cylinder, it was worked in a formal language that, by its own proportions and vocabulary, was then coming to slide easily across the borders of abstract and figurative. This mutability would be important in a number of Tsutakawa's later works. An instance of such mutability occurred already in an elegant sculpture of the early 1950s, *Quartet*. Its four attenuated walnut pylons are grouped in what could be called the remnants of a vertical cylinder, and horizontal copper tubes join them across the central space. Each of the four pylons is opened by three variously curvilinear holes, again a little like the Constructivism of Moore or Hepworth. While the work looks completely abstract, it alludes to the Budapest String Quartet; the sculpture actually came about as the response to a sort of challenge by a Seattle hostess, who had invited Tsutakawa to the Quartet's performance and to dinner with them in the late 1940s, encouraging him to make a work reflecting his response to the performance. His response, interestingly, is to the palpable and complex configuration of musicians and instruments, not to the music.

During this decade, Tsutakawa was as active in painting as in sculpture, and there, too, he worked in a variety of styles, pursuing different problems simultaneously. He made figurative and other representational works as well as thoroughly abstract experiments. The representational work is very often concerned with the construction of very deep spaces—an interest continuous with some of his work before and during the war (*Terrestrial Rhythm, Camp Fannin*). Not only does the new work suggest great sweep and distance, but more precisely the tension and pull between far, deep spaces and the nearby. On the other hand, the more abstract works often dispense with perspective and even with ground line and horizon. They are structured as relations on a plane; their elements are components of a lateral arrangement on a surface. In some works, the rhythmic surge and dynamic thrust of the elements predominates; sometimes a degree of landscape or seascape is suggested. In other paintings the neutral stillness of European Surrealism and Constructivism is achieved.

Many of the representational paintings were based on places and outings dear to Tsutakawa, as earlier works had been. The sweep of coast and the deep receding sky and islands of Puget Sound are conveyed by a 1950 watercolor, *Maxwelton Beach*; the intense blue and golds of *Summer Near Waterville* (oil, 1954) are a response to the wheatlands of central Washington that he had visited so regularly before the war. The integration of a more domestic personal life with this love of place and nature was explored through a series of works that interested him very much then, which he called *Picnic at Low Tide*. A table and objects in the near plane are set in tension with the swooping pull of a steep perspective across the tide flats. In another instance, Arp-like figures occupy the foreground. Some stimulus for this series might have come from the Morris Graves painting *Burial of the New Law*, where mysterious and quasihistorical or religious elements are set in tension with dark tide flats. Graves liked the image well enough to do two versions, and one entered the Seattle Art Museum in the year of its execution, 1936, where Tsutakawa would have seen it. The difference between

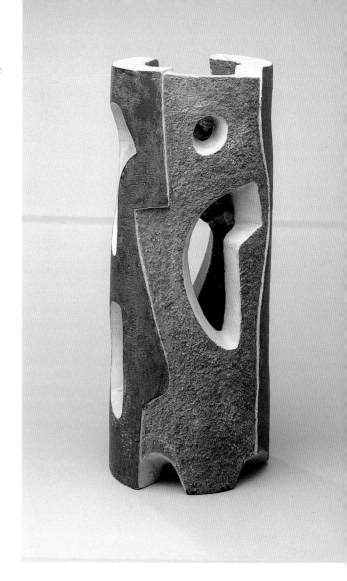

Abstract Cylinder, 1951. Plaster and color, 19⅜″ × 8⅛″ × 7⅝″. *Collection of the artist. Photo by Paul Macapia*

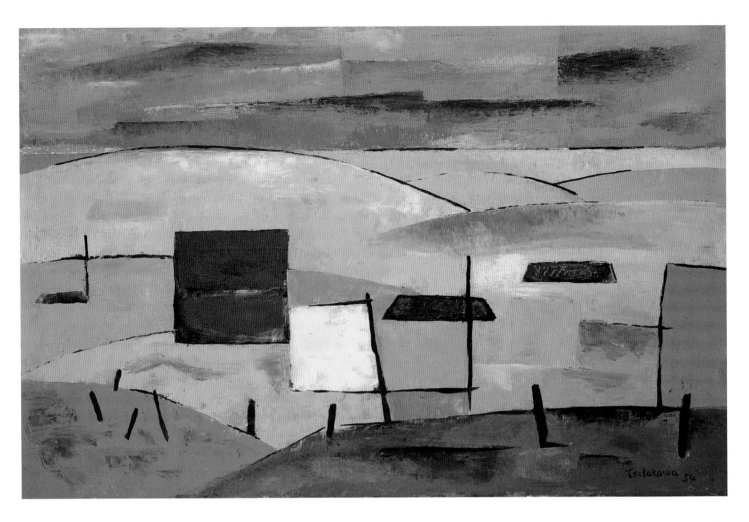

Summer Near Waterville, 1954. Oil on canvas, 28" × 43".
Seattle Art Museum, Gift of the Sidney and Anne Gerber
Collection. Photo by Paul Macapia

Picnic at Low Tide, 1948. Watercolor, 12" × 18¼".
Collection of the artist. Photo by Paul Macapia

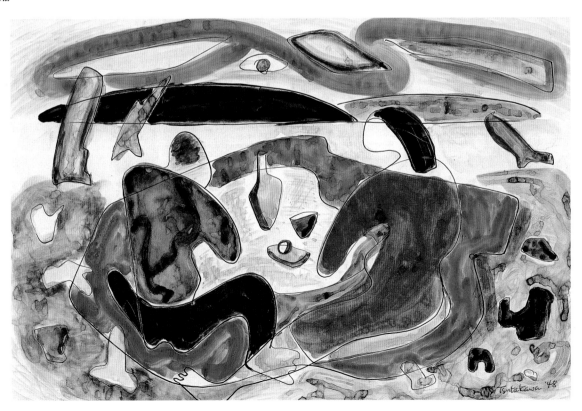

Graves's and Tsutakawa's works represents Tsutakawa's move away from the deeply psychological and romantic aspects of both Surrealism and Rockwell Kent's heroic mode toward a more formalist, impersonal expression.

Another extended series was called *Ikada,* a Japanese word for rafts. In the Inland Sea near Fukuyama, emplaced raftlike structures for various forms of aquaculture form vast patterns across the water. The rafts in Tsutakawa's paintings were the logbooms that tugs pulled to mills via Lake Washington, Lake Union, and Puget Sound. In particular, he had been struck by the powerful contrasts of black and white rafts on a snowy day vivid against the deep tones of the water. Out of this startling encounter, he constructed a number of works in which zigzag and staccato patterns made a very strong surface pattern and formed an equivocal relation with the deep recession that they also suggested. The paintings asserted a fine balance between representational and abstract. In two long horizontal paintings, *Waves* and *Rocks and Waves,* he pushed further toward letting the dynamic pattern of angular relations dominate the whole work, and emphasizing the supporting surface.

In the early fifties, Tsutakawa painted some works that were thoroughly nonrepresentational: a small set called *Rescue,* and the *Ascent* and *Descent* in the Seattle Art Museum, for example. Others include *Deep in My Memory* and, eccentrically, *Crucifixion.* They were characterized by a thoroughgoing abandonment of conventional perspective and deep space, in some cases relinquishing even a firm groundline or quality of gravity. They were lateral constructions across a surface; and like many late Cubist works (Braque's, for example) they employed whited and opaque colorations and highly controlled and wide-ranging subtleties of texture and surface as components of an emphatically relational construction. In many of Tsutakawa's paintings, an interplay emerged between areas of color and texture, forming one system, and shapes designated only by thin dark lines, forming another counterpoint system. *Crucifixion* is more still than the others and focused toward a center; in it, a fragmented geometry of dark dots and thin linear arcs suggests a vertical axis—and more than that, suggests the presentation of the body. In expressing an urge toward vertical geometry with latent organic imagery, the painting anticipates one of the great strengths of Tsutakawa's fountains.

Ikada No. 4, 1950. Oil, 12⅝" × 35".
Collection of the artist. Photo by Paul Macapia

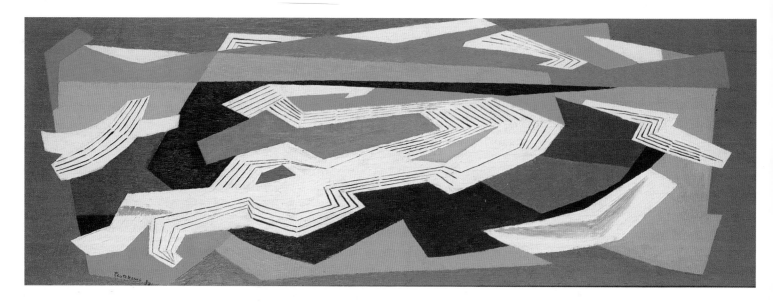

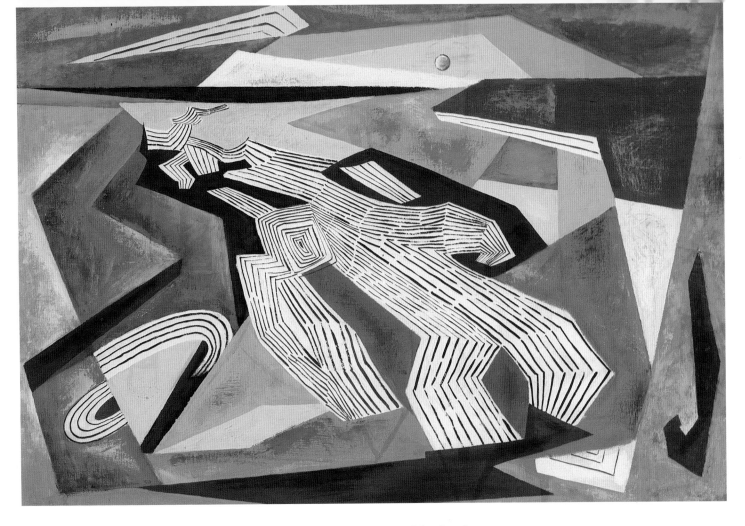

Ikada No. 5, 1950. Oil, 30¼" × 43".
Collection of the artist. Photo by Paul Macapia

Rescue No. 1, 1950. Oil, 14" × 22".
Collection of the artist. Photo by Paul Macapia

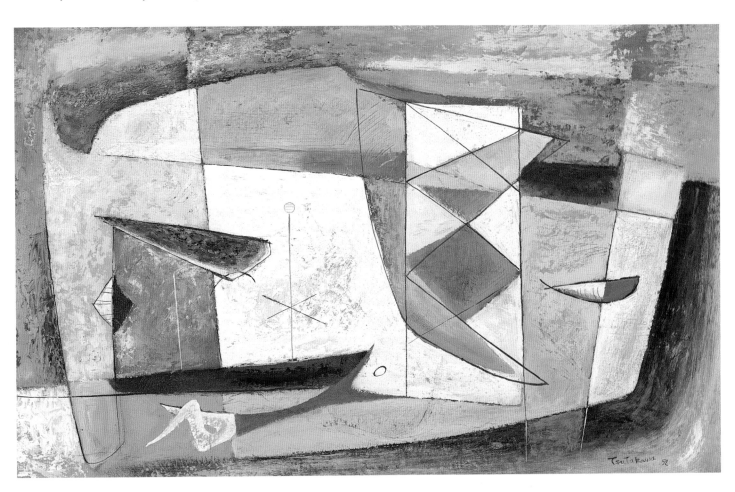

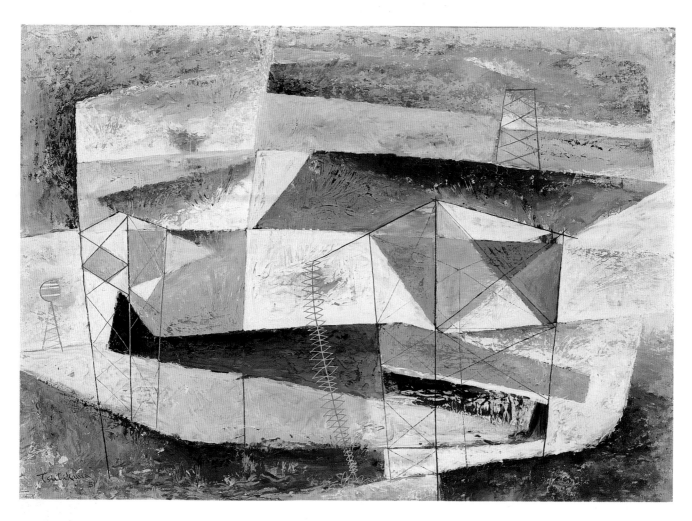

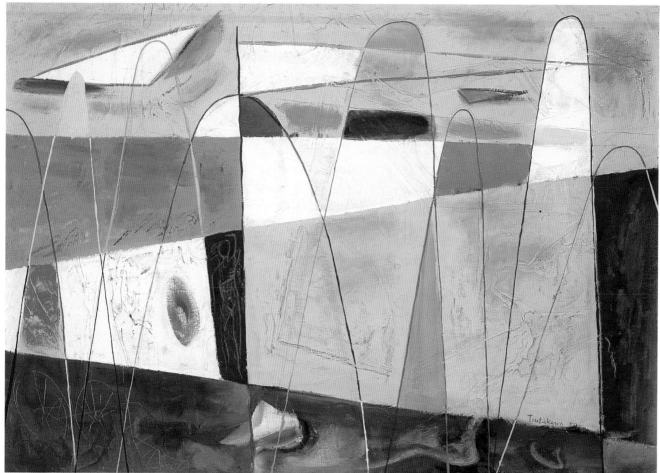

Rescue No. 2, 1950. Oil, 21⅞″ × 29⅞″.
Collection of the artist. Photo by Paul Macapia

The Ascent, 1950. Oil on canvas board, 21″ × 30″.
Seattle Art Museum, Gift of Mr. Dwight E. Robinson, Seattle.
Photo by Paul Macapia

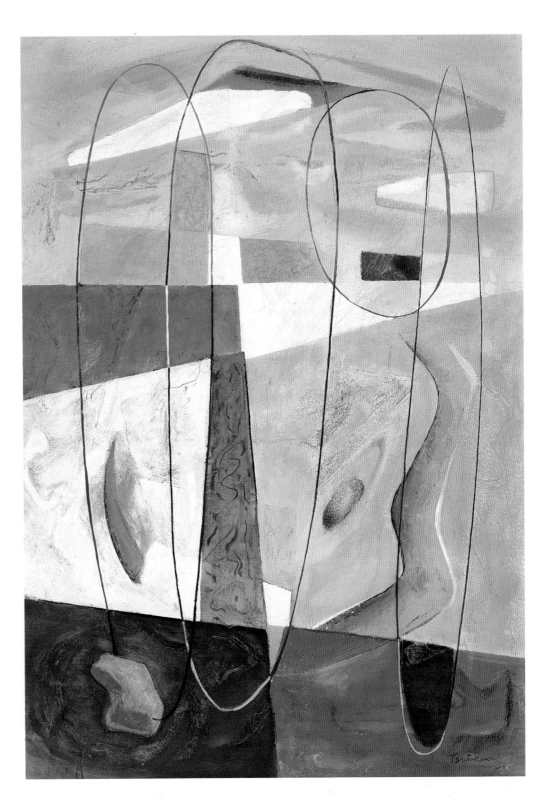

The Descent, 1950. Oil on board, 29⅜″ × 20¼″. Seattle Art
Museum, Gift of Mrs. Sidney Gerber and the late Mr. Gerber.
Photo by Paul Macapia

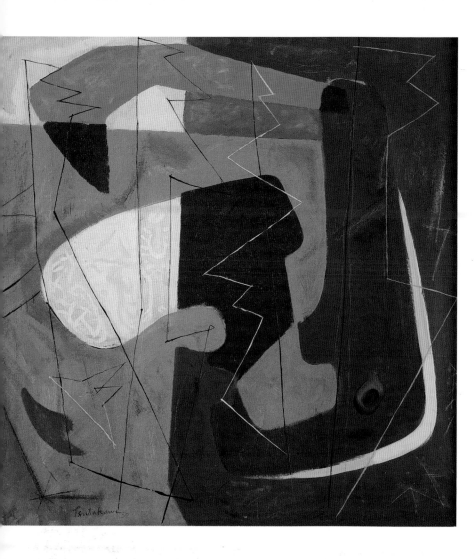

Deep in My Memory, 1950. Oil, 21" × 21½".
Collection of the artist. Photo by Paul Macapia

Crucifixion, 1954. Oil, 34" × 20⅛".
Collection of the artist. Photo by Paul Macapia

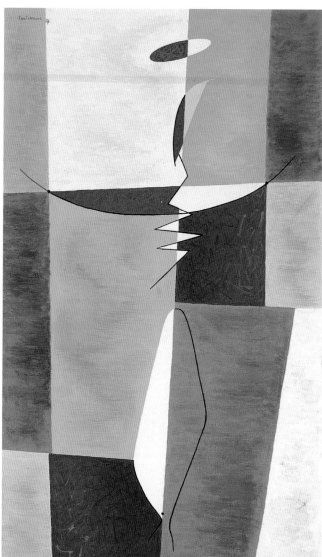

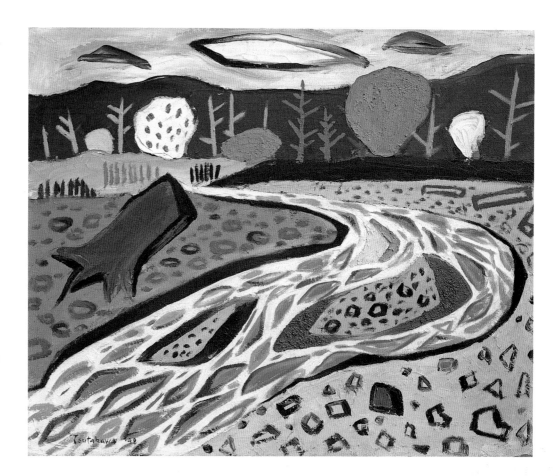

Carkeek Beach, 1948. Oil, 23½" × 21½".
Collection of the artist. Photo by Paul Macapia

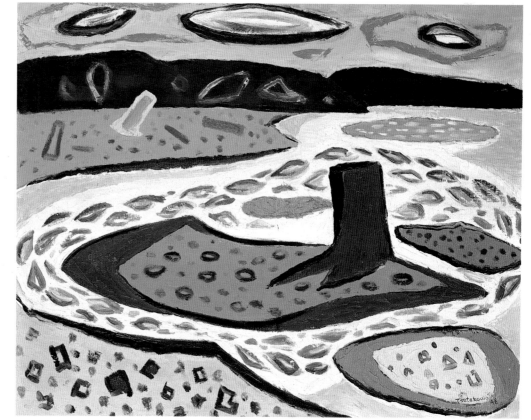

Meditating Tide, 1948. Oil, 24" × 30".
Collection of the artist. Photo by Paul Macapia

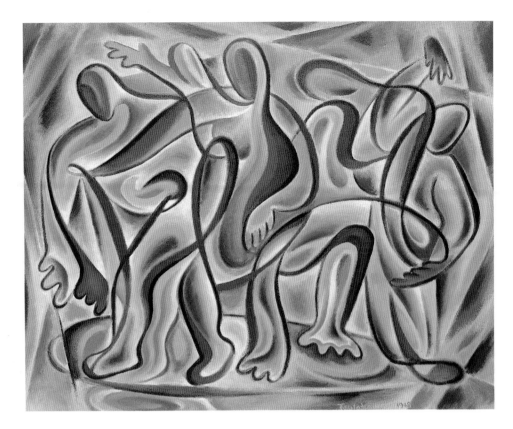

Human Moving Forms, 1948. Oil, 26¼″ × 31½″.
Collection of the artist. Photo by Paul Macapia

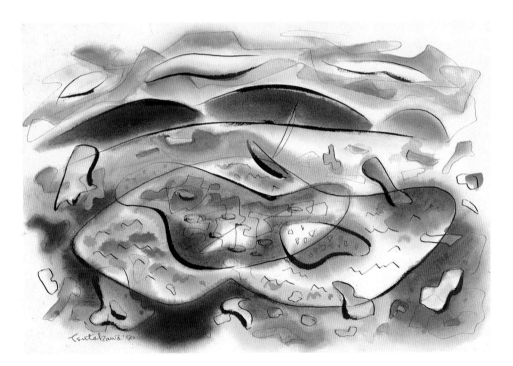

Beach Pattern, 1949. Watercolor, 13¾″ × 20¼″.
Collection of the artist. Photo by Paul Macapia

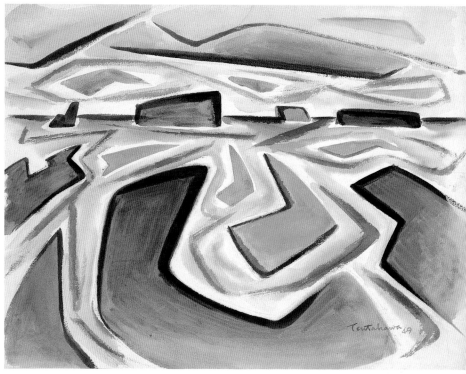

Puget Sound, 1949. Watercolor, 21⅝" × 29".
Collection of the artist. Photo by Paul Macapia

Floating Form, 1950. Terra Cotta, 7" × 21" × 7".
Collection of the artist. Photo by Paul Macapia

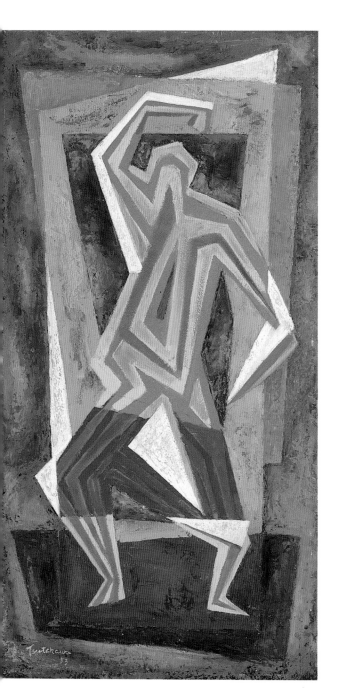

Dance Macabre, 1953. Oil, 30¼" × 15⅜".
Collection of the artist. Photo by Paul Macapia

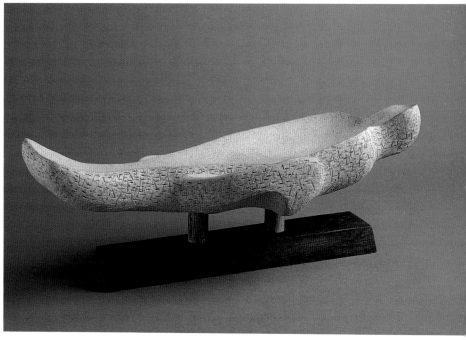

THESE NEW directions in painting undoubtedly received clarification and impetus from colleagues new to the Art Department in the late 1940s and early 1950s. Alden Mason, like Tsutakawa a native of the Northwest, had an enormously vigorous and organic sense of nature's forms, and his landscape paintings then addressed the sorts of places that remained important to Tsutakawa. Wendell Brazeau and Glen Alps concentrated on form and relationships, with a firm disregard for gravity and ground line. Also, they were indifferent to the Expressionist gesture and to the literary effects of narrative or emotional elements. Alps developed great complexities of overlap and interlace as components of a plane or a shallow lateral space. His prints often had the density of the New York Expressionism that was coming into increasing dominance on the American art scene, but without the cult of personal angst. Alps devised new printmaking techniques that would enlarge the prints' possibilities for texture in the direction of paintings. In addition, Alps was much interested in Japanese prints and printmakers after the war. Wendell Brazeau had a strong inclination toward geometry and clarity of contour. He developed a very rigorous and refined hard-edge style in which human figures played a central role, although reduced to portions of perfect circles and straight lines. Systematic considerations of modular and mathematical relations underlay much of his work. Many of his works from at least 1948 to 1954 shared similar forms and structures with Tsutakawa's abstract paintings. When Tsutakawa later became absorbed by his work in sculpture, he always felt the crucial importance of proportion, though his geometries were always more intuitive than Brazeau's.

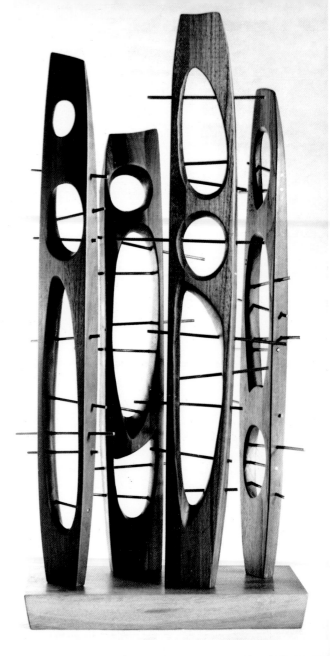

Quartet, 1955. Walnut and copper, 18″ × 12″

Rocks and Waves, 1954. Oil, 15″ × 35¼″.
Collection of the artist. Photo by Paul Macapia

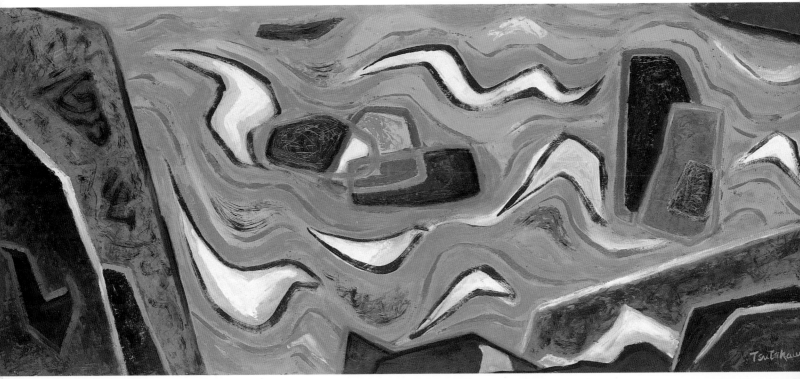

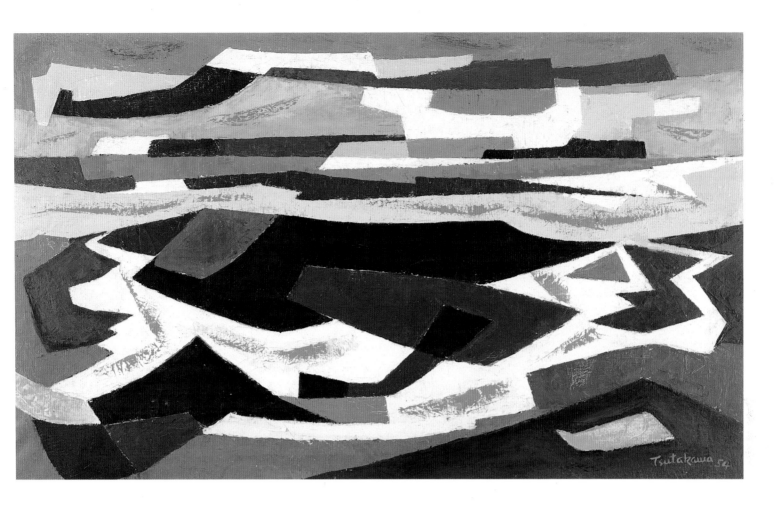

Beach Pattern, 1954. Oil on canvas, 24″ × 40.
Bellevue Art Museum. Photo by Paul Macapia

In the same decade, Tsutakawa reestablished a circle of friends and painter colleagues beyond the university. Among them was John Matsudaira, a painter with whom he sketched and exhibited. Johsel Namkung also became a good friend. Born in Korea, he had studied music in Tokyo in the 1930s and in Seattle after the war. In the early 1950s he became interested in photography and eventually became an accomplished professional color photographer and artist. Namkung and Tsutakawa went hiking and mountain trekking with the much older Dr. Kyo Koike, a pictorial photographer whose work went back to the 1920s. Koike had been an important leader of the Seattle Camera Club then, and of its periodical *Notan* (Japanese for light-and-dark). In his articles for *Notan* he had been strongly concerned with a synthesis of eastern and western ideas: "A few young people, like myself and Johsel Namkung, used to accompany him to the various glaciers and different areas. Just a good hike, you know. And he would tell us about all the rocks and all the pebbles and all the plants and everything along the way; it was just marvelous following him. Then he'd take pictures." Namkung was fascinated but not yet photographing. Another friend was Paul Horiuchi, a painter who moved to Seattle after the war and who was friends with Tobey and Namkung.*

*Tsutakawa was alert to the successes and prospects of Asian Americans nationally, as he was locally. He was attentive to the presence nationally of Yasuo Kuniyoshi (b. 1893, immigrated to the United States in 1906). Kuniyoshi, working mostly in the New York area, was known for his painting, was an example of achievement through the prejudices of the war years, and was noted by Tsutakawa for his energy in helping to organize artists' associations.

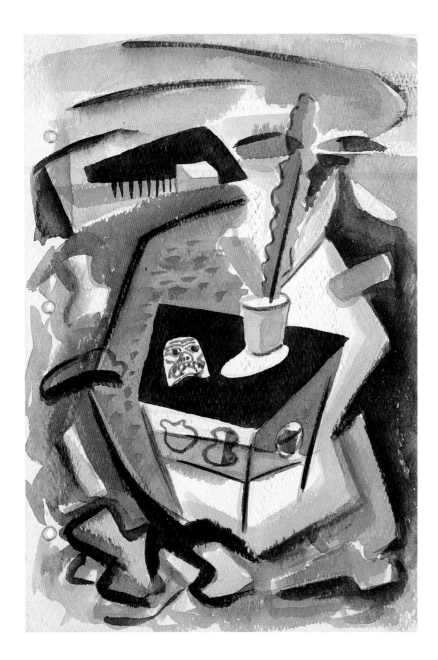

Still Life at Low Tide with Noh Mask, 1948.
Watercolor, 6½″ × 8½″.
Collection of the artist. Photo by Paul Macapia

By the mid-1950s, Tsutakawa had become more productive and more confident. He had reestablished himself through work, artist friends, and family in a position from which he experimented widely. His return to three-dimensional work had been particularly stimulating. His personal sense of art as transcending the private and emotional was clarified. His inclination toward collaborative situations and public results was given some focus by the architecture program.

With all this, Tsutakawa naturally began to exhibit his work much more. The 1947 exhibition at the Studio Gallery had been his first extensive showing. In 1953 he was in the first of several shows at the Zoe Dusanne Gallery; as it was Seattle's first gallery to show European modernists as well as American artists, this was an important step. Through these years Tsutakawa sent work regularly to the many exhibitions throughout Washington. In 1953, for example, in addition to his exhibit at the Dusanne Gallery, he mounted solo groupings of work in three different institutions' spaces, exhibited in three other galleries' group shows, sent works to nine invitational shows, and showed in two open competitions. He also served on two juries, gave half a dozen lectures or demonstrations, and was treasurer of the Seattle chapter of Artists Equity Association. As well, he was teaching in the Art Department and School of Architecture and going home to a wife and three children.

By 1955 Tsutakawa began to think more broadly and submitted a watercolor to the Bienal in São Paulo, Brazil, where it was exhibited and sold. But his interests at this point had been gradually drawn more toward Japan and toward sculpture. During the next five years he passed beyond many of these styles and media to a differently focused manner of work, for which this was the preparatory stage.

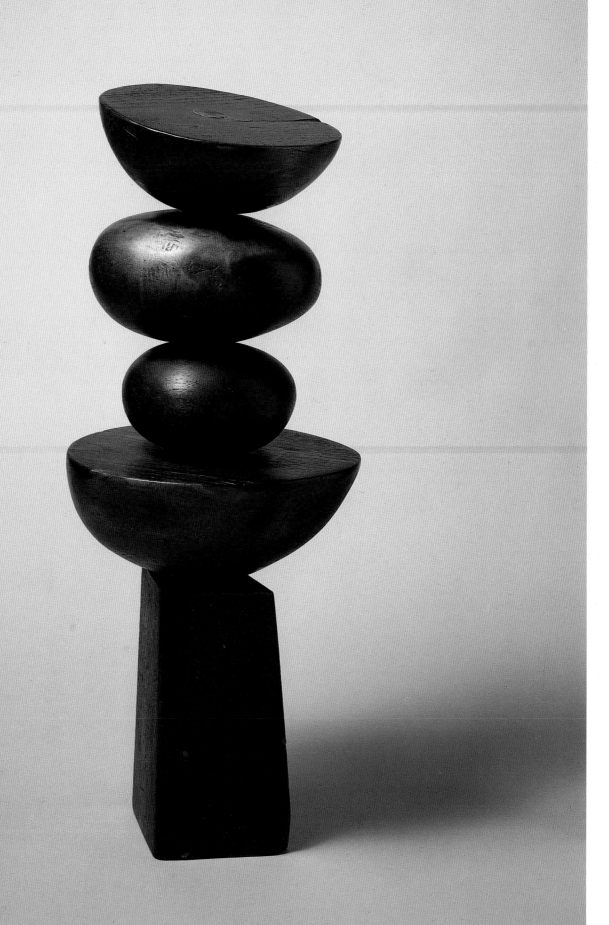

Synthesis, 1955–1959

Painter-philosopher Mark Tobey sits meditatively beneath his art . . .
and panels of Chinese writing which influenced it.

　—*Life Magazine,* September 28, 1953 (caption)

Bearded and bundled up, Brancusi sits in his cold studio,
smilingly contemplating his work.

　—*Life Magazine,* December 5, 1955 (caption)

AFTER THE PRODUCTIVE and experimental decade following the war, the mid-1950s became a point of resolution and synthesizing focus for George Tsutakawa. In 1954, the fourth and last of his and Ayame's four children was born. The following year they moved to a large house on Mt. Baker ridge in Seattle. In 1956, Tsutakawa returned to Japan for the first time in twenty-nine years. On his return, he began a series of abstract wood sculptures he called *Obos,* whose sculptural and personal concerns were so satisfying that they became the basis of much of the rest of his life's work.

The house, built in 1910, was one of those spacious multistory homes with big windows and comfortable porches characteristic of Seattle in the early decades of the century. While not far from lower Jackson Street where the Tsutakawa market had been situated above the city, the house in contrast looked out east over Lake Washington and Mercer Island to the Cascade Range. The slopes directly below it were steep and wooded, and Mercer Island, though connected to the city by a bridge since 1939, still looked very nearly as forested and rustic as when the young Tsutakawa had skinny-dipped with friends along the lake shore. The home's basement, garage, and yard served a whole range of Tsutakawa's studio needs. Its generous rooms accommodated the family and also numerous guests through the following decades.

Japanese artists, scholars, writers, and musicians visited the United States in increasing numbers during the 1950s, and the U.S. State Department office in Seattle helped coordinate some of their plans. Tsutakawa observed that the office "had my name on the list for one of the people to contact because I and my wife—both of us—could speak Japanese fluently; we were very useful to them. Because then they came and they really felt very much at home. We entertained them and as a result we became good friends for many, many years." Without doubt, the esthetic richness of the household as well as language was important in making the visitors feel at ease. The new house provided more than ample space for Japanese art works, musical instruments, and hospitality.

The Tsutakawa house immediately became a comfortable gathering place for the artist's friends. Matsudaira, Namkung, Horiuchi, and other artists visited frequently. Guests of the university were entertained, as when Glen Alps brought the Japanese printmaker Kiyoshi Saito to teach workshops. Alexander Archipenko returned for a teaching workshop and was invited to try his hand at *sumi* ink—he made a horizontal scroll of quirky little modernist figures.

Obos No. 1, 1956. Teak, 23¼" × 9¾". *Seattle Art Museum, Gift of Seattle Art Museum Guild*

73

Some dinner parties at the house in 1957 evolved into group painting sessions exploring the quick fluid effects of *sumi* ink—somewhat, no doubt, as they imagined Chinese scholars would have done when they visited each other's mountain retreats. Morris Graves had spent five weeks in Japan in the fall of 1954, then gone to Ireland before returning to Seattle for most of 1956 and 1957. Mark Tobey had returned to the city in 1956 after spending much of the previous two years in Europe. Both of them actively experimented with *sumi* painting in those years. A spirit of celebration prevailed whenever the old group of friends was able to get together with Tobey. It was a time of high individual confidence for them: Graves, already widely known, had had prestigious solo exhibits across the United States (most notably by the Phillips Collection in Washington, D.C.). Tobey was beginning to establish a European reputation (with a solo show in a Paris gallery in 1955—in 1962 he would be honored with a retrospective exhibition at the Louvre's Musée des Arts Décoratifs).

Curiosity about Japanese culture and thought was widespread throughout the United States and Europe after the war. Alan Watts's writings about Zen attitudes began to be widely read, and young artists listened excitedly to John Cage's promulgation of an artistic practice in harmony with the nature of existence as he felt Asian philosophies revealed it. Some critics speculated about how the increasingly gestural qualities of postwar Expressionism might be compared to calligraphy, and about how the unplanned and chanced quality of that art might have been related to the *I Ching,* or Zen, or other nonwestern systems and intuitions. In 1958, Tobey wrote an article, "Japanese Traditions and American Art," for the *College Art Journal.*

But in fact, the interest in Asian art and thought that Tobey and Graves had pursued even before World War II was part of an earlier wave of American interest in Asia. Tsutakawa came to know them and their artistic practice more intimately after the war than he had in the 1930s, and he recognized a distinct difference between their understanding of Japanese artistic practice and the more recent interest of many others. Tsutakawa felt that Tobey and Graves were "the two American painters who thoroughly understood the *sumi* technique and philosophy . . . Many French painters went to Japan to study Zen and study *sumi* technique. And then later, many Americans went to Japan to study this, and some still do . . . and I'm convinced that so many of them have picked it up and learned it quite superficially. But Tobey and Graves are the two who thoroughly understood this." The difference lay in control and nuance, for while many postwar painters indulged in "very wild and bold brush strokes, huge brushes, a three-, four-, five-inch brush," they nevertheless lacked skill at "manipulation of the brush in bringing out a certain peculiarity of nature." Tobey's and Graves's work was "much more delicate, more sensitive, and has more depth" for they did have "the uncanny ability to differentiate between big sweeping lines and delicate expression that the Chinese and Japanese did so well for a thousand years."

Tobey and Graves themselves had come far over twenty or thirty years, from their own curiosity about Asian artifacts to a more profound grasp of the media, techniques, and purposes involved. Tsutakawa's judgment about the depth of their understanding grew in part out of his reawakened sense of the traditional heritage that he had originally experienced with his grand-

parents. In the 1950s Tobey had a studio near the university: "He was very kind to me and my wife, and we used to visit him and just sit and talk and watch him. And those are the times when he would bring out his old collection of *sumi* paintings and landscapes and then also Zen paintings . . . He would bring them out and hang it there and he would talk about it for a long time . . . on the brush strokes and the spaces and the balance and simplification and many, many things. He could just talk about it for hours . . . It's interesting though that Mark Tobey really taught me the importance of my heritage and what to look for in Asian art . . . Then I realized that when I was a child in Japan I was seeing these things all the time . . . I was surrounded by these things."

Two of Tsutakawa's Asian American friends made crucial changes in their art in 1956, coming into the mode of work that best expressed their ideas. Johsel Namkung quit his job in the commercial world, left his emphasis on music behind, and began to concentrate on the photography upon which his artistic reputation came to rest. Paul Horiuchi made his first collages, impelled partly by the torn and layered complexities of weather-shredded outdoor bulletin boards in Seattle's International District. Tsutakawa was on the edge of a fundamental breakthrough, and he needed to go back to Japan to bring everything together. He had been corresponding with his family more since the war, and his interest in Japanese materials and art forms had been growing. In the fall of 1956 he made the trip.

Tsutakawa returned to Japan for only a few weeks, but it was long enough to reestablish the full vitality of his early years there. He made the 1956 trip as an expert, not a novice. For the first part of his journey, he guided a half-dozen American tourists, introducing them to the artistic treasures of Kyoto and Nara that he had seen as a child. He took them down along the Inland Sea to Hiroshima and to the nearby island shrine at Miyajima, one of the most renowned and sacred places in Japan. Then he sent them on their way to Tokyo and began his pilgrimage to his private history. The Hiroshima area was not far from Fukuyama, and from there a crowded local bus took him inland to his father's old village. His stepmother was still in Fukuyama, and a sister and other relatives gathered at a temple for a memorial service for his father (the kind customarily held at intervals of a certain number of years). Then he went on to Tokyo for the opening of an exhibition at the Yoseido Gallery, owned by Yuji Abe, who was to become a lifelong friend. Kiyoshi Saito had helped arrange the exhibition of paintings by Tsutakawa along with other Seattle work by Glen Alps and Paul Horiuchi.

L ATE IN 1956, after his return from Japan, Tsutakawa began the first of a series of small abstract wood sculptures. Over the next few years he made at least six more before moving on to larger works and changing his medium to metal. The significance of these earlier *Obos* lay partly in their great beauty and their own success as individual pieces, and partly in the artistic concerns and formal solutions they embodied, which became the basis for the great proportion of Tsutakawa's later work.

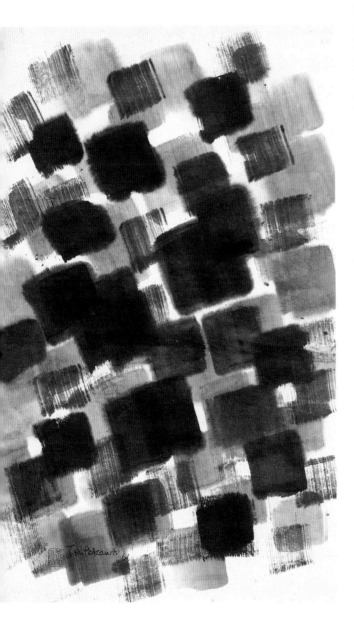

Reflection, Abstract, 1959. *Sumi* with *gansai* on scroll, 36" × 26". *Collection of the artist. Photo by Paul Macapia*

The essential form of each *Obos* is a vertical stack. Their fundamental arrangement is separate or segmented forms piled along a single vertical axis. *Obos No. 1* is constructed of four small irregular ovoids stacked on a slightly larger vertical fifth. It would all look quite precarious if the qualities of proportion and balance were not so self-sufficient. The wood is a dense, dark teak that has been rubbed and worn so that its grain is heavy within it. The simple compact shapes and heavy dark material have a definitive stonelike character. This piece and some of the others were limited in size by the dimensions of a wood beam of an old ship, from which their pieces were made. Tsutakawa and Everett DuPen had got the wood through acquaintances in the lumber and shipping businesses, who kept an eye out for materials suitable for the two artists. (DuPen, two years younger than Tsutakawa, had begun teaching at the university in 1945.)

Most of the other *Obos* are as fundamentally simple as the first. For example, the *Obos* in the Santa Barbara Museum has a more broadly scooped element, almost like a platter or basin, above the lowest and most vertical base element. And that base has been hollowed out at the bottom of each side so that the corners remain as "feet" separated by taut arches. The cedar *Obos* owned by Ayame Tsutakawa is the largest. It has blocky angular facets on all three of its elements. Some of their faces are smooth, others are cut with an array of little scoops, as buttery and fluent as the patterns of some of Tsutakawa's very early linoleum cuts. The lowest element is penetrated by a cylindrical hole that recalls the penetration of Tsutakawa's image in the critical self-portrait of the war years and anticipates later uses of the hole. This *Obos* has a rough vigor and is settled into its own bulk. In two other *Obos*, Tsutakawa created a kind of matrix to support and protect central elements that were smaller, compact and rounded, like beach stones that one might carry in one's hand. In one (Denver Art Museum), an irregular vertical loop of wood protects five stacked elements, though it touches only two of them. In the other (Akihito, Emperor of Japan), three arms or prongs arise from a common block to support a single rounded element within them. Each is also provided with a low wood base.

The *Obos* were received with enthusiasm by Tsutakawa's friends and colleagues when he showed them in Seattle, and they quickly made their way into three museum collections and discriminating private collections (of the widely admired architect Pietro Belluschi, for example). Within their simplicity and small scale, they synthesized a great richness of allusion. Mostly the richness is intuitively perceived through their balanced density and the stimulus of their odd name, but it is worth elaborating on their origin. Tsutakawa has recounted many times how his friend Johsel Namkung passed on to him a book that U.S. Supreme Court Justice William O. Douglas had recently published, in which he discovered the word *obos*.

In *Beyond the High Himalayas*, Douglas described his recent travels in Afghanistan and several parts of central Asia, and on foot and by pack train in the Indian Himalayas:

Whenever one gets over a pass without being afflicted by pass poison or without suffering any other injury or disaster, the gods have been good to him. And so he always celebrates the event. He does it in several ways. He builds a pile of stones at the pass—called OBOS in Ladkh and ORIS in Lahul—and each time a traveler passes that way he adds a stone. And so the piles grow into huge collections. Everyone adds to them. A lama of distinction who is carried across a pass in a chair or who rides in state will not go by without having a rock added to the pile. A servant will hand him one from the ground, and he will drop it with his own hand.

Obos No. 5, 1957. Cedar, 34" × 19½". Collection of the Santa Barbara Museum of Art, special purchase, Third Pacific Coast Biennial

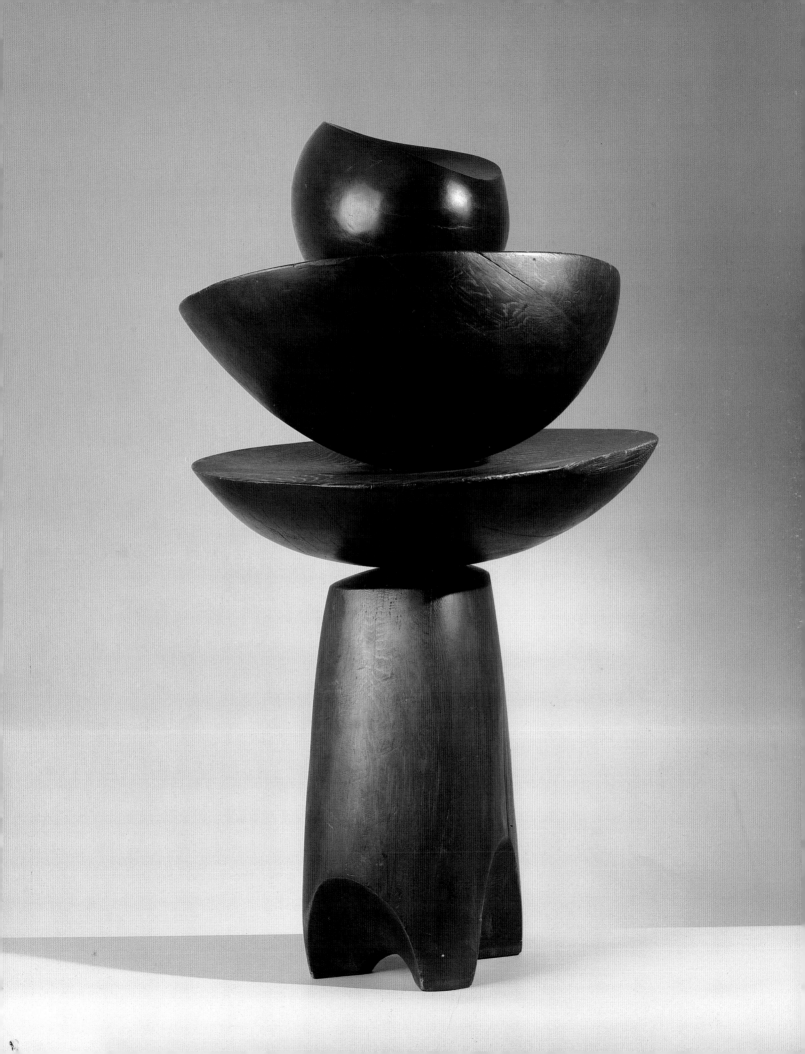

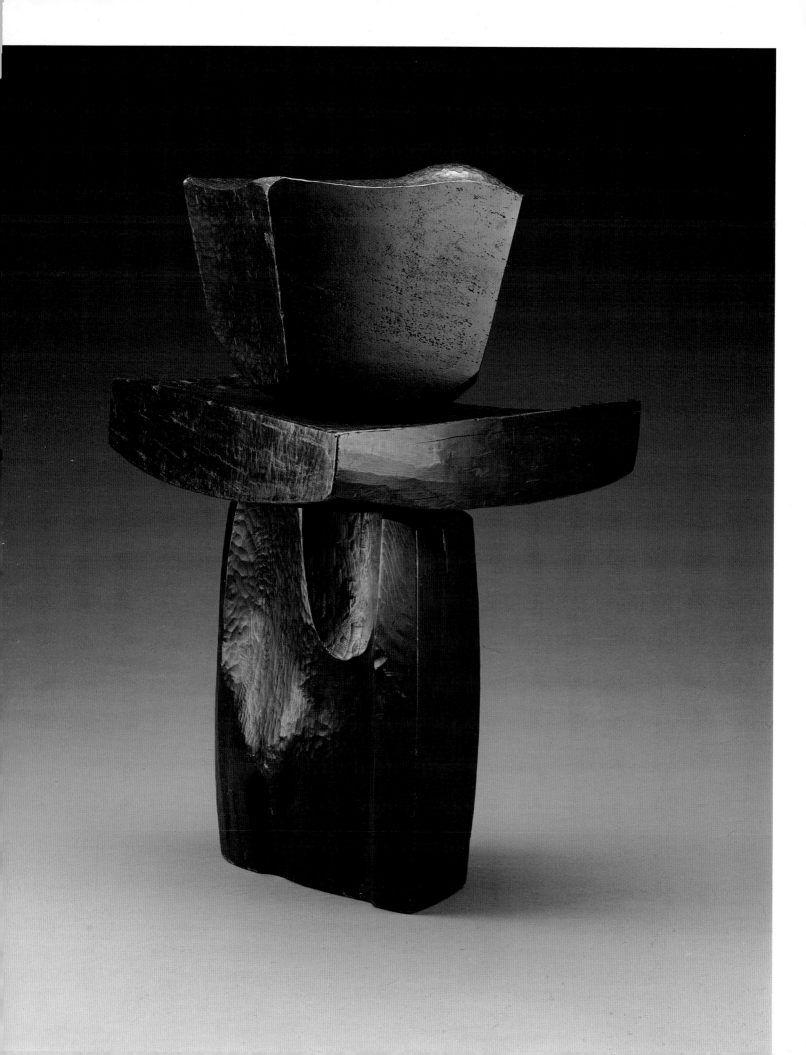

Obos No. 15, 1961. Cedar, 30½″ × 26″ × 18″.
Collection of Ayame Tsutakawa

Obos No. 9, 1957. Teak, 32½″ × 12″ × 9¾″. *Denver Art Museum*

As this recollection suggests, the Himalayan *obos* did not look much like Tsutakawa's; Douglas illustrates irregular broad heaps of rocks. The reverent and the collaborative aspects of the *obos* accumulations were important aspects of the description. In modern terminology they were public—in placement, in meaning, even in origin. In more traditional terms, they were a vernacular expression. In these ways, they were akin to stone piles found in many parts of Asia, including a variety of piles and stacks all over Japan, some of which resemble Tsutakawa's works much more closely than do the Himalayan ones.

Like those in Douglas's account, the "stone towers" or *seki-to* of Japan are anonymous, often collaborative, folk expressions. They are so frequent, so customary, and so indifferent a matter, that although the word for them exists, nobody bothers to mention them. Their locations are varied, their meanings are fluid and often obscure. They might be encountered in the corners of cemeteries or in an especially fine bamboo grove. The most secular and collaborative are the heaps of little stones thrown up onto the beams of the *torii* gates at shrines, purportedly as a kind of homage to the powers of the place, a pagodalike skyward gesture. Such stones purportedly have that purpose, but mostly they are tossed as a sport of little boys—Tsutakawa himself remembers "trying to balance them." Japanese pilgrims made more careful piles of single stones on a single axis as prayers for safe passage. The unresolved souls of deceased infants were said to be making such stacks on the banks of the river of the dead, struggling to accumulate enough virtue to pass over. Jizo, the little Buddhist protector of infants, came to be signified by a carefully balanced stack of rounded and well-shaped rocks; they might be found at road crossings, along the path or wayside, near a house where a child once died, and in the grounds of Shinto shrines and Buddhist temples—usually singly but sometimes, in certain religious sites, by the hundreds. Often a little red cloth is added to the top, or tied about below the top element, drawing the stacks closer to the dressed and tended images of Jizo, which in turn merge with the simplest vernacular images of the Buddha. Nobody can say exactly what many of them are. Thus the stacks are equivocally a pagoda-tower and a human figure; and something of this equivocation, of the architectural and organic image, occurs in much of Tsutakawa's later work that grows out of his *Obos*. The Japanese stones are linked to ideas of pilgrimage, of childhood and death, and of balance and effort arising out of earth and stone toward heaven.

It is perhaps worth noting that those who provided Tsutakawa with the name *Obos*, his friend Johsel Namkung and William O. Douglas, originally from Spokane, were both men whose experiences bridged the Pacific—from Tsutakawa's home state to Asia. The Asian *obos* and *seki-to* were not the whole basis for Tsutakawa's sculptures. There were strong components from his decades as a western artist, too. In contrast to the vernacular references made by his *Obos* through their form, there was a contrasting component of the deeply private, strongly individualized quality that western artists so intensely cultivate. The sculptures, and the fountains that followed, were after all carefully constructed embodiments of one person's vision. "Why do I go around looking at people's work—especially the so-called great masters' work—east or west, doesn't matter . . . sometimes I think what I'm doing is to look for something not to do . . . I try to do something that the other people have not done, or don't do, or don't think about. And that is a very, very difficult thing, I think, for anyone."

The sense of the artist as a solitary, heroic person was even stronger in the Expressionist postwar decades than it had been earlier when Tsutakawa was a student. Tsutakawa had by no means relinquished that sense of art. He felt, like so many westerners, that an ultimately universal expression must come out of insistently individual urgencies. Mark Tobey was a clear and articulate model of this attitude; his paintings addressed universal energies and mankind's fundamental relation to the whole, as did his Bahai faith. Yet Tobey's paintings were like no one else's and arose from the thoughtful seclusion of his studio.

Another model for Tsutakawa, closer in manner but more distant in space, was Constantin Brancusi. Much of Brancusi's work was in wood, often with a raw texture and ragged grain unusual in European work. His forms frequently bordered the representational and nonrepresentational— their organic imagery sometimes blurred into the architectural, as in the *Kiss-Gate* or the *Endless Column.*

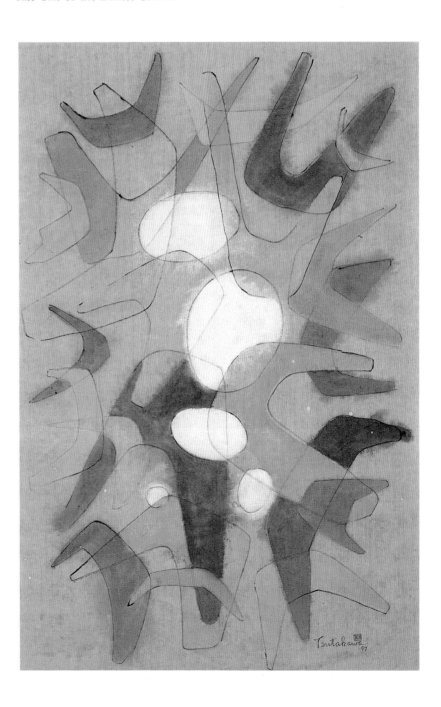

Obos Fragments, 1957. Tempera, 36" × 23¾".
Collection of the artist. Photo by Paul Macapia

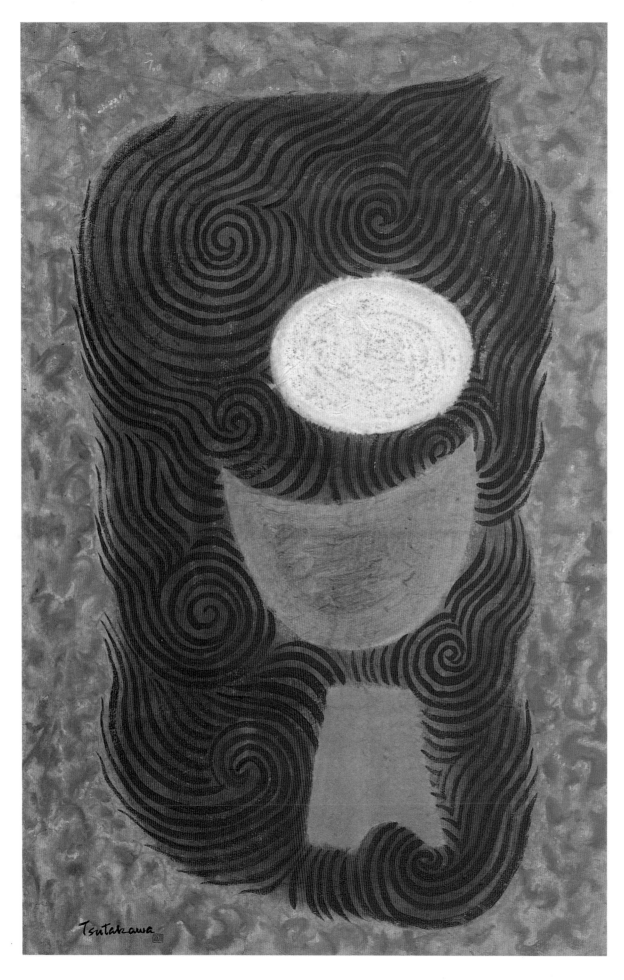

A particularly radical aspect of Brancusi's work—to which museums and collectors were reluctant to fully acquiesce—was his abandonment of the pedestal. He converted it into the lowest element of a total sculpture, stacking one or more additional forms, one above the other. Unlike Tsutakawa, Brancusi often used different materials for the segments, and early viewers had difficulty comprehending them as parts of a whole, rather than work-on-base. This concept was no obstacle for Tsutakawa. "One thing I can say is that ever since I was a student, young sculpture student, I was always very strongly influenced by Brancusi, his endless tower . . . things like that."

Tsutakawa would have seen Brancusi sculptures during the war, when he visited museums in Chicago and New York; Americans had admired and collected Brancusi works since the 1913 Armory Show. The Museum of Modern Art publications of the 1930s and 1940s reproduced Brancusi's work regularly in important catalogues. But most important for Tsutakawa's *Obos*, the Guggenheim Museum in New York held the first extensive retrospective of Brancusi's work from October 1955 to January 1956. The exhibition, featured in *Life* and *Newsweek* magazines as well as in the art magazines, undoubtedly confirmed Tsutakawa's admiration for Brancusi. "I think he had more guts than any modern sculptor, American or European, and a great sense of unity and harmony."

Apart from their clearly·Asian evocations, Tsutakawa's *Obos* of late 1956 might also be considered homage to Brancusi. In an almost too tidy instance of historical continuity, Brancusi died in March 1957, within months of Tsutakawa's return from Japan and his construction of the first *Obos*. (Tsutakawa's admiration for Brancusi was stimulated later, too, when he saw a major Brancusi show in Paris, in 1963, which included the re-creation of Brancusi's studio.)

One further stimulus of the *Obos* needs to be mentioned, for Tsutakawa was always "also very much interested in the Northwest Indian totem pole designs," which are, fundamentally, stacks of superimposed image-units. And of course they are of wood, the cedar that Tsutakawa, like Dudley Carter, had by now been working in for a number of years. Totem poles combined something of the public quality of Asian *obos* with the expressiveness and personal inflection of western art, referring as they do to the particular totems and traditions of an individual and social unit. Totem poles were not made by Seattle-area Indians, but by tribes further north. Nevertheless their form had become emblematic of Seattle, and in the 1950s, there were one or two dozen totem poles here and there about the city. And of course Tsutakawa had met Indian artists when he worked in Alaska earlier.

In these *Obos*, then, Tsutakawa achieved a deeply satisfying synthesis of many components of his experience—the Asian with the western, the informal vernacular with the deeply individualized, the personally meaningful with the publicly accessible. No one seeing the *Obos* would wish to become self-consciously aware of these facets as separate from each other; rather, they are subsumed within a unity and simplicity of total impact.

Obos No. 10, 1957. Tempera, 37" × 24".
Collection of the artist. Photo by Paul Macapia

The year 1956 was a good time for Tsutakawa to make his breakthrough with the *Obos* form. The artistic environment of the late 1950s in Seattle was more and more sympathetic to sculpture. Though issues of painting and Abstract Expressionism seemed to dominate in the official art world, a growing ground swell of interest in the old issues of public art, of sculpture and permanence, occurred in many quarters. This would lead in the 1960s to important changes throughout the American art world—renewed government funding for the arts, a great range of new and well-received directions in sculpture, a whole generation of important young artists concentrating on sculpture rather than painting.

In Seattle, the critics were not always quick to sense these changes. For example, in 1958, Tsutakawa showed paintings and *Obos* sculptures at the Zoe Dusanne Gallery, and local reviewers treated the sculpture as works of secondary importance. On the other hand, a new Seattle organization called Allied Arts began actively working toward more civic art that would be permanent, accessible, and often sculptural. This umbrella organization included a number of architects and directed itself toward public policy in the arts from assumptions very different from those of the painters in the privacy of their studios. Tsutakawa was particularly stimulated by one of the Allied Arts leaders, architect John Detlie: "A very good promoter and a very flamboyant guy . . . started talking about fountains . . . I heard Detlie talking about this and got excited."

Among artists, there occurred a surge of exploration and exchange of energy in which Tsutakawa participated. In 1955 the Woessner Gallery in Seattle held the first of several group shows of Washington sculptors. From 1956 through 1958, sculptors of the region convened at meetings of the Northwest Institute of Sculpture, an organization largely guided by Tsutakawa's colleague at the university, Everett DuPen. They discussed techniques, goals, opportunities, and they demonstrated working methods to each other. For both meetings and members, they reached out to Vancouver, B.C., and Portland, Oregon, as well as east of the Washington Cascades. There was a great deal of information to exchange. George Laisner from eastern Washington experimented with many materials and Tsutakawa remembers him demonstrating with a chain saw on wood—most vernacular of Northwest methods. James Fitzgerald, long-ago fellow-student with Tsutakawa, was establishing the only bronze foundry in the region. He used cast and welded bronze for fountain commissions in 1959–60 and 1961. Harold Balazs in Spokane supported himself and his family by the late 1950s from his commissions for liturgical and architectural work. His first large Seattle commission was in 1959, for a new Skidmore, Owings, Merrill building; the 20-foot-tall work, *Totem*, was fabricated from copper sheets, like a hollow box. Glen Alps experimented with cut and pulled-out metal sheets as the basis of sculpture. All these problems and techniques surely interested Tsutakawa, who started to fabricate his fountains and other sculpture from sheet bronze in the same years, beginning in 1958.

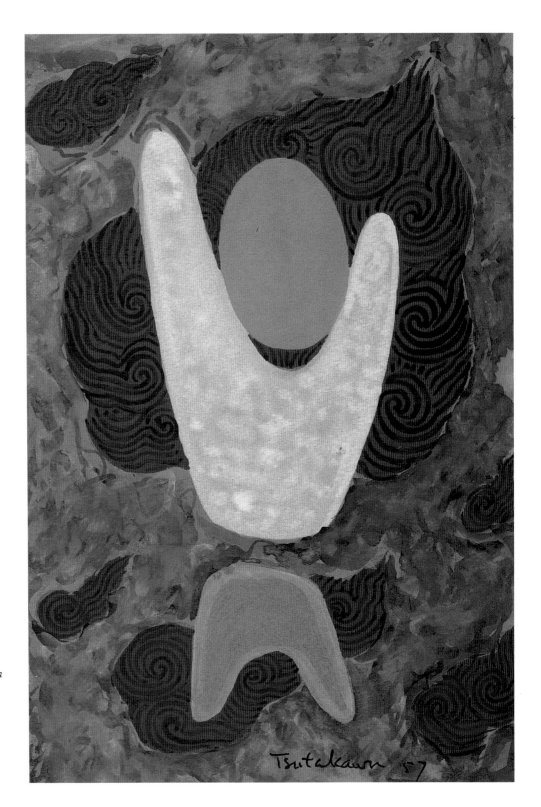

Egg and Obos, 1957. Tempera, 9" × 6".
Collection of the artist. Photo by Paul Macapia

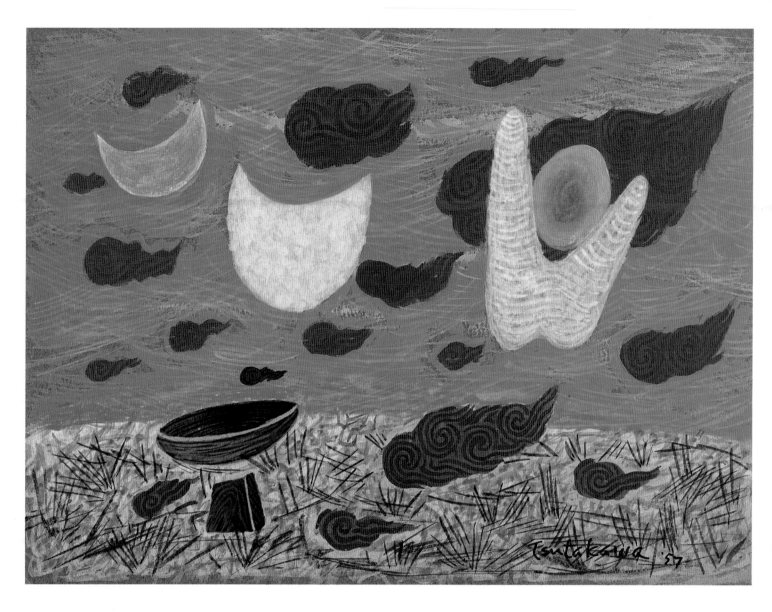

Flying Obos, 1957. Tempera, $6\frac{7}{8}'' \times 9\frac{3}{8}''$.
Collection of the artist. Photo by Paul Macapia

Tsutakawa received three commissions for wood sculpture in the late 1950s. The works he executed did not, however, grow directly out of the *Obos,* but from earlier work. The 1956 doorhandle sculptures for Canlis Restaurant were the most abstract. Like the plaster cylinder of the early 1950s, their three vertical sides were opened by great gaping holes of a Surrealist organicism, erosions of natural material like Henry Moore's work, but without any figurative reference. In 1958, the Arthur Chapel memorial sculpture for St. Mark's Cathedral in Seattle was on a fine border between abstraction and figuration. It seems like a relief in the form of circles and arcs, piled four or five high in two interlocked columns. In fact, the circles are heads, while the arcs are wide-planted legs and arms outstretched and uplifted. The sensual contrast of smooth grain with buttery cut surfaces is very like the *Obos* works of the same years. But the assertive geometry of the figuration looks back to the early 1950s and work like Brazeau's, and looks forward to the soaring geometries of Tsutakawa's fountains. The exuberance and open outreach of this imagery are in startling contrast to so many images in his earlier sculpture, figures with their arms close about their bodies and heads, images of reverie and withdrawal. The fountains would all be characterized by this open exuberance.

A related commission in 1959, for a firm in Alaska, was called *Eskimo Dance.* This horizontal relief took the figuration of the cathedral's relief farther in the direction of literal representation of human figures. This led to a reworking of one *Obos* configuration with figures similar to *Eskimo Dance;* in a small walnut *Family Group,* five simplified figures (man, woman, three children) clamber up the inner void of the vertical wood loop supporting them. *Family Group* is free-standing like the *Obos,* but kept within a shallow plane, like the reliefs. It is, again, an example of the mutability of organic and geometric-abstract configurations in Tsutakawa's mature sculpture.

Tsutakawa continued to paint all his life, but painting began to lose its primacy for him from the period of the *Obos.* Oil paint and English (transparent) watercolor were mostly abandoned from the mid-1950s, and he began to paint primarily in *sumi* ink and with more opaque Japanese watercolor, or sometimes with tempera. A number of works from 1957 and later were two-dimensional accompaniments for the *Obos.* Some were essentially studies of arrangements and stacks of ovoid shapes in a variety of media and scales. An especially coherent group consisted of several temperas, called *Obos* like the sculptures. The central configuration of the temperas was a vertical series of forms closely similar to the sculptures—ovals and cupped shapes above an arched or footed base. But the painted forms floated free of each other against the bright orange and brown whorls of a dynamic field. The coloration and dense patterning seem to refer to Asia, to Hindu and Buddhist paintings, and to the flames of hellfire or purification. Both the energy and the orderly repetitive structure of the coils seem to anticipate the interactive dynamics of water in Tsutakawa's fountains.

Why did Tsutakawa not make more *Obos*? They were admired, sought-after, and deeply satisfying. Why did he not expand their scale, using weather-resistant materials? The answer followed from the invitation that the Board of the Seattle Public Library extended him in 1958, to make a fountain for the plaza of the new main library then under construction. Tsutakawa was galvanized by the possibilities as he moved into the project. In effect, fountains became the continuation of the *Obos* concept, enriched, like the temperas, with the dynamics of flames/water.

The library board offered commissions to several artists in an atmosphere of some controversy; it was the first city government expenditure on art, except for war memorials, since a bust of Chief Seattle was commissioned 1908. While Allied Arts worked vigorously toward civic art, the local press was consistently against such frills. The architects Binden and Wright showed Tsutakawa a comprehensive plan of the plaza, in which a small space had been set aside for the anticipated fountain. "I looked at it, and it's a little funny pedestal stuck on the southeast corner of the auditorium . . . That's what really threw me off . . . So I said, 'Well, I'll have to think about this for a while.' So I came home and I really thought about it very seriously, day and night; I couldn't sleep sometimes. But I couldn't see putting a small fountain, and when they talked fountain, they were thinking maybe a figure, standing on this pedestal, you see. With a little water trickling down. Or something like that . . . I didn't want to go along with that, so I came home and then I started to draw the whole plaza area. I already had some drawings. And I took this pedestal and pulled it out in the middle of the plaza and started designing. Oh, I guess it took me about a month, and I finally came up with a certain idea, which is as it is now . . . But in the beginning I wasn't so sure, nobody was so sure."

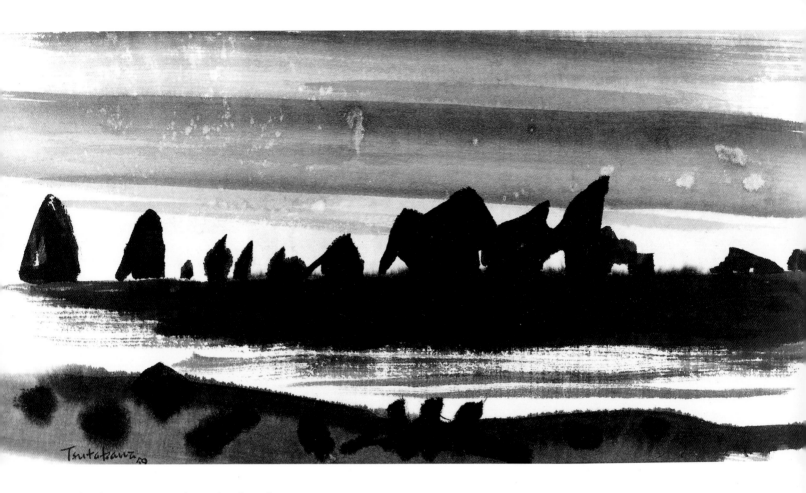

Point of Arches, 1959. *Sumi* with *gansai*, 8⅞″ × 17½″.
Collection of the artist. Photo by Paul Macapia

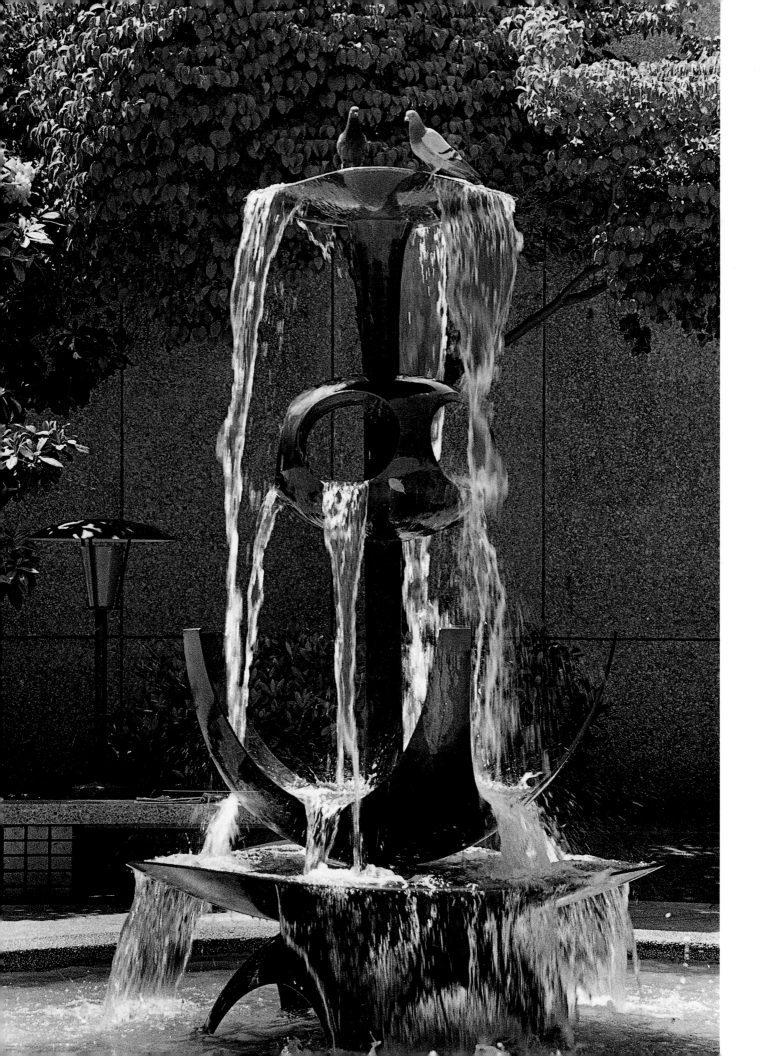

Transcendence, 1959–Present

The Obos . . . seems to signify man's basic act to create perfect balance of solid forms in space, his desire to attain greater height to heaven and finally to achieve harmony of man himself with space and earth.

—George Tsutakawa, *Denver Art Museum Summer Quarterly,* 1964

This great cycle and movement of water, which has been going on ever since the earth was formed . . . That's what I like to express in my fountains . . . It's the spirit and the movement, the cycle, that I try to express.

—George Tsutakawa, 1983

I N 1964 TSUTAKAWA, referring to his *Obos* sculpture, wrote: "I am consciously or subconsciously trying to create something permanent that defies identity with any epoch or civilization." The words fit his fountains as well. By that time he had completed the first two (in 1960) and taken on a half dozen more. Later he reflected that from around 1960 on was the time when he felt a need to be separate and personal, not so overtly linked to art movements, as earlier. This need was associated with his making sculpture that involved water and with his looking at work by other artists "for something not to do." Fountain sculpture became so deeply gratifying as a medium, and each successful piece so fully resolved, that he repeatedly expressed his puzzlement about how few other artists work in the genre.

Tsutakawa's first fountain, the *Fountain of Wisdom* at the Seattle Public Library (1958–60), is essentially a stack of abstract forms on a single vertical axis. The basic shapes as well as this fundamental structure are reminiscent of the *Obos*. Here, from the bottom up, are a footed base, a shallow bowl, a pronged remnant of a sphere, a hollowed ovoid, and another shallow bowl. The material is quite unlike the centered density of teak and walnut: sheet bronze is formed into the surfaces of curved forms and given a deep black finish. The forms are geometric and symmetrical, in great contrast to the nuanced organic irregularities of the *Obos*. Water piped to the top spills over the lips and edges in a cascade of sheets and planes that add their own geometry to the bronze forms.

The basic characteristics of this first fountain persist throughout the more than sixty fountains that followed it: a segmented series, strong inclination toward geometry and symmetry, and almost always a single vertical axis and muted black finish. A typology of related forms developed quickly; most continued to appear in variations through the years. All can be understood as evolving from the *Obos* stack and the upreaching containing elements that two of the *Obos* had.

Fountain of Wisdom. 1958-1960. Bronze, 12′ × 6′ × 6′. Seattle Public Library. Photo by Mary Randlett

An important recurring element in these works is the sphere with sides opened to various degrees; sometimes a smaller element is contained within it, or sometimes the basic sphere is flattened or elongated. It may occur as the topmost element or within the stack (as at the Seattle Public Library), and sometimes constitutes the single major element of the work (as in the University of Washington piece of 1962–67, and *Moon-Song* at the Seattle *Post Intelligencer* building, 1971). It is an important instance of how mutable and elusive are the fountains' suggestions. The open sphere suggests an eye of powerful impact and physical amplitude (like those Tsutakawa admired on the Indian carvings); the eye becomes a seed, and a globe (like the title *World* he gave to a number of works in the sixties and seventies); and sometimes opens like a chalice (National Cathedral, Washington, D.C., 1968). The *Fountain of Pioneers* (Vancouver, B.C., 1969) has such an element prominently capping its top. A powerful basin of rising prongs spills out water that reverses those prongs, and a splay-footed base reminiscent of *Obos* supports the whole. A few years after its construction, Tsutakawa spoke about it: "Now, in the Vancouver fountain I was thinking about Northwest Indian art, the great wing, you know of course, it's reversed here. But the raven and the big eye—a big impressive eye—and a big wing and the legs spread out, the wonderful feeling they carved. They did more figures, very tall, grotesque figures, sometimes a hat on, a funny hat on, sometimes a fish or some animal around it; this particular one inspired me." At the same time he mused about other stimuli for the fountain shapes: "There are forms which I remember from my childhood. For example . . . *matoi* was a symbol in the local district, community organizations [in Japan: a traditional heraldic three-dimensional sculptural shape]. They had banners, flags [on poles], with this symbol at the top." He mentioned the hundreds of variations of Japanese *mon* crests and acknowledged, "There is a floral form to some of my fountains. I guess I don't get away from natural floral form: tree, leaf." The human figure, though, is conspicuously absent from almost all forms and references he admits to his late work; that most central subject to European art was important to his early work, but allusions to subject or pattern in the later works were more mutable, modest, and ultimately subordinate to the cycle of water and matter.

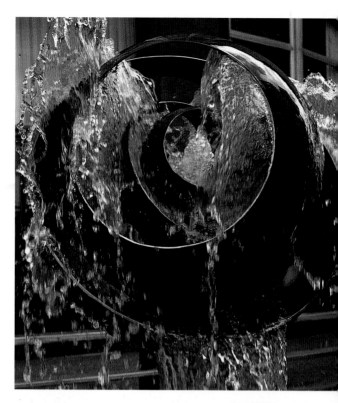

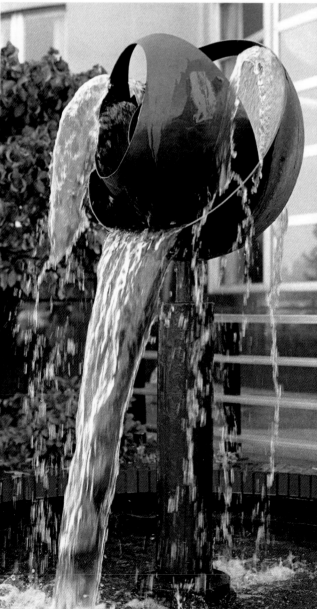

Moon Song Fountain, 1971. Bronze, 6'. Seattle Post-Intelligencer Building, Seattle. Photo by Mary Randlett

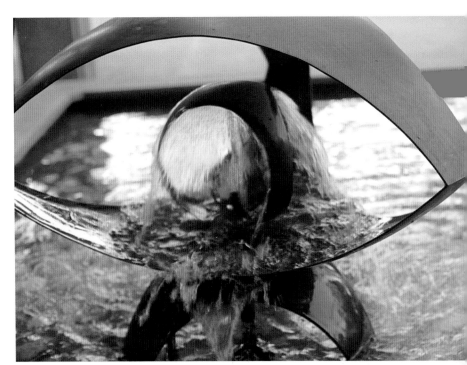

Fountain of Reflection (Phi Mu Fountain), 1962–1967. Bronze, 5'. University of Washington, Seattle

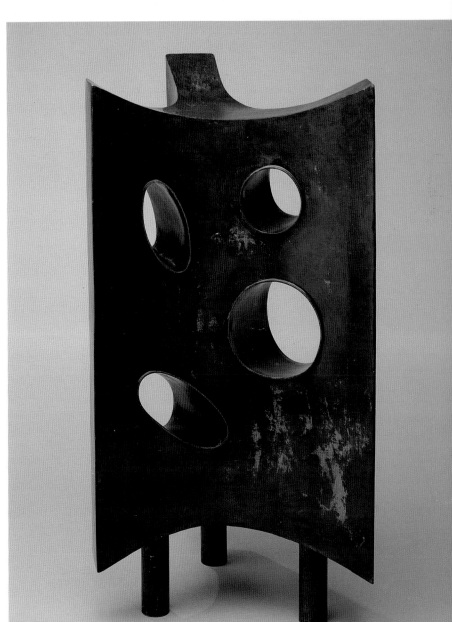

Three-Sided World, 1962. Bronze, 12¾" × 14" × 10½". Collection of the artist. Photo by Paul Macapia

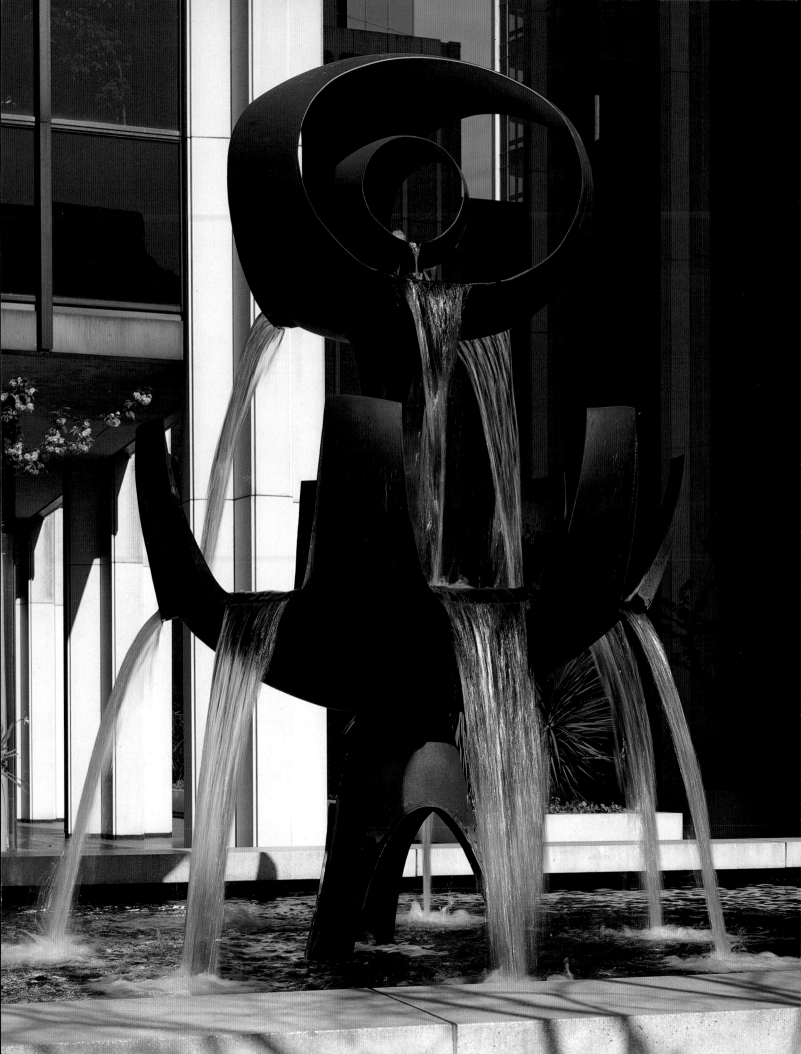

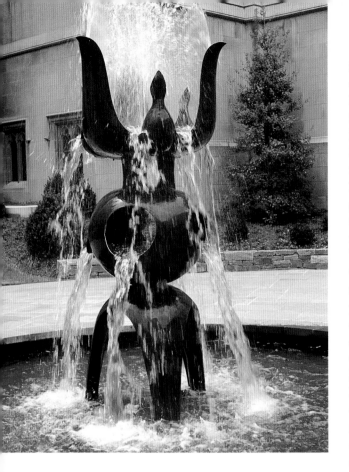

East Cloister Garth Fountain, 1968. Bronze, 10'.
National Cathedral, Washington, D.C.

Fountain of Pioneers, 1969. Bronze, 15' × 8'.
Bentall Centre, Vancouver, B.C.

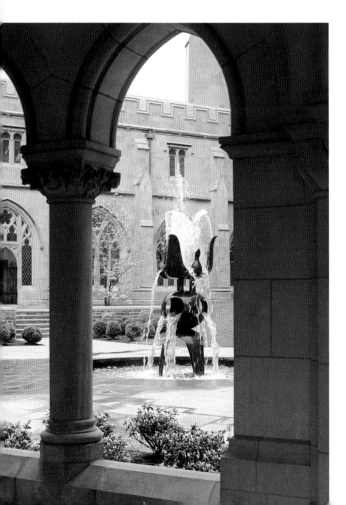

When lower elements of the fountains are relatively large and stand away from the axis, they often take on a character of leaves or petals—depending on shape, proportion, and geometry. An architectonic abstraction of organic life is created (Tacoma, Pacific First Federal, 1964; Seattle, Safeco, 1973). In the few fountains that are predominantly horizontal and lack the single axis, leaflike botanical suggestions are often quite clear and the cluster of interlocking growths becomes complex and multiple (Portland, Lloyd Center, 1961; Bellevue, Pacific First National Bank, 1970; Fukuyama Fine Art Museum, 1988). In a few fountains, the up-reaching elements lack the crisp geometry of prongs or petals conforming to a sphere; instead they are irregular and so large that they dominate the fountain, giving it a likeness to flames as well as leaves (Kansas City, Mo., Commerce Tower, 1964; Seattle University, 1989). These are slightly reminiscent of the energetic convolutions of orange flames in *Obos* drawings around 1957, and of the artist's abstract wood scupctures of the 1950s. More fountains, however, take the plant allusion toward geometry rather than toward botany. The gatherings of petals shrink in toward the axis; they become a series of cups or basins, or open planes along the shaft of a column, and larger elements at top or bottom become the crown or base of the column (Troy, Ohio, Hobart Research Center, 1967; Seattle, Naramore Park, 1967; Tokyo, Setagaya, 1982). More severe fountain sculptures lack a crown or base altogether, and become articulated columns of open-cut flanges or segmented towers of stacked units (Troy, Michigan, 1974; Spokane, 1974; Sendai, 1981). When stacked units are gradually smaller toward the top, and capped with a variant sphere, the result is very like a pagoda (Issaquah, Wa., 1987). More often, however, uniformity of size prevails, and certain instances with relatively closed curved units or blocky angular units recall the weighty density of Tsutakawa's earlier *Obos*, as well as totem poles and Brancusi.

In the 1970s, an alternative fountain type to the dark weighty bronze emerged, with more austere geometry and bright pale tone. A small series called *Rain Fountains* and several related dry sculptures were constructed from thin discs of stainless steel mounted parallel to one another with a common axis through their centers. The graduated radius of the parallel circles generated an implied geometric "solid," a sphere or ovoid. In the fountain versions, the discs were mounted horizontally and pierced with holes, so that water dripped through the planes "until the fountain is a column of dripping water—like a slow quiet rainstorm—a natural thing," as Tsutakawa described it (Seattle, Burien Library, 1972; Seattle, Design Center Northwest, 1973; Seattle, KING Broadcasting, 1981).

When Tsutakawa began work toward the first fountain, for the Seattle Public Library, he imagined it would somehow be cast in bronze, like so much traditional European sculpture. He found the costs prohibitive and the lack of understanding in foundries he contacted was discouraging. He began to think of cut and welded sheets instead—a technology well understood in the Seattle shipyards. Jack Uchida, a welding engineer for Boeing, became Tsutakawa's welding teacher, then his collaborator for many years.

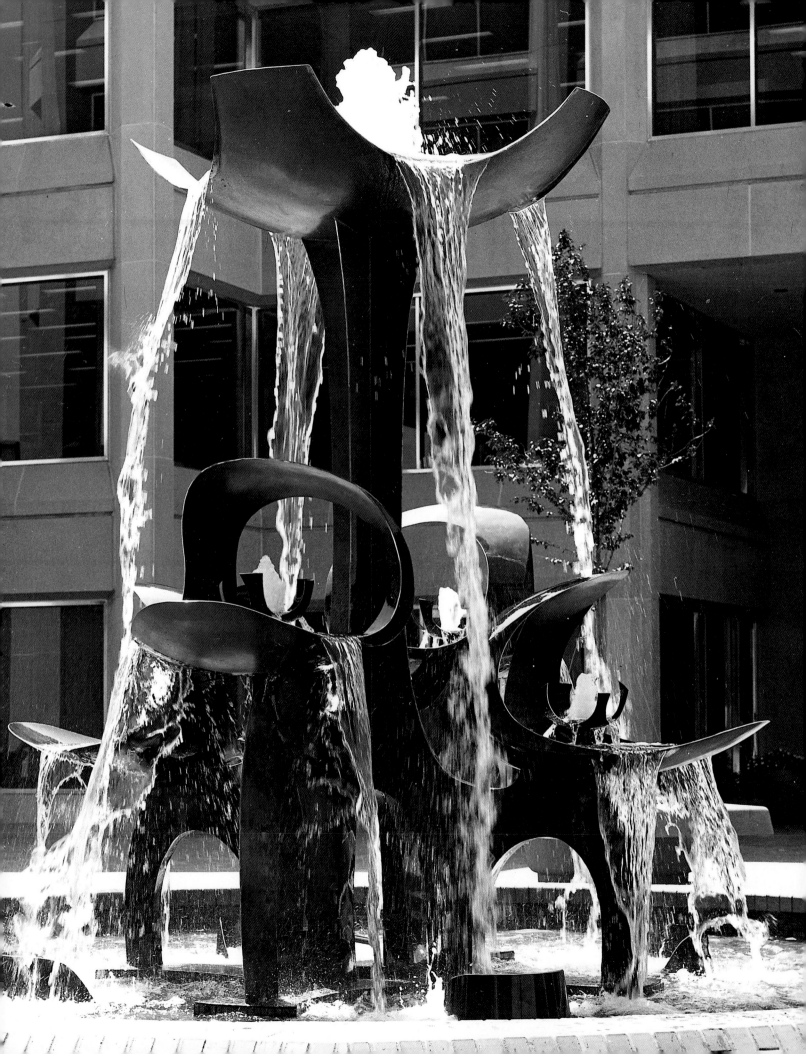

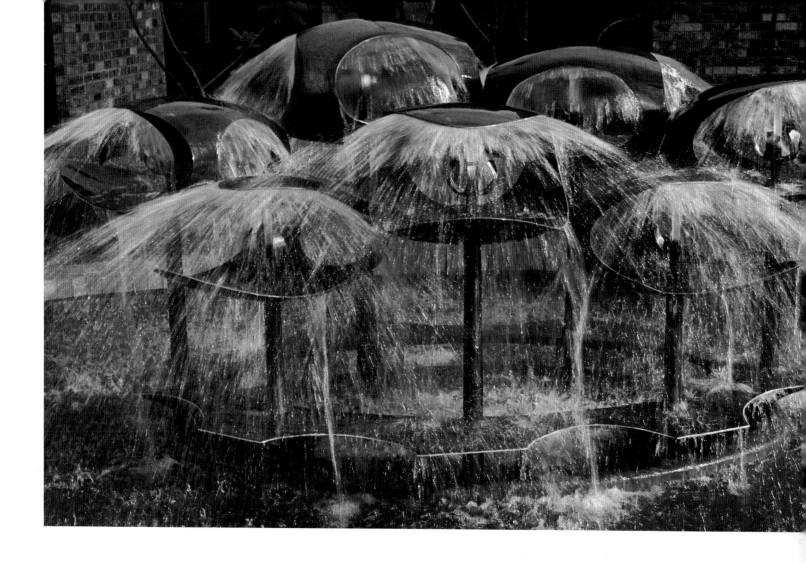

Pacific First Federal Fountain, 1970. Bronze, 10′ × 7′ × 4′.
Pacific First Federal Savings Bank, Bellevue, Washington

A fountain is cut from flat bronze sheets marked from the wood or cardboard templates that composed the trial version. The cut pieces are shaped by rolling and by pressure and are sometimes pressed into a built form to conform to its shape. The fountain is assembled by welding, and the plumbing is incorporated into it. Cutting, forming, and sometimes welding are carried out in the Markey Machinery Company in the Duwamish Valley. These traditional industrial techniques were also used by Alexander Calder and David Smith as well as by many younger sculptors since the 1960s. Tsutakawa's works are exceptional in their degrees of curvature and precision of forming, in comparison to much modern sculpture. In his workshop at the house, Tsutakawa undertakes some of the welding as well as the many stages of cleaning, polishing, patination, and finishing of surfaces. In the mid-1960s, Tsutakawa's eldest son Gerard began to work with him, gradually learning welding and fabrication techniques. Gerard has taken on increasing responsibility for the production of the metal fountains and sculptures. He now carries out all the technical production with his assistants, and in recent years has collaborated in design work with his father as well as creating his own predominantly geometric sculptures and fountains.

Safeco Fountain, 1973. Bronze, 13′ × 9′ × 9′.
Safeco Plaza, Seattle.

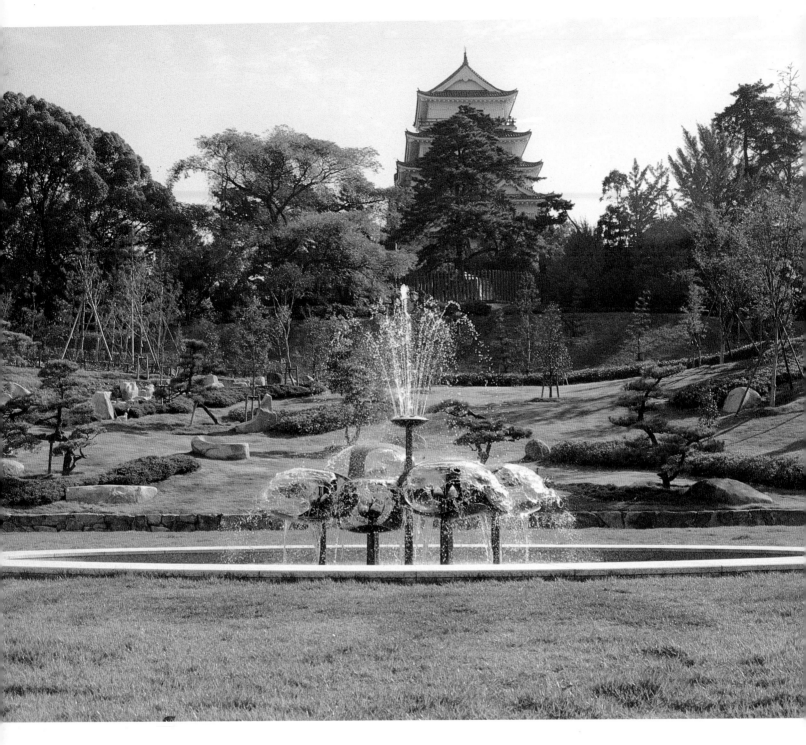

Lotus Fountain, 1988. Bronze, 6′ × 9′ × 7′.
Fukuyama Fine Art Museum, Japan

Hobart Fountain, 1967. Bronze, 20'.
Hobart Research Center, Troy, Ohio

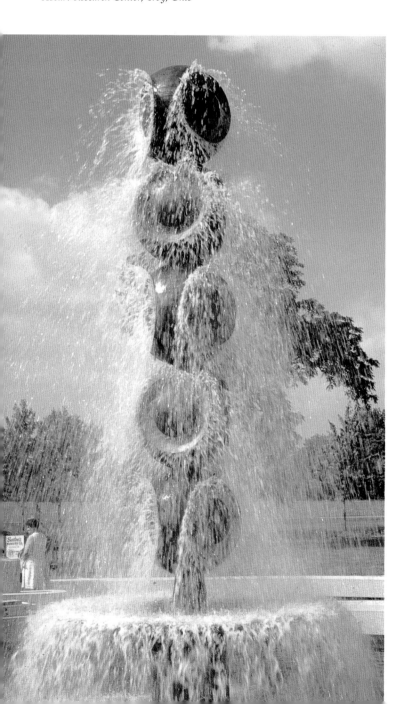

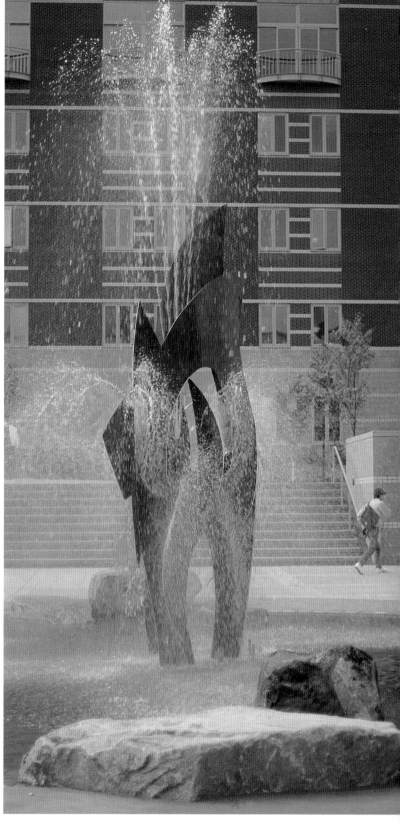

Centennial Fountain, 1989. Bronze, 16'.
Central Plaza, Seattle University. Photo by Larry Gill

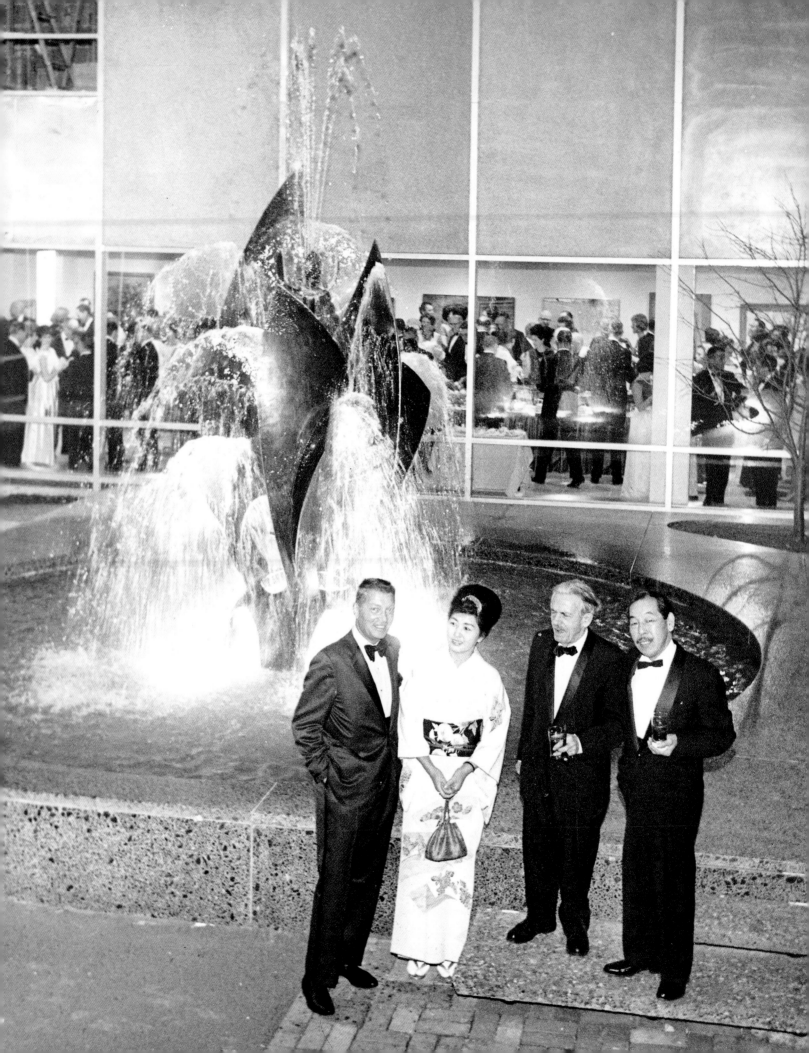

Dedication of *Fountain of Good Life*, 1964. Bronze, 12′ × 7′. *Commerce Tower, Kansas City, Missouri.* Left to right: Berny Hoffman, Ayame, Thomas Hart Benton, George

Behind the fabrication of the physical piece lie several other stages. Tsutakawa's ideas evolve from three-dimensional models, perhaps 3 in. to 12 in. tall, in a variety of easily worked materials—cardboard, sliced Ping-Pong balls, wire, foil, copper sheets. The shapes that can be generated by folding, turning, pulling cut sections, and stacking units all anticipate the final possibilities of the bronze. Further models are fabricated from hammered metal sheets and become, in effect, small sculptures. They reveal no water pattern; it arises separately from rough sketches and from Tsutakawa's "playing around" with what water can do. Holding a spoon under a faucet and "messing with plumbing in the back yard" are open-ended strategies he names for exploring this. Water passing over shapes or through openings takes on particular forms that continue or react to what it meets; the water's direction and force affect the outcome.

A lot of talk with Gerard and Jack Uchida follows when a model has been chosen for working up. Uchida eventually makes mechanical drawings—nozzle types, sizes, and their placement, for example—and he calculates the requirements of water pressure, velocity, and volume, pipe and pump capacities, and the required thickness of the metal sheets. He works out the technical drawings, for the pools, walls, and pump houses of the installation, from which the engineers, architects, and contractors will work. He writes out the specifications for parts and construction, and for many years he carried out or supervised much of the welding. The mechanical drawings and the processes they represent are daunting. To anyone but perhaps George Tsutakawa, they are ample explanation why many more sculptors do not make fountains.

The fountains, with their symmetry, their metal sheets and water, as well as size and location, create a very different sort of work from the *Obos*. The *Obos*, by their small size and their beauty of surface detail, remain essentially private and contemplative, even with all their rich associations toward more public and vernacular traditions. They are linked to the hermetic reverie of Tsutakawa's earlier sculpture, painting, and printmaking, and to a modernist esthetic of personal nuance. In terms of modernist painting or sculpture, the symmetry of the fountains is almost defiantly traditional. This symmetry links them to architecture. "When I make my sculpture I keep thinking . . . how can I make this thing right, balanced? I have another idea about sculpture also, and this comes from study and observation of architecture . . . I think it's the easiest thing to make a symmetrical design . . . it's the easiest thing to do. *But,* it's the hardest thing to make it interesting." The challenge became a crucial aspect of the fountains: "The success and the rightness of the symmetrical design is in its proportion, of all the parts." Tsutakawa observes that there are innumerable cathedrals and temples in the world, but "they're not all beautiful. Some are, you know, just symmetrical . . . I think, to me, it's the hardest thing to do to make something symmetrical and beautiful at the same time."

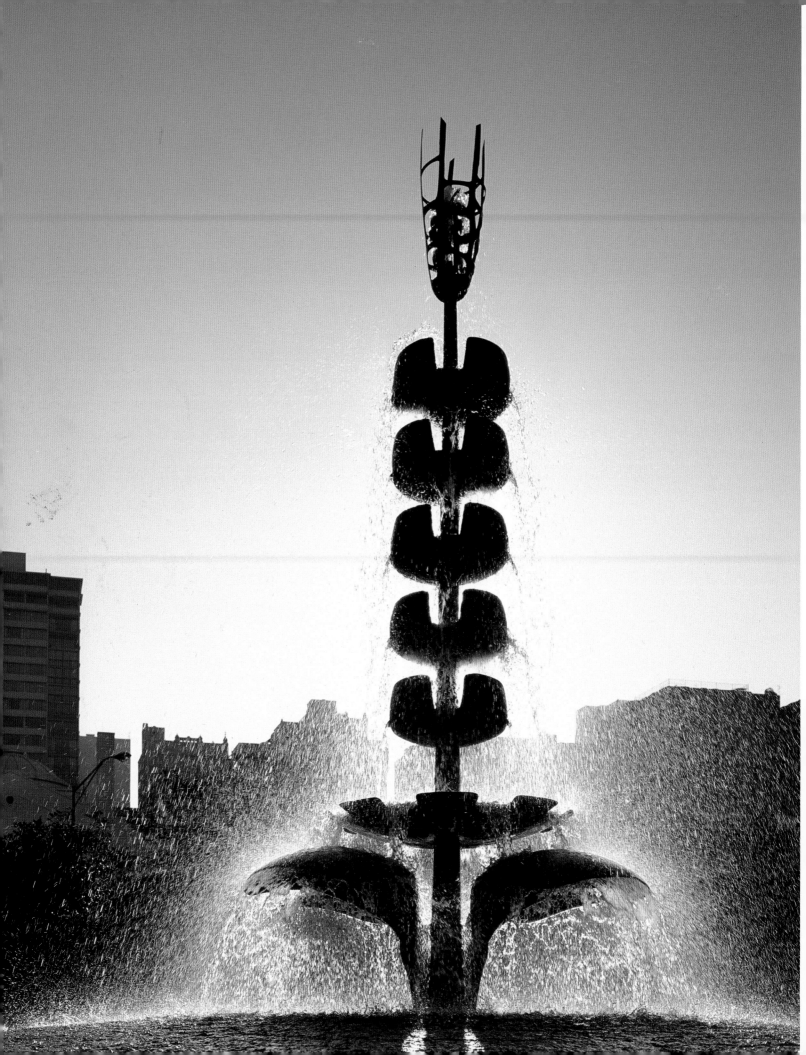

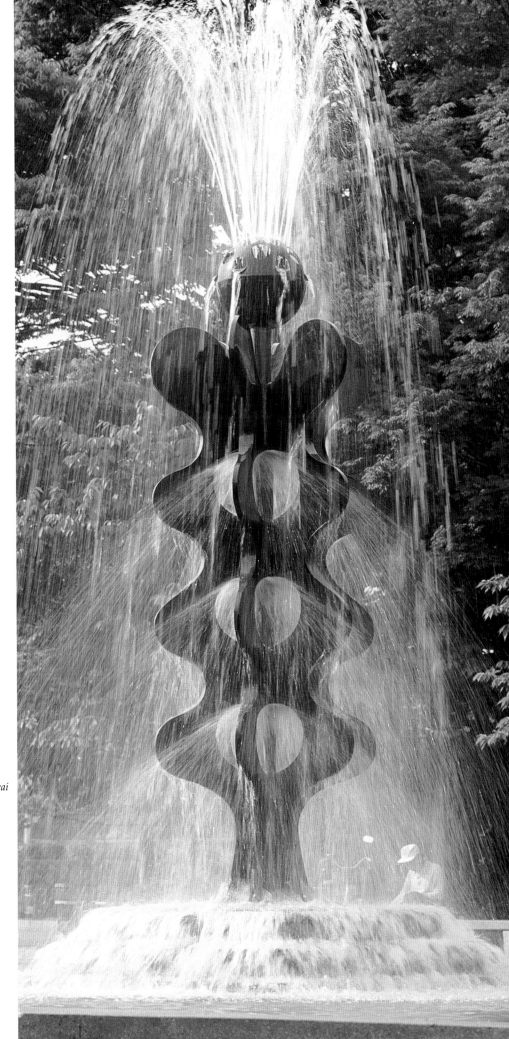

Naramore Fountain, 1967. Bronze, 18'.
Naramore Park, Seattle. Photo by Osamu Murai

Fountain of Vibrant Spring, 1982. Bronze, 15'.
Okura Park, Setagaya-ku, Tokyo. Photo by Osamu Murai

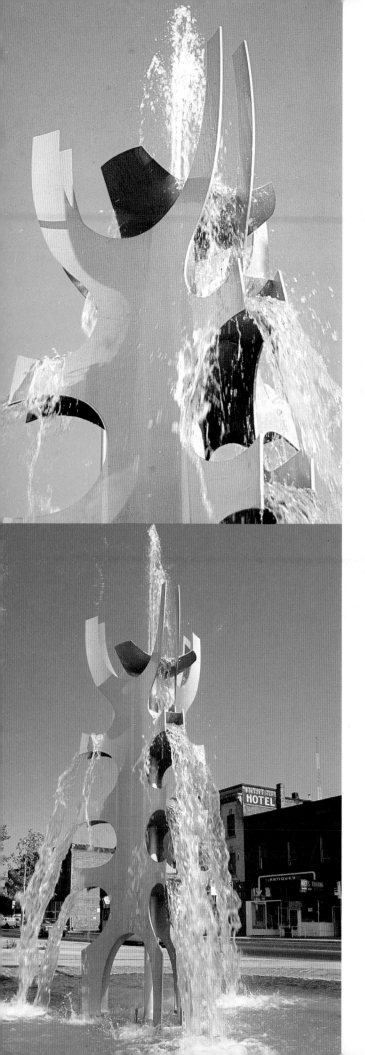

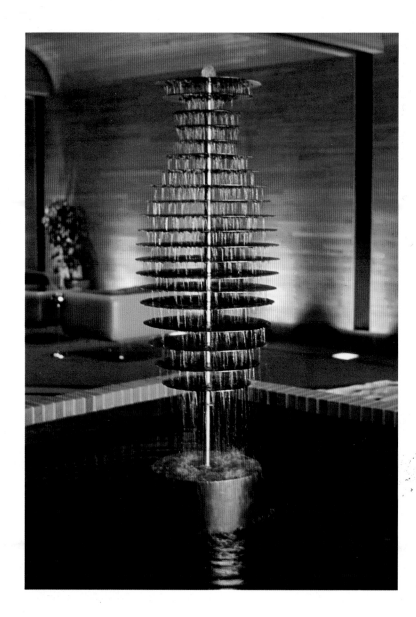

Rain Fountain No. 3, 1973. Stainless steel, 6½'.
Design Center Northwest, Seattle

Expo '74 Fountain, 1974. Aluminum, 17' × 7' × 7'.
Spokane, Washington

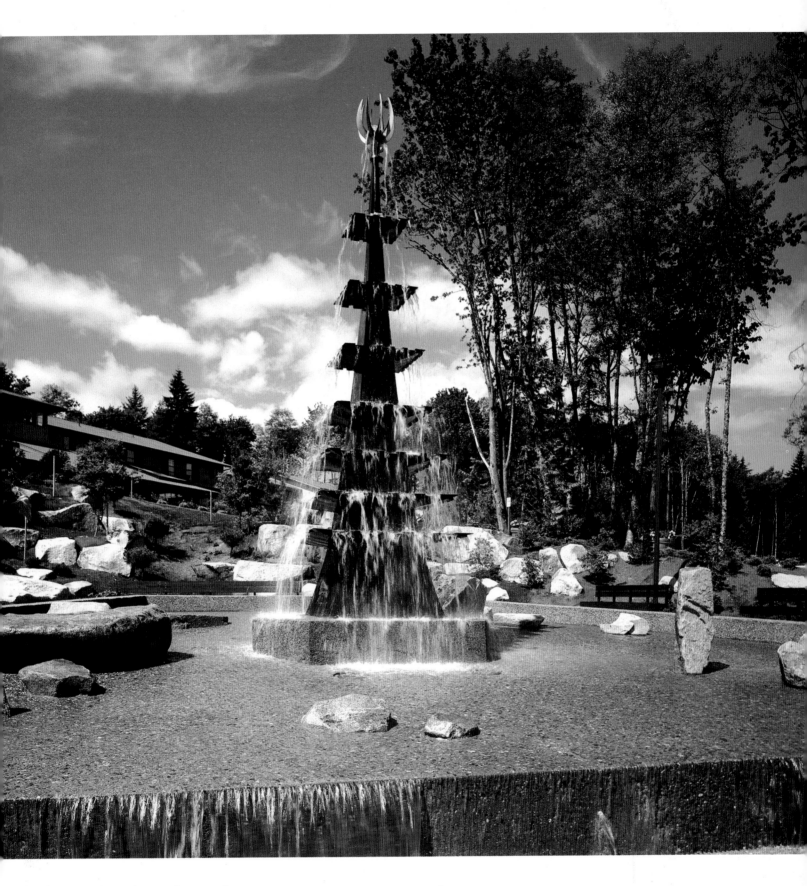

Marionwood Fountain, 1987. Bronze, 20′.
Marionwood, Issaquah, Washington
Photo by Eduardo Calderón

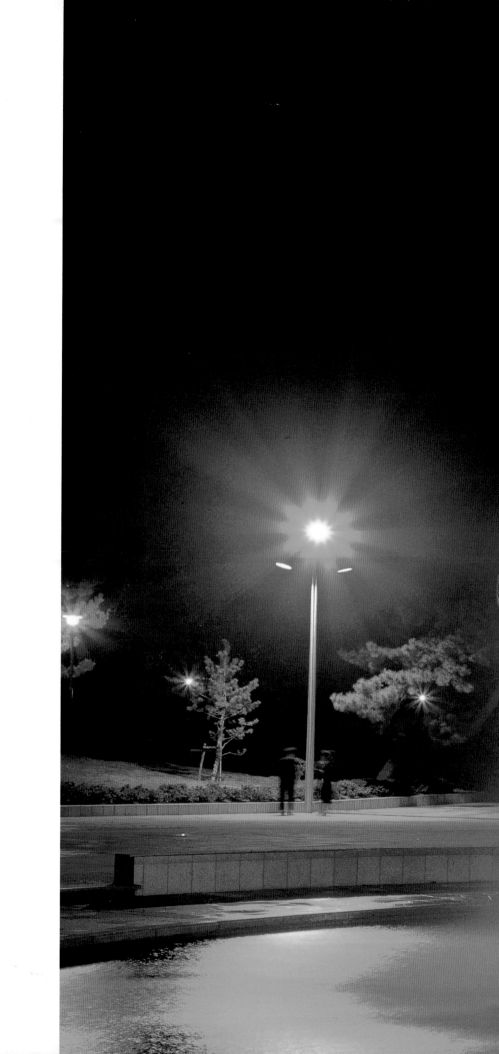

Song of the Forest, fountain, 1981. Bronze, 20'.
Tsutsujigaoka Park, Sendai, Japan. Photo by Osamu Murai

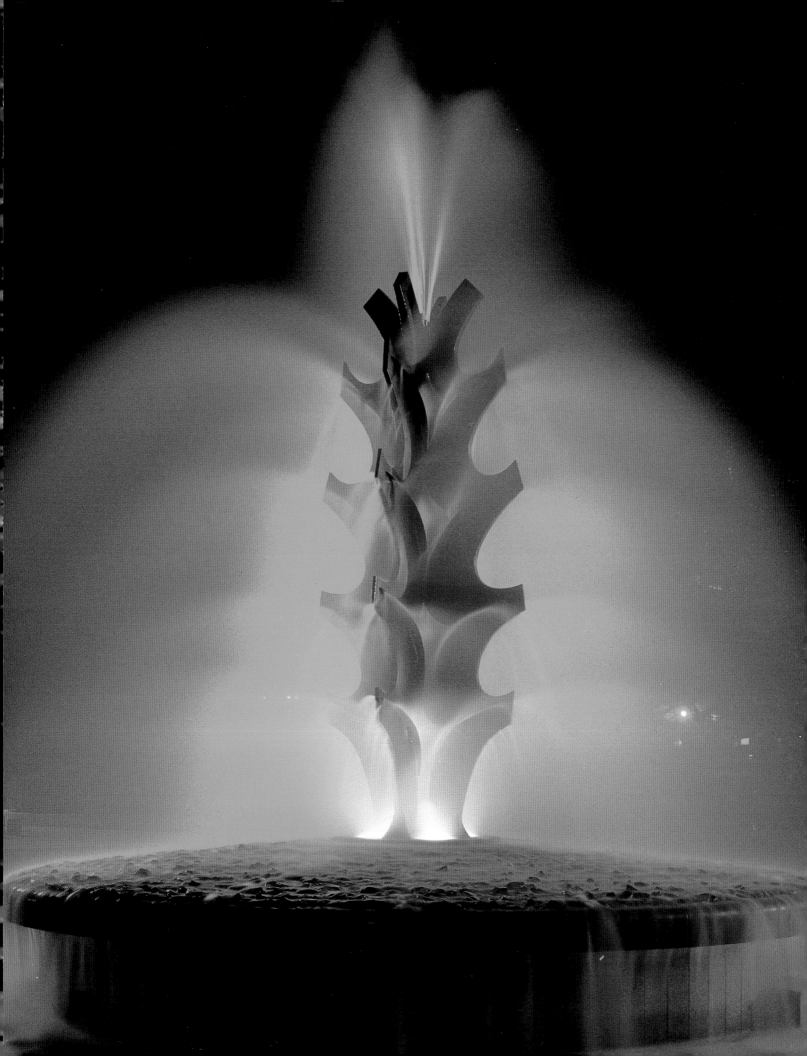

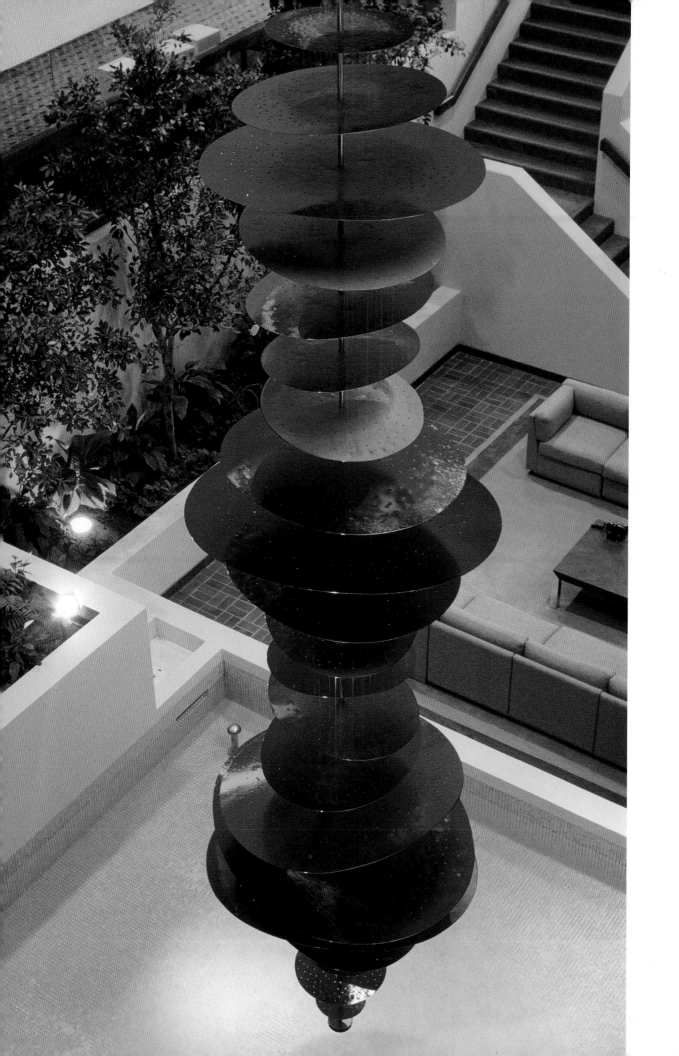

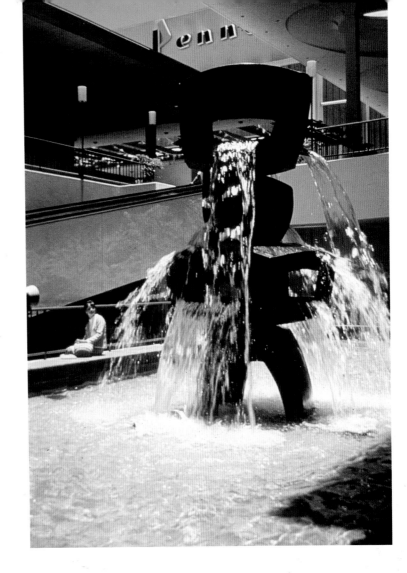

Hanging Fountain, 1981. Stainless steel, 20'. *KING Broadcasting Corporation, Seattle. Photo by Osamu Murai*

George and engineer Jack Uchida supervise the installation of *Hanging Fountain* at KING Broadcasting Corporation, 1981. *Photo by Mary Randlett*

Waiola Fountain, 1966. Bronze, 15'. *Ala Moana Center, Honolulu*

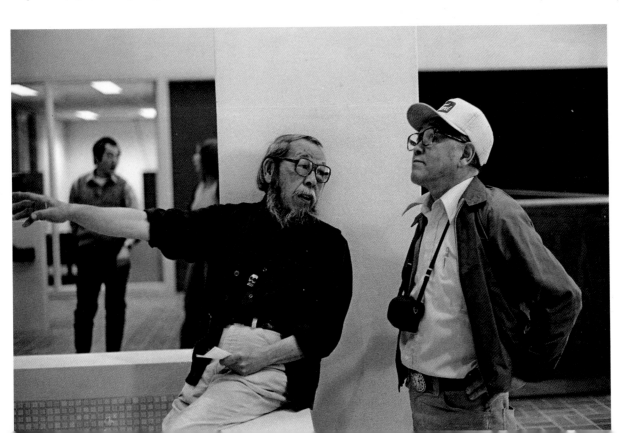

George in his studio with models of his fountains
and sculptures, 1989. *Photo by Paul Macapia*

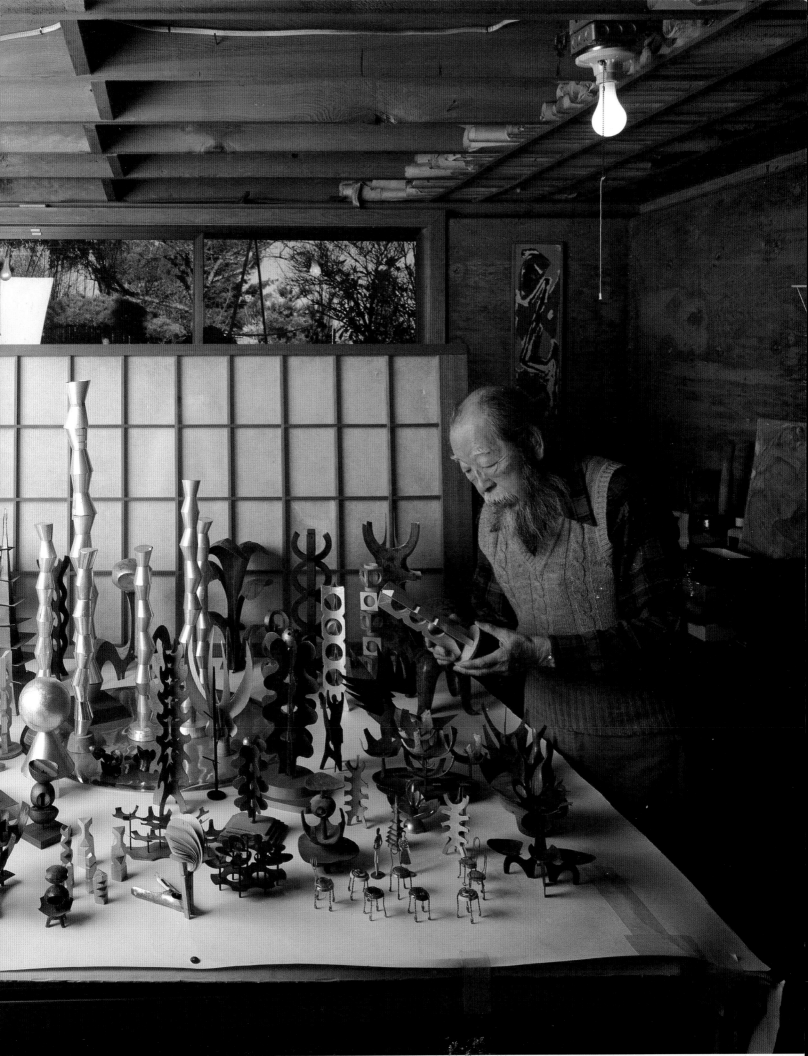

An important component of the proportions, the beauty, the rightness of the fountains is the water as a sculpted form. Water is rarely a mist or spray and rarely a simple linear trajectory in these fountains. Jetted out across some metal surface, it acquires the shape of that curve or fan, to continue and resolve; or spilling out over some particular edge, it is given both trajectory and plane. The origins of Tsutakawa's handling of water are somewhat obscure. The Asian cultures from which he received so much stimulus for the *Obos* had no traditions of fountains per se. "When they used water, it was usually as a waterfall or stream or pond, or one of these very interesting devices where the water falls into a pool through a bamboo tube which tips when filled with water, and makes a hollow sound . . . and then they did have waterwheels to water their rice paddies." But, he notes, they "didn't want to use water or force water to do something, like Roman fountains."

In contrast to Asia, Europe has a long tradition of fountains, but Tsutakawa did not feel himself its inheritor. He was thoroughly contemptuous of the innumerable fountains of western civilization whose use of water is simply a jet, or spout, or spray. Likewise, he rejects those in which representational sculpture is used in counterpoint with water: "In Europe . . . where they have a little boy standing there peeing, a little bronze statue with the water around it . . . They do two things: they either squirt water at the sculpture or the sculpture squirts water out at you." Tsutakawa felt that in the use of water western fountains had not changed fundamentally from Roman times through the Baroque age of great fountains and right up to the works at the World's Fairs in the twentieth century.

To understand the success of Tsutakawa's fountains, it helps to realize that much of the urge toward fountains has come from architects throughout western history, and that fountains are often embellishments of architecture. For example, the designers of the Seattle World's Fair of 1962 responded to the new urges toward public art that were becoming more manifest by the 1960s, partly by making the Fair a realization of the Allied Arts call for fountains in Seattle as a city of water. Five big fountains were commissioned for the exposition grounds, and in differing ways they all paid homage to the energy of water "to jet, spray, gush or bubble forth, to immerse the sculpture in falling water or surround it with mist"—in the words of an art historian, who noted that only one of them was "quiet, flowing, not spouting or gushing." None of these fountains was by Tsutakawa. (He loaned a small fountain to the private garden of the Federal Science Commissioner for the duration of the Fair. It was a single open oblate form on an arched pedestal element, only 37 inches high and more self-enclosed than the others at the Fair. Titled *Fountain of Reflection,* it became the gift of Phi Mu Sorority to the University of Washington in 1967.)

The condition of contemporary fountains was summarized well by a photographic exhibition, "Fountains in Contemporary Architecture," circulated by the American Federation of Arts through 1965–67. Over two-thirds of the fifty fountains included were credited to architects' and designers' firms—for example, I. M. Pei (three examples), Philip Johnson (three), Edward Durrell Stone (seven), and the important West Coast firm of Lawrence Halprin (eight). Each one could be described as some arrangement of jets (a line, a ring, an avenue, a single centered vertical, of spouting water) or as a simple falling plane. Only sixteen were fountains by sculptors; five of them were by Tsutakawa.

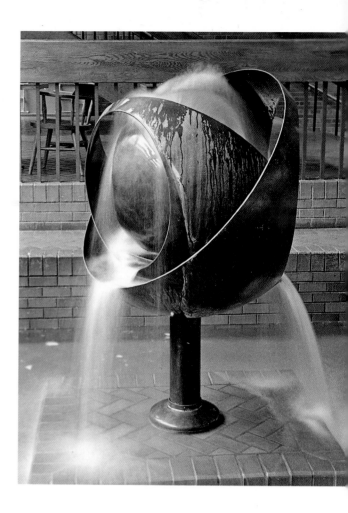

Fountain, 1973. Bronze, 8′ × 5′ × 5′. *Central Seattle Community College. Photo by Mary Randlett*

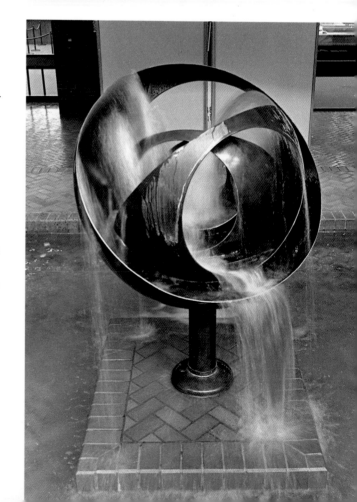

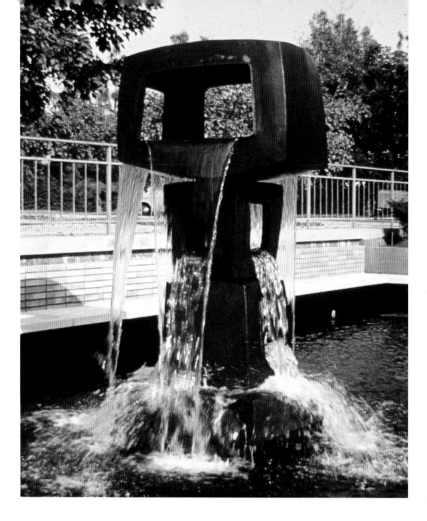

Obos '69, Fountain, 1969. Bronze, 9′ × 6′.
Franklin D. Murphy Sculpture Garden, University
of California, Los Angeles

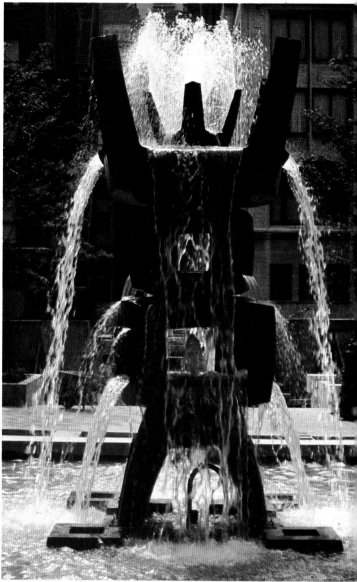

Jefferson Plaza Fountain, 1971. Bronze, 15′ × 8′ × 8′.
Indianapolis, Indiana

Fine Arts Court Fountain, 1974. Bronze, 8′ × 5′ × 5′.
Pennsylvania State University, University Park

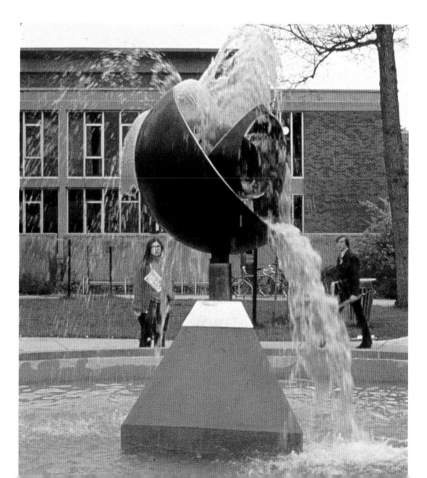

When designed by architects, the water jets of fountains had the simplicity of some added element, like a railing on a pathway, that enriched the whole space but was itself rudimentary in form. When designed by sculptors, the water was frequently a kind of splashy addition, spouting, as Tsutakawa says, at or from some sculpture. An architectural understanding of spatial design is not lacking, but in many it is very simplistically treated. Though Tsutakawa might decry the comparison, one can propose that his success with fountains must, like the success of the great seventeenth-century fountain artist Bernini, arise from the fact that both Tsutakawa and Bernini were well grounded in architecture as well as sculpture. The works each created are outstandingly complex interactions of solid and void, and of still and moving shapes.

While Tsutakawa's fountains in no way emulate Baroque predecessors, they arise from that tradition's evolution into a modernist formalism. It is Bauhaus attitudes and the School of Architecture studios that lie behind his dozens and dozens of fountain models, generated out of cut and folded paper, pulled and bent planes, Ping-Pong balls, and pins, and that also lie behind the spoon held under the water faucet and turned about to generate moving surfaces of water—planes, fans, shells. Tsutakawa observes: "The water becomes one of the elements of the entire work . . . light, whether it's natural daylight or artificial light, is a very important element." And further: "Sound is certainly important . . . and there's a lot one can do to control it: the size of the pool, the shape of the pool, and the relative position of the wall, and then the length or the distance or width of the waterfall or the jets that you employ." Rather than "fountain sculpture," it might be as accurate to call Tsutakawa's works "fountain architecture."

Or perhaps "symbolic fountain architecture" would better explain these works. While he takes a western architect-designer's positive attitude toward total space and environment and toward complex technical means, Tsutakawa is by no means a pure Bauhaus formalist. He desires that the fountains be as evocative, as reverent, as the *Obos*. He means them to participate in "the symbolic quality of water all over the world—the purifying, the cleansing, the offering, the water of life. In Japan, Buddhist monks come and cleanse themselves before they go into the temples. They duck under water flowing out of a high rock wall through pipes of bamboo."

For Tsutakawa, ultimately water stands in relation to humanity and to life as the great containing cycle of all things. He speaks of it in a manner as flowing and relentless as his subject: "How water envelops our whole world and it moves constantly, it evaporates, and it fills the atmosphere, and sometimes it's clear and sometimes hazy, foggy, and then eventually the water falls to the ground in the form of rain, snow, and wet mist, and then it accumulates in places, top of the mountain, becomes glacier, snow, and then in the valleys it'll flow down and form lakes, then eventually go out to the ocean, and then it evaporates again. It's a constant movement of water. And this same movement—the water is going through our body all the time, all the living things, the water is moving in and coming out, evaporating, drying, and, oh, rotting, you know, and disintegrating, and reforming again. This great cycle and movement of water." The symbolism of these fountain sculptures or fountain architectures is one of permanence and continuity embodied in flux; and *obos*-like, of harmony and upward reach constructed within the perpetual cycle.

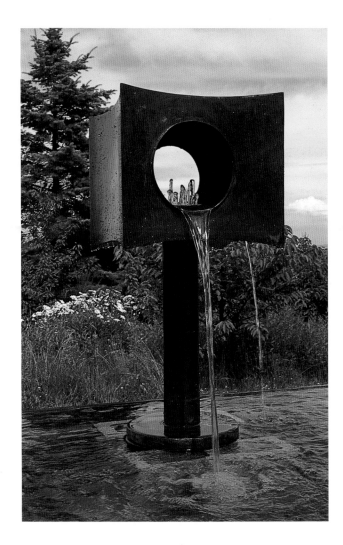

Fount Zen, 1976. Bronze, 3'. Collection of Mr. and Mrs. Doug Fox, Camano Island, Washington

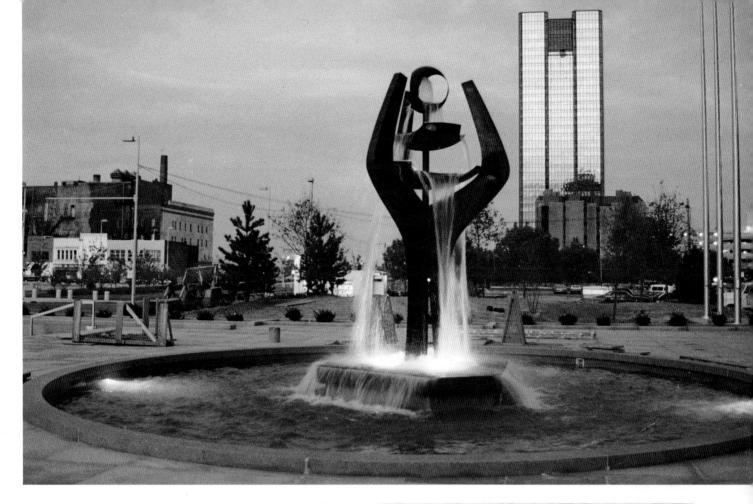

Chalice Fountain, 1983. Bronze, 15′.
Government Center, Toledo, Ohio

Fountain of Hope, 1987. Bronze, 8′. Water Department
Building #2, Sapporo, Japan. Photo by the artist

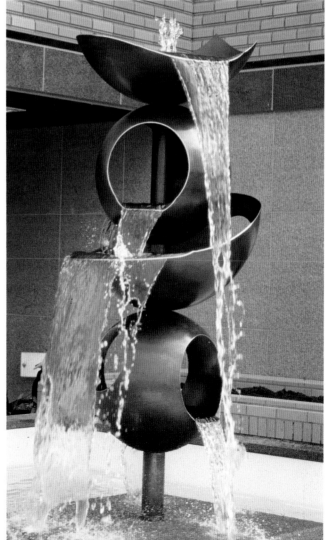

At the practical level, Tsutakawa always intended that the fountains be as permanent as possible. Through them he achieved his longstanding goals of a public and collaborative art. "Well, let's put it this way—I think every sculptor, a real, genuine sculptor, likes to do big things, permanent things, placed and be seen by more people. I think this is just a born natural desire of almost every sculptor." Beyond that personal ambition, he believed that "outdoor and public sculpture is for the public, is for the people. And I think it's very important that you design something which is appropriate to the scale, and to the environment, and to the wishes of the people, and also to the wishes of the owners . . . I do feel a strong sense of responsibility to the community and to the area where it's going to be." He visited the sites of large pieces before he started designing: "It's important that the artist really understands the environment: the space and the scale and size, whether it's in an area with concentration of large buildings or open space . . . and then the sun angle . . . wind situation, the weather, climate." He frequently offered those who commissioned a work alternative possibilities to help them clarify their desires—until he found that they often couldn't make up their minds, and it seemed better to go in with one proposal. And he felt so strongly about the specifics of site and client that he declined opportunities to make editions of the fountains. (The very smallest, the domestic scale *Fountain of Reflection* of 1962, was a trial exception. He made three of an intended four, but the need to adjust each for a different place made the project impractical.)

When faced with choices among more commissions than he has time for, Tsutakawa has generally preferred the larger and more public opportunities over private and domestic works. He executed over sixty commissions in metal between 1960 and 1989, the vast majority of them fountains. The larger ones (15 to 25 feet tall) take roughly a year for design through fabrication. In the 1960s especially, many of the works were commissioned by corporations to grace and soften their office buildings, and by commercial firms wanting to enliven the public's experience of their business environment. Yet there were always commissions, like the first Public Library site, for civic buildings and public-service locations. Through the 1970s into the 1980s, the preponderance of this kind of commission has increased. City government sites, libraries, universities and schools, hospitals and medical centers, and public parks are often among the commissions Tsutakawa accepts. His fountains are found throughout the United States, from Florida and Washington, D.C., to California and Washington State, as well as in Canada and Japan. He has found it especially gratifying to install public works in Sendai, Tokyo, Sapporo, and recently in Fukuyama.

W HILE FOUNTAIN sculpture dominated Tsutakawa's work after 1960, he also continued to explore other sculptural expressions. Design commissions varied from medals for the Seattle World's Fair in 1962 and Spokane's Expo in 1974 to the architectural gates at Seattle's Lake City Library and at the University of Washington's Arboretum.

Memorial sculpture for West Coast Japanese Americans interned during World War II, 1983. Bronze, 10' × 30' × 30'. *Puyallup Fairgrounds, Puyallup, Washington*

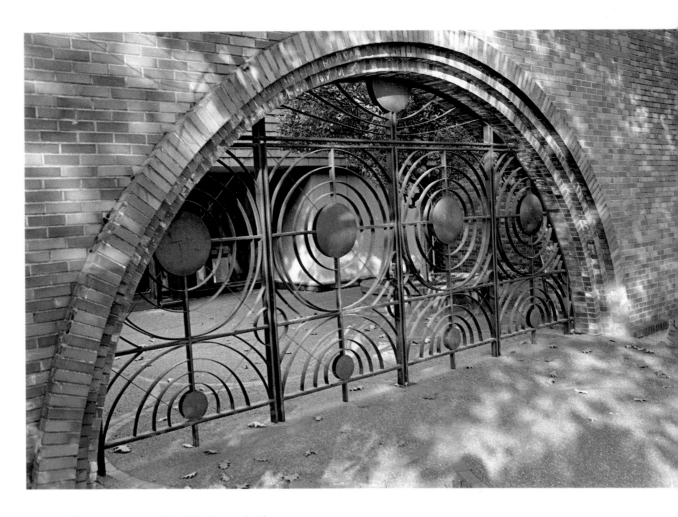

Gates, 1967. Bronze, 9' × 21'. *Lake City Library, Seattle.*
Photo by Mary Randlett

Gates, 1976. Bronze, 6' × 22'. *University Arboretum, Seattle.*
Photo by Mary Randlett

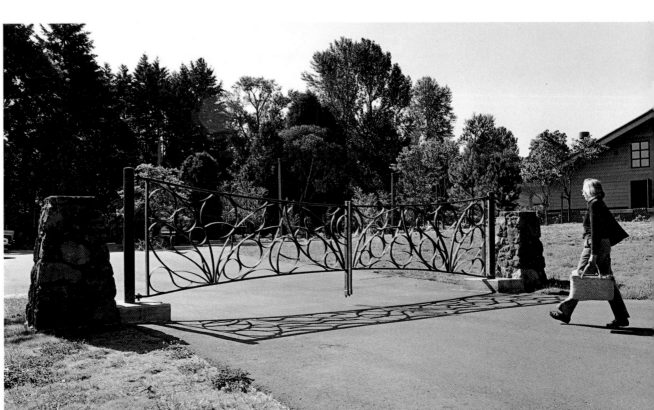

An especially difficult situation arose in 1983 out of a commission for a memorial sculpture for West Coast Japanese Americans interned during World War II. Tsutakawa's original response was to reactivate figurative concepts from work closer in time to the event itself—like the simplified but recognizable figures in his own work of the late 1940s and early 1950s. Adults and children were grouped within a curved enframement, clearly carrying suitcases, departing. The site of the memorial was to be in the fairgrounds in Puyallup, Washington, where internees had been brought together for evacuation. Controversy arose over any responsibility that might seem implied by the siting; the fairground owners wanted the sculpture situated elsewhere, or canceled. Tsutakawa's final bronze version was more abstract and geometric, with upreaching figures like his wood commissions of the late 1950s. It was sufficiently neutral or uplifting to gain acceptance at the original site. The political issues implied can finally be acknowledged after forty years, but they are still by no means easy to deal with.

Most of Tsutakawa's independent sculpture after 1960 was related at least indirectly to the *Obos*-fountain concepts. Some retained the vertical axial form and moved it back toward figuration (somewhat as Japanese stone towers, the *seki-to*, merge with the Jizo figures). Beginning in the early 1960s, he made a number of smaller works, 2 to 5 feet tall, cut from bronze sheets like the fountains and welded into boxy hollow forms. These often bulged at the sides or corners in taut shallow curves, like the powerful contours of Northwest Coast Indian carvings. The bronzes are provided with stems or footed bases that increase the latent figural references. Often metal-walled tunnels connect holes in opposite sides; these may suggest mouths, or eyes, or undifferentiated openings of an animate self. The assertive frontality and taut symmetry of some of these may also recall the Haniwa pottery figures of early Japan.

Their titles reinforce figurative associations: *Ancient Warrior, Evil Eye, Spirit Box, Eternal Laughter, Sentinel, Guardian.* Some of these titles also suggest their connection with Japan, with the fierce guardian figures of temples, with samurai warriors, even with the energetic grotesquerie and drollery that is evident in them. On the other hand, the figures also preserve the Surrealist quality of Tsutakawa's earlier work, and in particular the self-scrutiny of those crucial war years, when he was pressed to know and assert who he was culturally. The self-portrait of 1943 foreshadows these sculptures of the figure as a hollow geometry with a hole, the figure as a watching self whose mouth/eye/hole is both a void and an active agent. Not surprisingly, the vertical totemlike guardians of Tsutakawa share common Surrealist roots with other postwar totemic-abstract sculpture; for example the *Sentinels* of David Smith, the marble figurations of Isamu Noguchi, and, of course, Henry Moore's works.

In two *Votive Sculptures* of the 1970s, Tsutakawa moved closer to the Japanese allusions, abandoning the hollow welded form for cut planes that are more like the layered fall of Japanese armor, or, remotely, the folds of garments of religious sculptures.

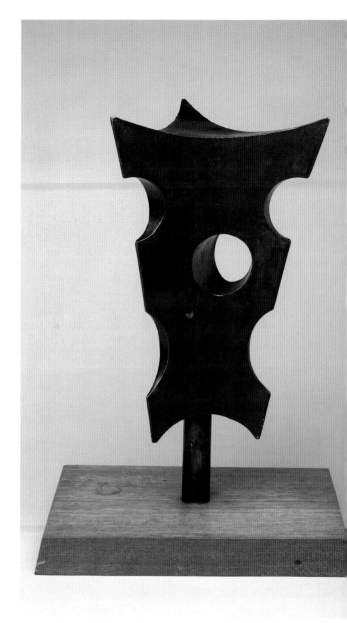

Ancient Warrior, 1964. Bronze, 17¾" × 10" × 9". Collection of Mr. and Mrs. Chris Louie, Edmonds, Washington. Photo by Paul Macapia

Sentinel, 1964. Bronze, 17″ × 17½″ × 7¼″. Collection of Mr.
and Mrs. Robert M. Sarkis, Seattle. Photo by Paul Macapia

Timeless, 1963. Bronze, 18″ × 12″ × 7″.
Collection of the artist. Photo by Paul Macapia

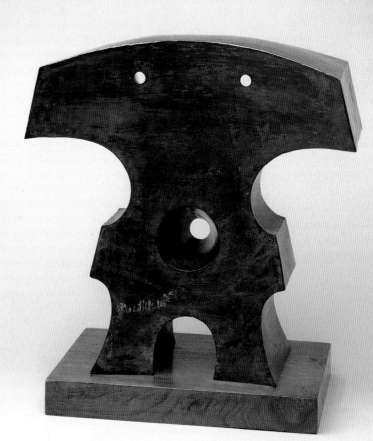

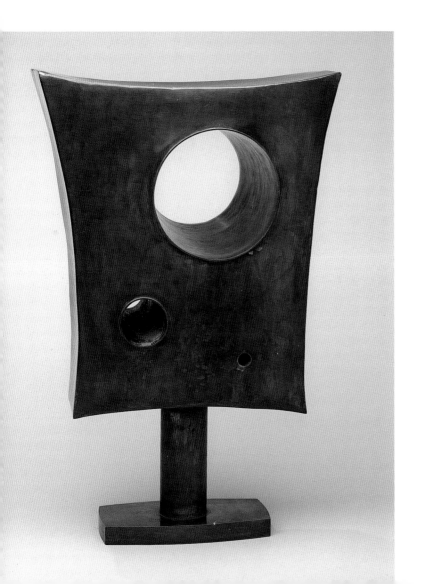

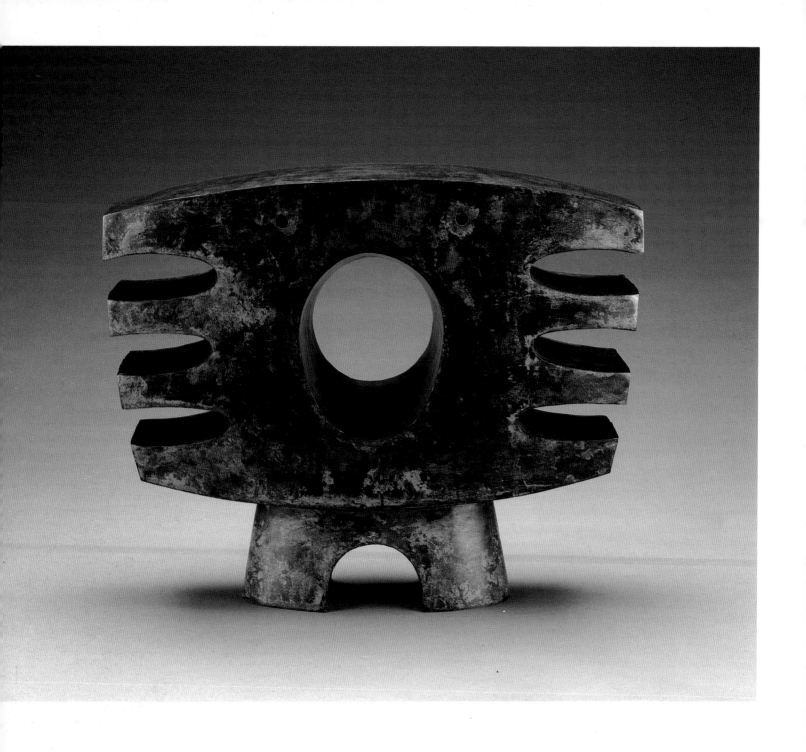

Eternal Laughter, 1966. Bronze, 20" × 25" × 9'.
Collection of Dean Yee, Seattle. Photo by Paul Macapia

Evil Eye, 1968. Bronze, 6' × 3' × 3'.
Collection of the artist. Photo by Paul Macapia

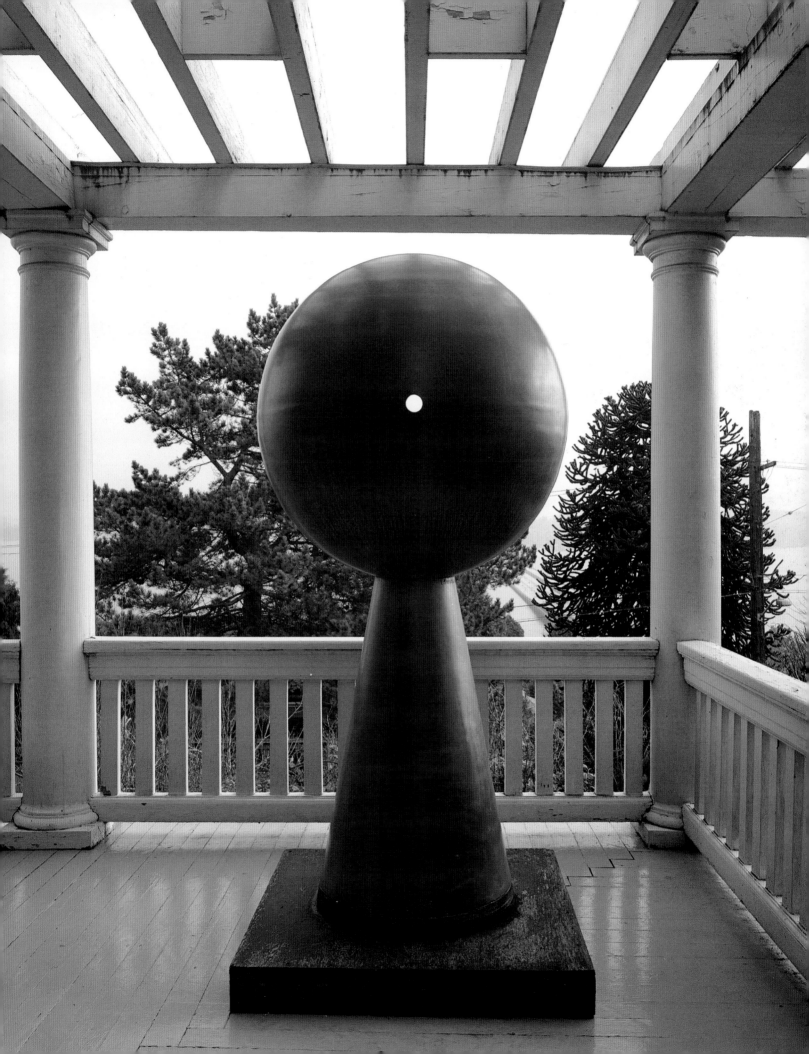

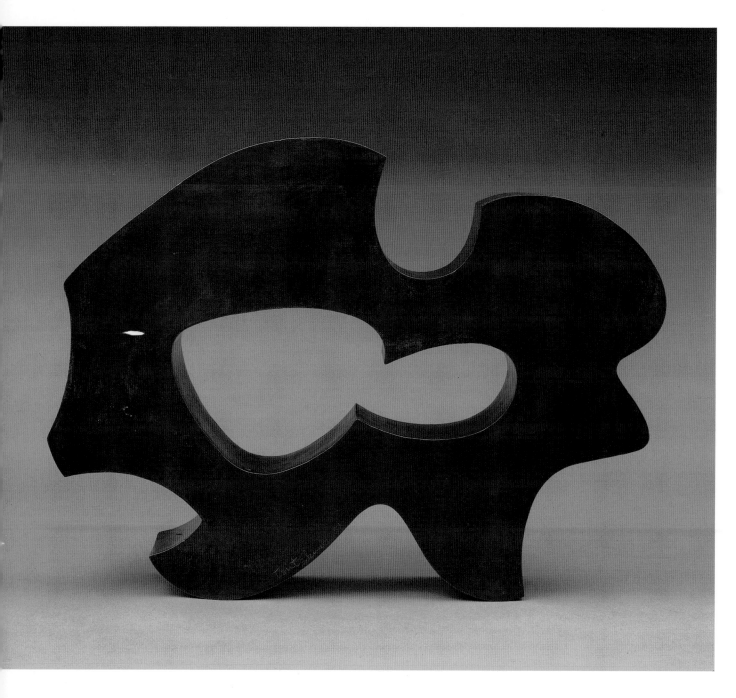

Chimera, 1988. Bronze, 18½″ × 25½″ × 4″.
Tacoma Art Museum. Photo by Paul Macapia

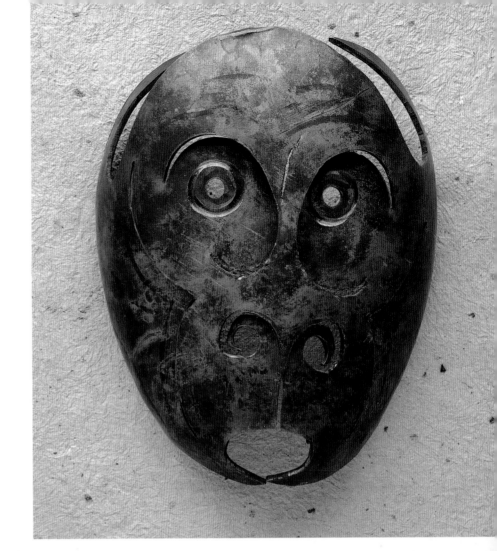

Saru, mask, 1969. Bronze repoussé, $7\frac{1}{2}'' \times 6'' \times 3\frac{1}{4}''$.
Collection of the artist. Photo by Paul Macapia

Legend, 1986. Bronze, $6'' \times 32''$. *Collection of PACCAR.*

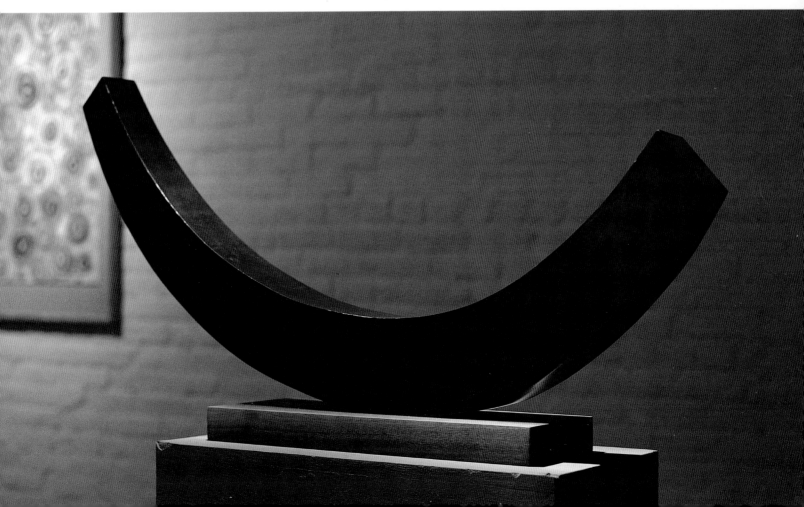

Particularly in the 1970s and 1980s, some of Tsutakawa's independent sculpture employed the pure geometry of fountain sections to make severe works of identical or similar segments. Among these were stainless steel arcs, like sections of doughnuts, that formed a vertical sequence or a horizontal form: *Floating World* and *Two and a Half Worlds,* from 1970, for example. The minimalism of 1960s sculpture may have stimulated their austere geometry. Some bronze and stainless steel sculptures were like segmented towers of flanged planes, closely similar to some of the fountains (Silverdale, Wa., 1979; International District, Seattle, 1978). A wood version of the towers, about four feet tall, was made as the circulating trophy for the University of Washington's Minority Students Organization.

Behind these towers, one senses Tsutakawa's avowed admiration for Brancusi's *Endless Column.* The completed works, however, are all opened into planes and holes more elaborate than the compacted angular segments of Brancusi's work. Among Tsutakawa's undeveloped models is a set of six eccentric columns of silvered cardboard, closer to Brancusi's concept—except that Tsutakawa envisions "a forest" of columns 20 or 30 feet high of stainless steel, with water dropping from the tops to course down the angled sides, and a great play of light. The model rests on a shelf in his workshop, suggestively juxtaposed with a cluster of splendid bamboo poles 6 or 8 inches in diameter—bamboo, of course, being the original segmented column. A grove of large bamboo does have the scale, the same play of light, that he imagines.

One further type of work drew Tsutakawa's energies through the decades since 1960: *sumi* ink painting. He gradually came to use tempera and even Chinese watercolor less. Painting became, like the fountains, a construction of black within light. In the early 1960s, a number of paintings were built of broad arcs, as controlled and geometric as sculptural segments but floating free rather than constrained by gravity and axis. Especially around 1970, several series of works appeared based on concentric and radiating circles (*Radiation* series, *Light Signals*). These were related to the *World* sculptures, segments of circles, of the same year, and both had precedents in the increasing geometry and large scale of the spherical *Evil Eye* of 1968. The central point on the plane is analogous to the single axis in three dimensions. A resolution of static form and energetic flux is achieved in both media. Perhaps it is not too much to suggest that the ink and paper transpose to two dimensions the challenging pleasures of the fountains—fluid, interactive, black, and gestural, like the shapes of bronze and water.

Tsutakawa also used *sumi* painting for a range of representational works. They include many landscapes and some still-lifes and plant forms. As in the fountains' allusions, the human form is discarded but other organic forms of the natural world are retained, which transcend the narrowly human. The *sumi* landscapes include many vigorous, bold, and sometimes stark forms: of Mount Rainier, of the Cascade Mountains, of the rugged coastal rocks at Point of Arches on the Olympic Peninsula (where Tsutakawa went repeatedly from the late 1950s on). Many *sumi* paintings were derived from places intimately known and important to the artist, like Hood Canal toward the Olympic Mountains where he acquired a summer property in 1961. Others record in rich black simplicity and sensuous broad washes the impact of particular travels—to the Oregon coastal dunes in 1972 and, very importantly for Tsutakawa, to Nepal in 1977.

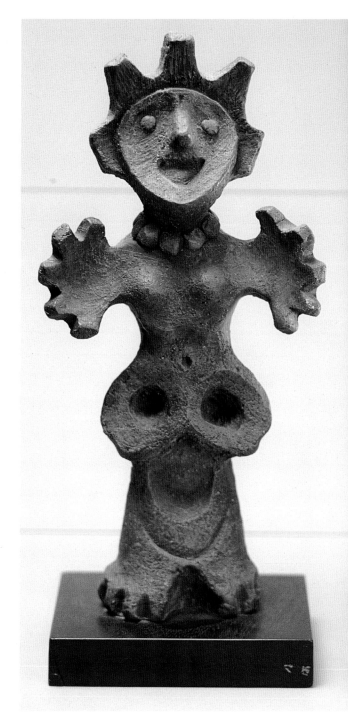

Extrovert, 1963. Terra cotta, 12" × 12⅞".
Collection of Cornelius Peck, Seattle

Votive Sculpture No. 1, 1977. Bronze, 49" × 16½" × 15".
Collection of the artist. Photo by Paul Macapia

Votive Sculpture No. 2, 1977. Bronze, 44" × 13⅜" × 14".
Collection of the artist. Photo by Paul Macapia

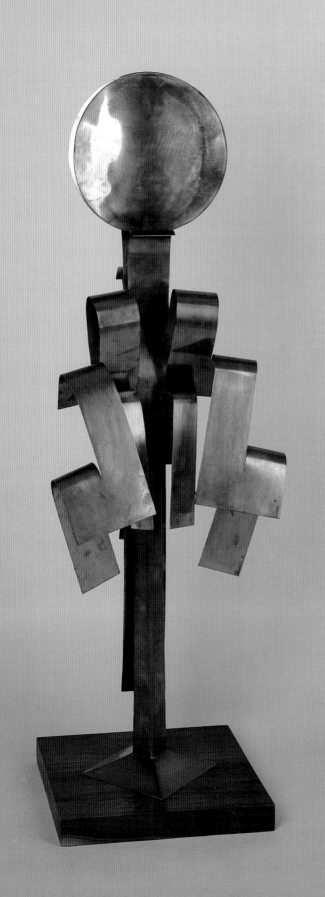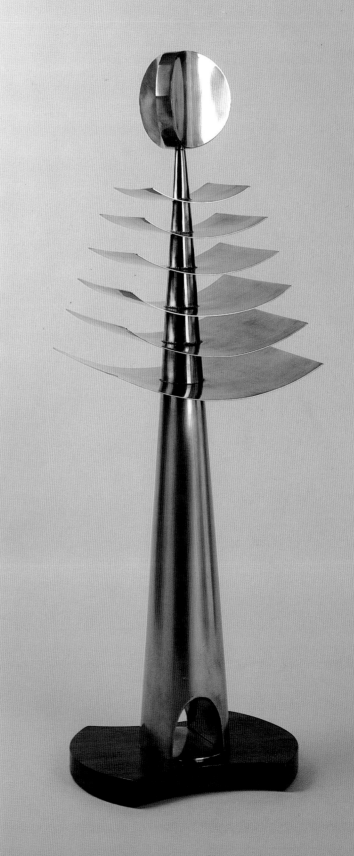

In Nepal, Tsutakawa trekked into the high Himalayas, as Justice Douglas had done: "At about 16,000 feet, place called Labouje on the trail to this base camp . . . I saw the *obos* . . . and I was so excited about this. It was a very cold, freezing day, and I was far behind in the climbing party because the blizzard started. But about that time, I looked around and I saw piles of rocks." The next day was bright and clear; the party came down through the same area and he photographed the structures. "And at one spot," Tsutakawa recalls, "I saw twenty or thirty of these standing against a huge valley, thousands of feet down and then looking at Mount Everest . . . oh, that was the most exciting experience I had in my whole life. So that's still—that concept, the whole notion—is still very, very strong in my mind." In *sumi* paintings, the remote vastness and dazzling scale are suggested by the delicacy, the floating quality, of the Himalayas in contrast to Northwest mountains. In his other works, his sculpture, the *obos* allusion was reinforced by those he saw in Nepal. "Talking with the natives . . . they're not professionals, they're not craftsmen, they're just plain travelers . . . They just naturally or automatically gathered rocks and piled them." Many travelers in many cultures recognize the urge, but few are so methodical and reverent as the Central Asians and the Japanese: "This same concept works through in my idea of stacking forms. First it was stone, then it was wood, and then in metal."

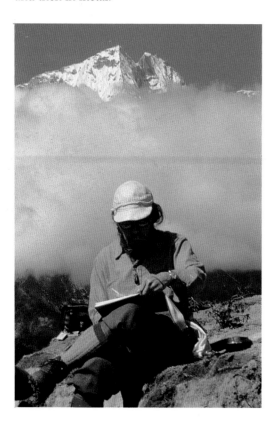

George sketching during his trip to the Himalayas, 1977

Sand Worm, 1987. Bronze, 51½" × 13" × 11⅛".
Collection of the artist. Photo by Paul Macapia

Mo (Seaweed), 1986. Bronze, 50½" × 15" × 13". *Collection of
Mr. and Mrs. Marshall Hatch, Seattle. Photo by Paul Macapia*

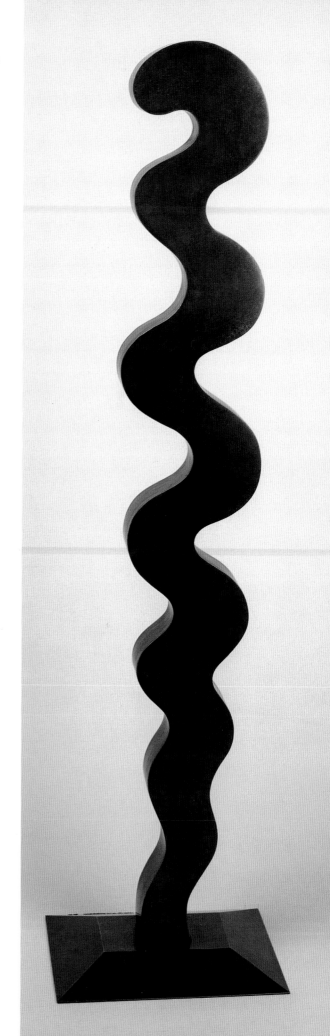

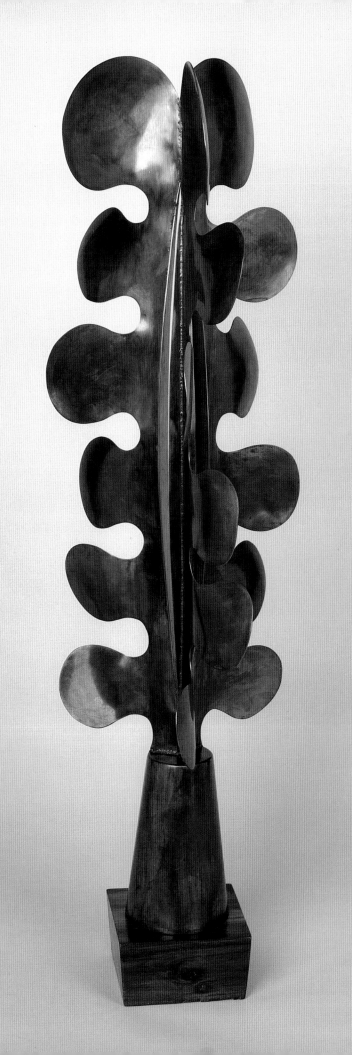

I N SPITE of the great complexity of the fountain commissions, Tsutakawa found time in these decades for many explorations of the world. His sense of its cycles, energies, and cultures was continuously confirmed. He traveled extensively in Europe in 1963, to Mexico in 1964, and widely throughout East and Central Asia and to Europe in 1969. After he retired from teaching in 1976 and went to Nepal in 1977, his trips to Japan became frequent and varied, including those for commissions.

Today the children of George and Ayame, with their own children (six by 1989), form a more extended family community of Japanese American synthesis. Ayame continues to play an important role in promoting fine art and cultural traditions in the Asian American and greater Seattle community. Gerard became a sculptor, Mayumi a journalist and arts administrator, Deems a jazz musician, and Marcus a music teacher. In many undertakings of the four, a reexamination of Japanese culture and a concern for its interaction with western traditions is evident. All four live in close proximity to their parents and actively support their parents' and each other's work.

Tsutakawa's *sumi* paintings appeared in solo exhibitions at Seattle's Foster-White Gallery from the 1970s, and in group shows in many places. His early works were included in several historical exhibitions curated in the 1970s and 1980s. Awards reflected the impact of his work after 1960. In the 1960s, he received honors for particular sculptures at museum exhibitions outside Washington State; and within the state, the 1967 Governor's Award of Commendation. By the 1980s, he had received, among others, the Order of the Rising Sun Award, fourth class, given by the Emperor of Japan; honorary doctorates from Whitman College and Seattle University; the University of Washington Alumnus Summa Laude Dignatus award; awards of honor from the King County Arts Commission and the Washington State Historical Society; and an honorary membership in the Seattle Chapter of the American Institute of Architects.

The recent awards honor Tsutakawa for his life's work, and in particular for the fountain sculptures through which he has reached so many thousands of people. "One thing I always keep in mind . . . I still say, if you're making a sculpture for the public places, you are making it for the people to look at. If you don't want people to look at it, if they don't like it, you have no business putting a piece of sculpture out in the public, you see . . . I think it's awfully presumptuous—for *any* artist—to want to make something to stand out there for fifty years . . . Well, that's just in me, and I guess I got started and can't stop. Keep doing it." It is clear that the awards mean far less to him than having made the work and having reached those people. He has, and he continues.

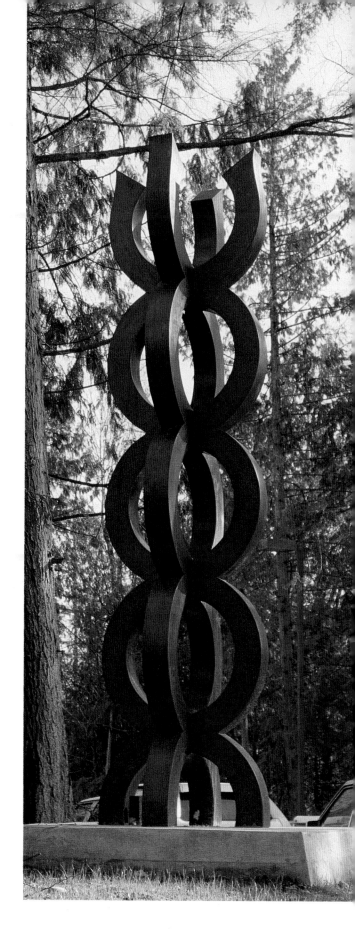

Sculpture, 1979. Bronze, 15'.
North Kitsap High School, Silverdale, Washington

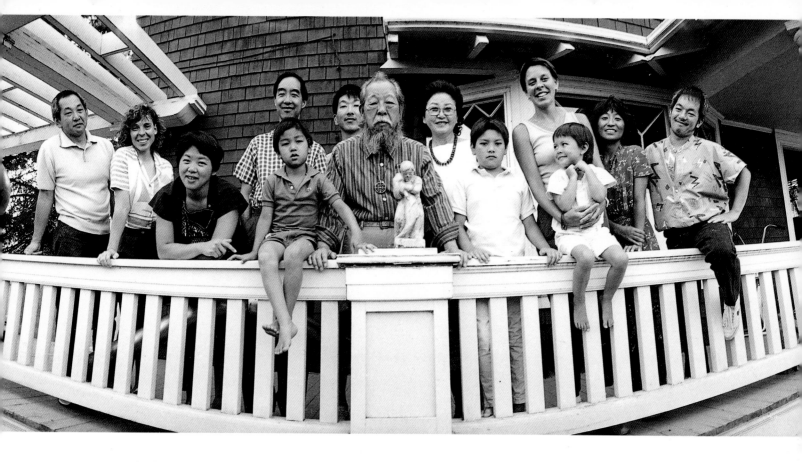

George (center) and Ayame (right of center) with their children and grandchildren outside the family home in a photo accompanying a 1985 feature article in the Seattle *Weekly*. *Photo by Kim Zumwalt*

Waterville, 1968. *Sumi* with *gansai*, 23½″ × 38″. *Collection of the artist. Photo by Paul Macapia*

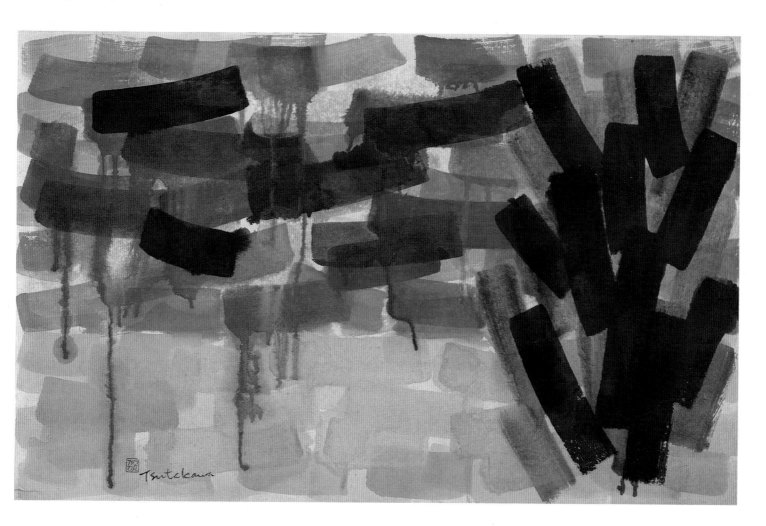

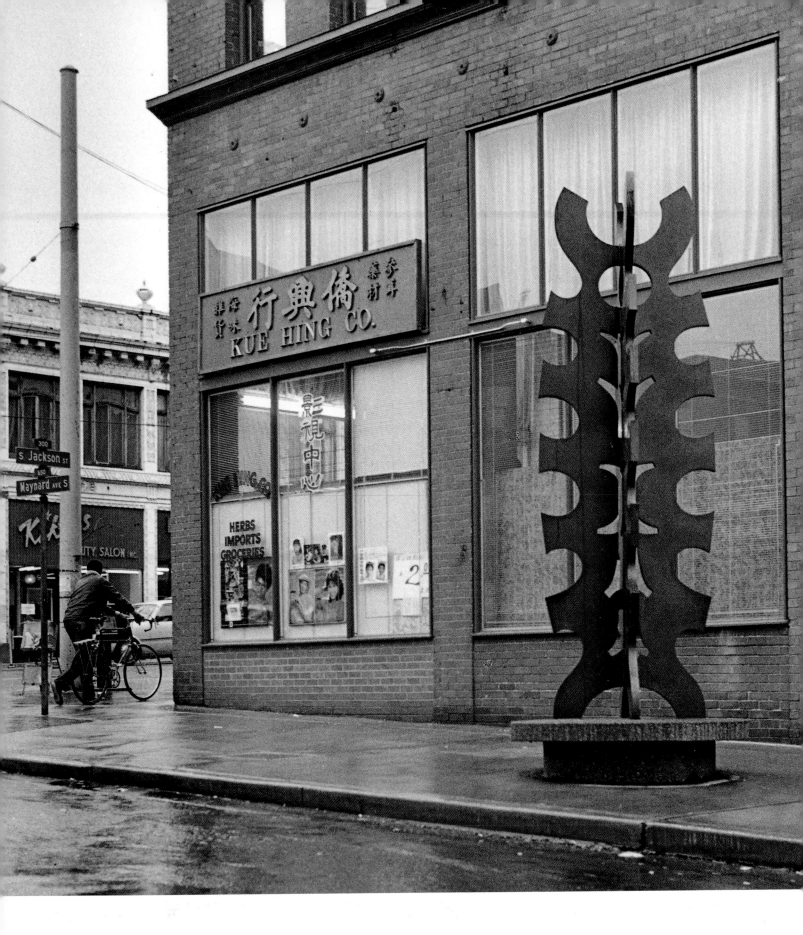

Sculpture, 1978. Bronze, 14'.
International District, Seattle

Winter Forest, 1987. Sumi, 52³⁄₄″ × 26¹⁄₈″.
Collection of the artist. Photo by Paul Macapia

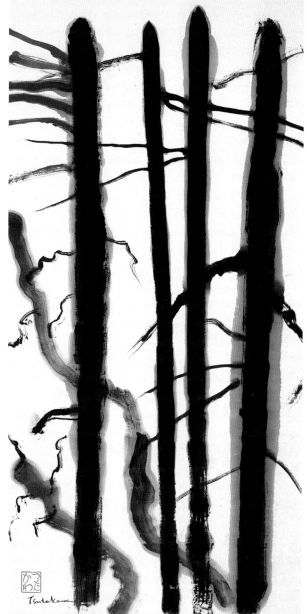

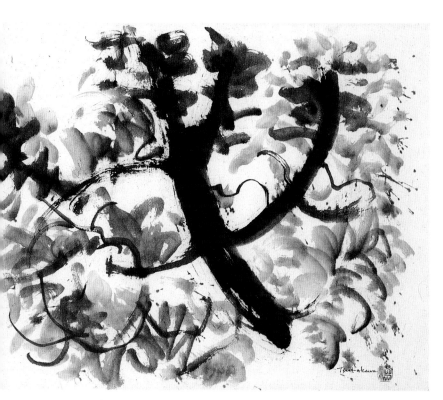

Fig Tree No. 6,1976. Sumi, 23″ × 30¹⁄₄″.
Collection of the artist. Photo by Paul Macapia

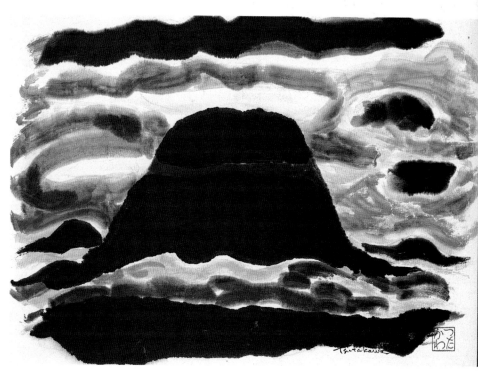

Mount Rainier, 1975. Sumi, 26″ × 36″. Collection of the artist.
Photo by Paul Macapia

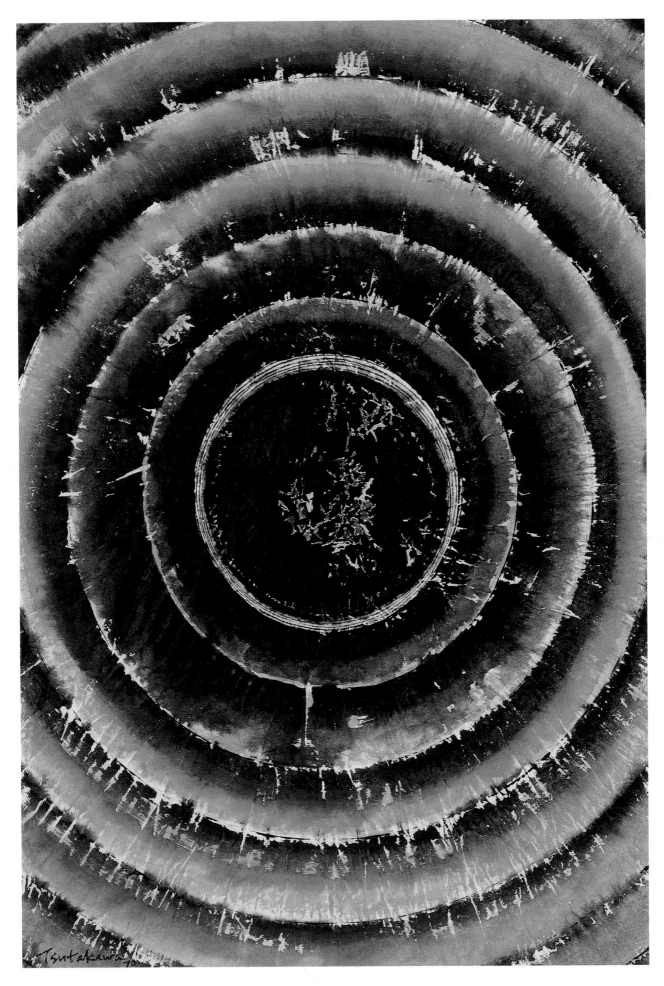

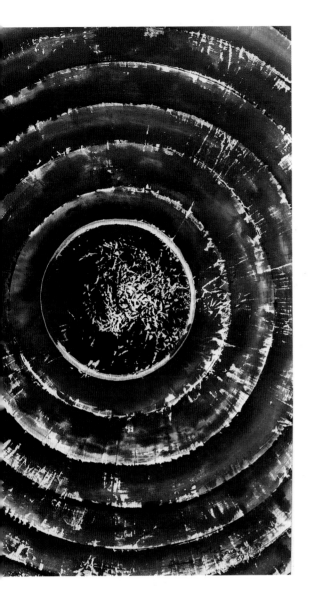

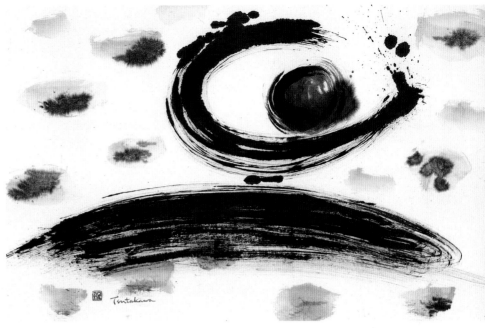

Sumi Quirk, 1986. Sumi, 23½″ × 38″.
Collection of the artist. Photo by Paul Macapia

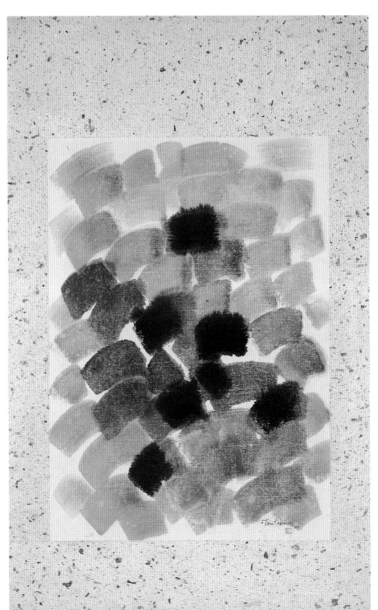

Radiation Series No. 2, 1969. *Sumi* with *gansai*, 23³⁸″ × 37³⁴″.
Collection of the artist. Photo by Paul Macapia

Radiation Series No. 11, 1970. *Sumi* with *gansai*, 38″ × 26″.
Collection of the artist. Photo by Paul Macapia

Reflection No. 7, 1961. *Sumi* with *gansai*, 35¼″ × 21⁷⁸″.
Collection of the artist. Photo by Paul Macapia

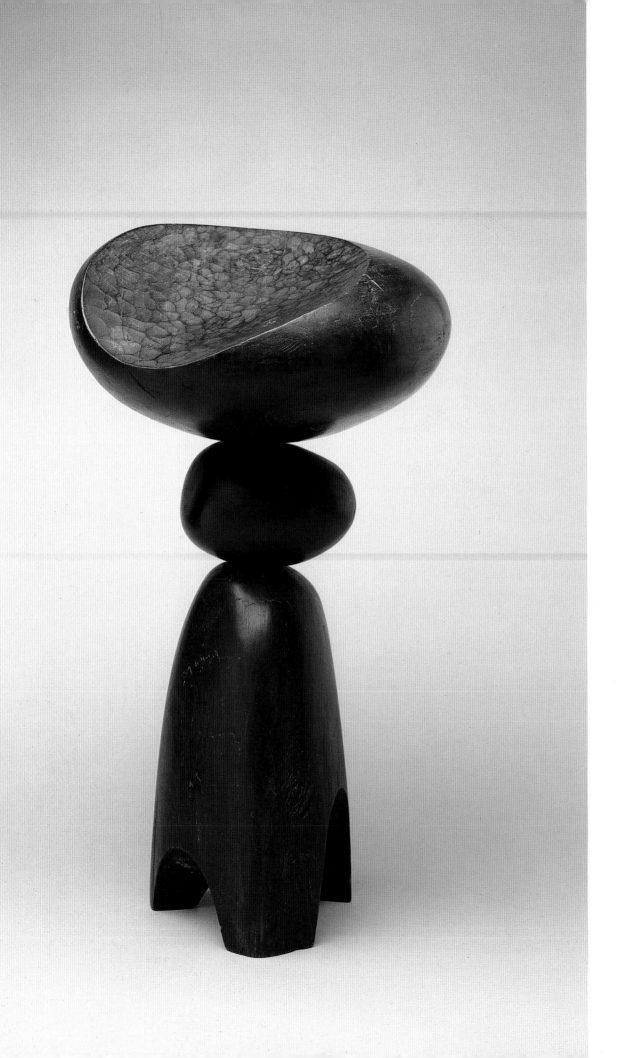

References and Remarks

MUCH OF the personal information in this essay is based on recollections of the artist and on his files of clippings, gallery announcements, photographs, and other documents. For information about Tsutakawa and other artists with whom he associated, I consulted material in the Pacific Northwest Collection in Special Collections, and in the Archives of Northwest Art in the Manuscripts and University Archives Division, both located in Suzzallo Library of the University of Washington. The archives of the School of Art of the University of Washington also provided information.

All the quotations of George Tsutakawa come from the written transcriptions of two extensive interviews with him: "George Tsutakawa: A Conversation on Life and Fountains," Gervais Reed, interviewer, *Journal of Ethnic Studies* (spring, 1976); and "Interview with George Tsutakawa" (September 8, 12, 14, 1983), Martha Kingsbury, interviewer, for the Archives of American Art, Smithsonian Institution, Washington, D.C.

Clarifications and related information are drawn from conversations among George Tsutakawa, Ayame Tsutakawa, and Martha Kingsbury during August to December, 1989.

Early Years

For amplification of the Japanese interest in European art, and the enthusiasm for it on the part of many artists in the late nineteenth and early twentieth centuries, see Michiaki Kawakita, *Modern Currents in Japanese Art* (New York: Weatherhill, 1974); and Shuji Takashina, with J. Thomas Rimer and Gerald D. Bolas, *Paris in Japan: The Japanese Encounter with European Painting* (Tokyo: The Japan Foundation, and St. Louis: Washington University, 1987).

The Art Student

For an overview of Seattle art during these years, see Martha Kingsbury, *Art of the Thirties* (Seattle: Published for the Henry Art Gallery by the University of Washington Press, 1972).

For Seattle's Japanese American artists, see Dennis Reed, *Japanese Photography in America 1920–1940* (Los Angeles: George Doizaki Gallery, 1986); Martha Kingsbury, "Kunishige," *Artweek* (August 7, 1971); and *Turning Shadows into Light: Art and Culture of the Northwest's Early Asian-Pacific Community*, edited by Mayumi Tsutakawa and Alan Chong Lau (Seattle: Young Pine Press, 1982). Information about this subject will be amplified by an oral history project currently in progress, sponsored by the Archives of American Art of the Smithsonian Institution and carried out by Mayumi Tsutakawa, Alan Chong Lau, and others.

For the work of Alexander Archipenko, see Katherine Janszky Michaelsen and Nehama Guralnik, *Alexander Archipenko: A Centennial Tribute* (Washington, D.C.: National Gallery of Art, 1986). For his personality and teaching activities, also see Donald H. Karshan, editor, *Archipenko: International Visionary* (Washington, D.C.: National Collection of Fine Arts, 1969).

Obos No. 11, 1965. Cedar, 23" × 15½" × 12½". Collection of Anne Gould Hauberg, Seattle. Photo by Paul Macapia

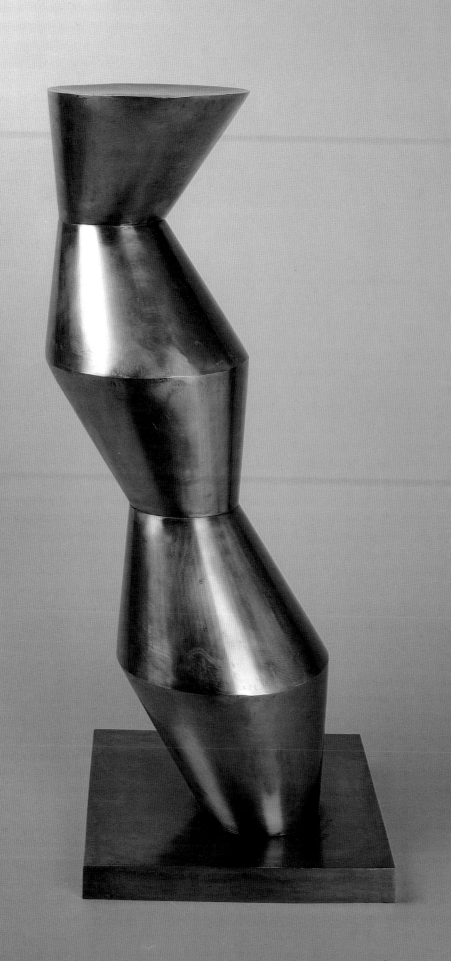

The Citizen

For developments in Seattle area art during these years and after, see *Group of Twelve* (Seattle: Frank McCaffrey at His Dogwood Press, 1937); Martha Kingsbury, "Seattle and the Puget Sound," in *Art of the Pacific Northwest* (Washington, D.C.: National Collection of Fine Arts, Smithsonian Institution, 1974); Martha Kingsbury, *Northwest Traditions* (Seattle: Seattle Art Museum, 1978); William Cumming, *Sketchbook: A Memoir of the 1930s and the Northwest School* (Seattle: University of Washington Press, 1984).

And more particularly, for those who became most widely known, see William Seitz, *Mark Tobey* (New York: Museum of Modern Art, 1962); Ray Kass, *Morris Graves: Vision of the Inner Eye* (Washington, D.C.: Published for the Phillips Collection by Braziller, 1983); and Barbara Johns, "Order and Disorder: The Architecture and Theatrics of Morris Graves" (M.A. Thesis, San Diego State University, 1984).

For the Henry Moore exhibition so vivid to Tsutakawa, see "Moore: A Mountainous Sculptor Draws" (exhibit at Buchholz Gallery of 40 drawings and watercolors), *ARTnews* (May 15, 1943); and Henry Moore, *Sculpture and Drawings*, with an Introduction by Herbert Read (New York: Curt Valentin, 1949).

Artist-Experimenter

The increasing numbers and varieties of sculptures in Seattle during these years and after is cumulatively revealed in "Art in Seattle's Public Places: Five Urban Walking Tours," by Gervais Reed and Jo Nilsson, published as five separate booklets by the Seattle Public Library, 1977. See also James Rupp, *Art in Seattle's Public Places*, with photographs by Mary Randlett (forthcoming, Seattle: University of Washington Press, 1991).

On associates of Tsutakawa, see Spencer Moseley and Millard Rogers, *Wendell Brazeau: A Search for Form* (Seattle: Published for the Henry Art Gallery by the University of Washington Press, 1977); and *Johsel Namkung: An Artist's View of Nature*, with an Introduction by Charles Cowles (Seattle: Seattle Art Museum, 1978).

For a good overview of Isamu Noguchi's life and work, see his book, *A Sculptor's World* (London: Thames and Hudson, 1967). Like Tsutakawa, he was born in the United States and was taken at an early age to Japan. He returned to this country at the age of thirteen. The trauma of World War II led him to declare, after the war, that "I resolved henceforth to be an artist only" (*A Sculptor's World*, p. 26). He visited Japan in 1931, in 1950, and many times later, eventually locating one of his work sites there.

From the late 1920s into the 1930s, there were very few published references to Noguchi's drawings and figurative sculpture, but from 1938 through 1941 there appeared nearly a dozen notices and reproductions of his enormous relief executed in 9 tons of cast stainless steel for the Associated Press Building in Rockefeller Plaza, New York. The style of this Cubist-derived blocky figuration, like so much public work in its day, was familiar to Tsutakawa, who made a point of seeing it when he was in New York in 1943.

Leaning Column, 1968. Stainless steel, 42" × 20" × 20".
Collection of Mr. and Mrs. Robert M. Sarkis, Seattle.
Photo by Paul Macapia

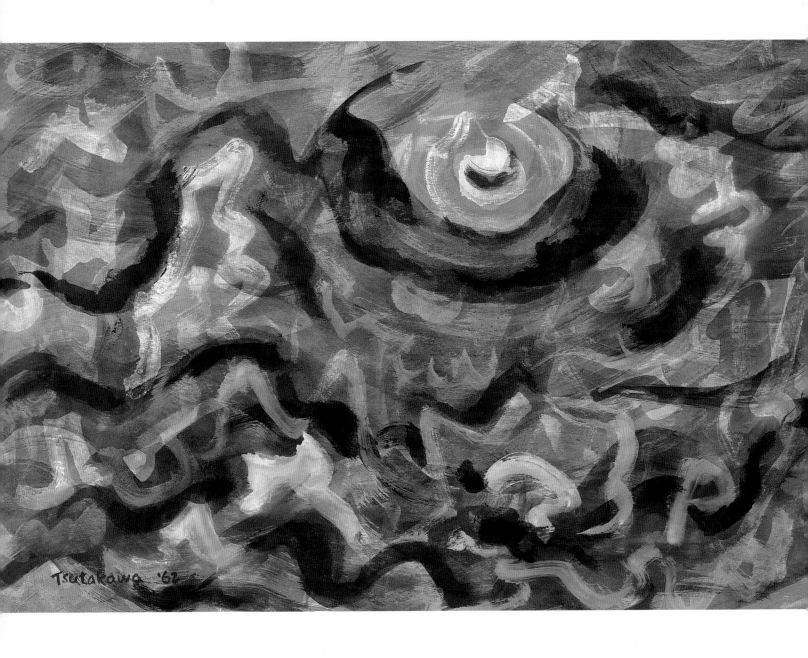

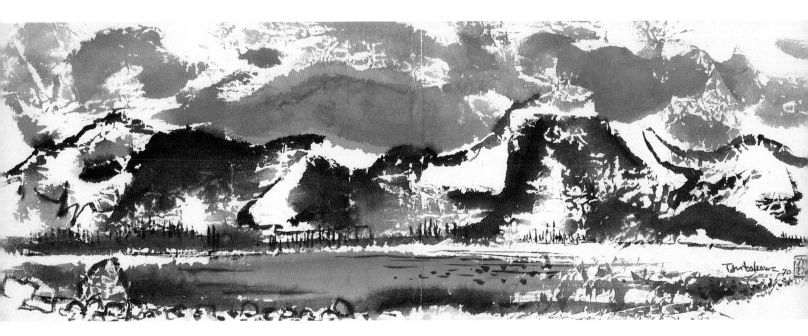

A parallel suggests itself between Noguchi's pierced cylinder of 1943, *Monument to Heroes* (paper, wood, bones, and string), published in a dark black-and-white photograph in *ARTnews* in 1946, and Tsutakawa's glazed and colored plaster cylinder with pierced sides from the early 1950s. On the other hand, the seven Noguchi works reproduced in the Museum of Modern Art's catalogue, *Fourteen Americans,* in 1946, were all quite unlike Tsutakawa's work.

From 1947 through 1950 Noguchi's coffee table, made of notched and fitted slabs and very close to Tsutakawa's tables in form and construction, was published several times. In the same years, three articles by Noguchi, dealing with the meaning of sculpture, with space in art, and with reintegration of the arts, appeared in *ARTnews, Interiors,* and the *College Art Journal.*

Tsutakawa's interests during these years were very similar to Noguchi's and their experiences of the war years and the cultural issues they raised had much in common. Noguchi's lamps were published a number of times from 1950 through the middle of the decade, just after Tsutakawa had made and exhibited his lamps. In 1955–57 there were several publications of Noguchi's *Even the Centipede* (Museum of Modern Art), a strongly reiterative vertical work of eleven ceramic elements mounted on a 10-foot pole. This work became prominently associated with Noguchi, although in fact it is almost unique in his work for its preoccupation with verticality and its segmented quasi-organic structure. Although its publication followed Tsutakawa's preoccupation with segmented verticality in the *Obos, Even the Centipede* was executed earlier, in 1952. Starting in 1957, Noguchi's stone garden for UNESCO in Paris was also widely published, and his sustained interest in art as the design of site and context—going back to his earlier designs for stage sets and playgrounds—became well known.

Overall, it appears that when they were relatively young and unformed, Tsutakawa's and Noguchi's artistic preoccupations were quite different, and were heavily influenced by their different circumstances, locations, and acquaintances. In their mature works since the 1950s, their works also appear quite unlike, although the shared concern with total context is fundamental and very important to both. It is during the years of World War II and just after, when both faced similar dramatic problems of cultural identity, that the most telling similarities occurred in their works. These similarities seem to testify more to the nature of their common struggle than to any strong influences.

They became acquainted in the 1970s and met a number of times in the seventies and eighties. Noguchi visited the Tsutakawas when going through Seattle, as he did in connection with the installation of three large works in the Puget Sound region, and entertained them at a large formal luncheon at his studio on Shikoku Island, in Japan, in November, 1988.

Synthesis

In the exhibition "Seattle" (Tokyo: Yoseido Gallery, 1956), Tsutakawa exhibited six paintings including *Rescue No. 2, Crucifixion, Deep in My Memory, Ikada No. 5, Mountains Trees Water,* and *Ikada No. 6.*

For the *Obos* sculptures and related paintings, see Bruce Guenther, *Documents Northwest: George Tsutakawa* (Seattle, Seattle Art Museum, 1985). William O. Douglas's book, *Beyond the High Himalayas,* was published in New York, by Doubleday, in 1952.

Search, 1961. *Sumi* with *gansai,* 23¼″ × 35¾″. Collection of the artist. Photo by Paul Macapia

Winter Lake Ketchelis, 1970. *Sumi* with *gansai,* 9⅝″ × 27⅞″. Collection of the artist. Photo by Paul Macapia

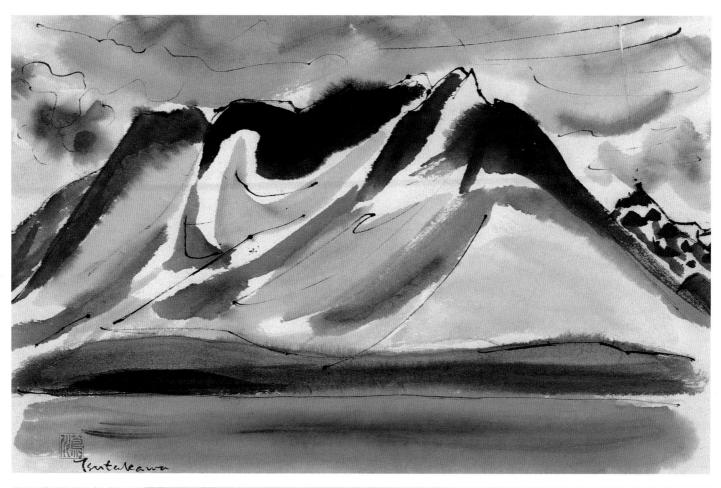

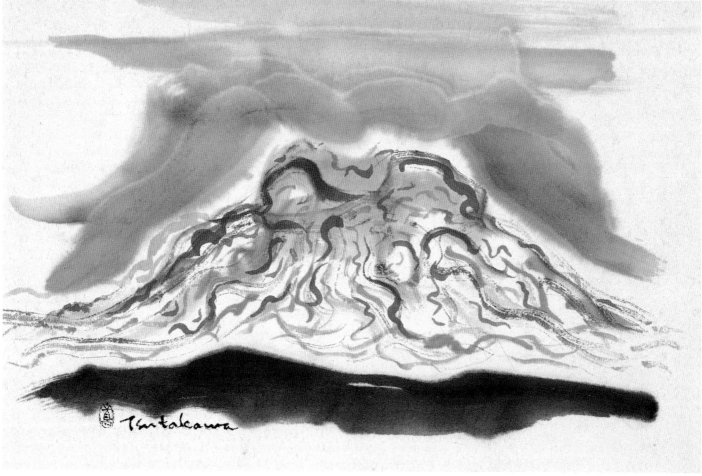

See *Life Magazine*'s feature stories on "Mystic Painters of the Northwest" (September 28, 1953); and "Great Recluse: Brancusi and Art Come from Hiding" (December 5, 1955).

For personal information and documentation of Brancusi's work and career, see Pontus Hulten et al., *Brancusi* (New York: Abrams, 1986). For a detailed bibliography of Brancusi publications during Tsutakawa's formative years, see Carola Giedion-Welcker, *Constantin Brancusi* (New York: Braziller, 1959).

For the gradual shift to the perception of Tsutakawa as primarily a sculptor, rather than a painter, see Ann Faber, "George Tsutakawa Has Indoor-Outdoor Show," *Seattle Post-Intelligencer* (May 25, 1958); and Kenneth Callahan, "Northwest Artists Dominate Show List," *Seattle Times* (June, 1958; clippings in Archives of Northwest Art).

Transcendence

Lake Lanazi, B.C., 1974. *Sumi* with *gansai*, 3' × 5'. *Collection of the artist. Photo by Paul Macapia*

Tsutakawa's statement was in the *Denver Art Museum Quarterly*, "70th Western Annual" (summer, 1964).

The connection of *Obos* to fountains was acknowledged as early as 1960 in John S. Robinson's feature, "Seattle, Where Far East and Northwest Meet," in the *New York Times* (Sunday, May 15, 1960); it was illustrated by a photograph of Tsutakawa at the Seattle Public Library fountain.

Selected early references to the fountains include: "Fountains," *Art in America* (December, 1964), an article introduced by a photograph of Tsutakawa and the Seattle Public Library fountain; Minor Bishop, *Fountains in Contemporary Architecture* (New York: American Federation of the Arts, 1965); Jack M. Uchida, "Welding in Modern Metal Sculpture," *Welding Journal* (February, 1966); and Gervais Reed, "Fountains of George Tsutakawa," *American Institute of Architects Journal* (July, 1969).

Mount Rainier, 1975. *Sumi* with *gansai*, $8\frac{1}{8}'' \times 12\frac{3}{8}''$. *Collection of the artist. Photo by Paul Macapia*

Tsutakawa's developing connections with Japan are underscored by the publication of his works in several exhibition catalogues published in Japan, including: *Pacific Northwest Artists and Japan* (Osaka: National Museum of Art, 1982); *Exhibition of Fountain Sculptures by George Tsutakawa* (Sendai: The History and Folk Museum, 1981); and *Fountain Sculptures by George Tsutakawa* (Tokyo: Setagaya Ward, 1982).

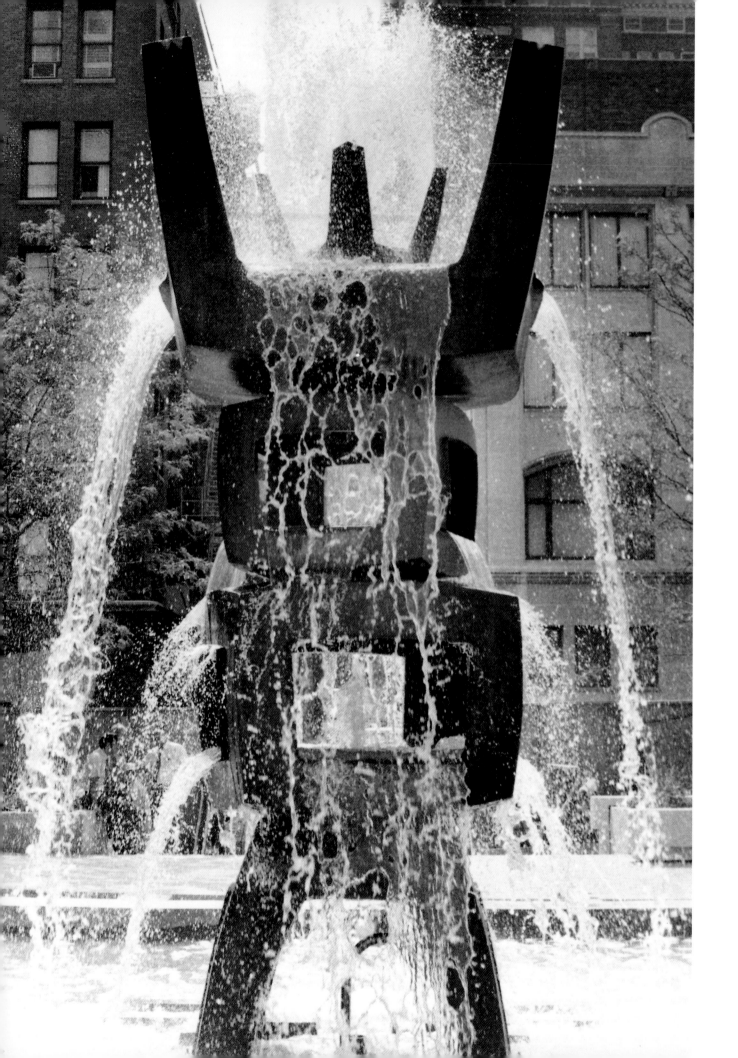

Chronology

*Compiled by George
and Mayumi Tsutakawa*

1910	Born February 22 at home at 1815 Federal Avenue E., Seattle, the fourth of the nine children of Shozo and Hisa Tsutakawa.
1916–17	Attended Lowell Elementary School on Capitol Hill.
1917	Sent to Fukuyama, Japan, to live with Mutsu Naito, his maternal grandmother.
1917–27	In Japan, attended public grade school and high school.
1927	Returned to Seattle, estranged from his father. Settled to live with extended family associated with his father's business concerns and worked in the family's produce market on Jackson Street for several years.
1928	Attended Pacific Elementary School to relearn English. Won second prize for soapstone sculpture contest sponsored by the *Seattle Times.*
1928–32	Attended Broadway High School and studied printmaking with Hannah Jones and English watercolor with Matilda Piper.
1930–35	In the summers, worked on farms in Auburn and Kent and at the salmon cannery at Union Bay, Alaska. Made many sketches.
1932	Won first prize with a linoleum cut print in a national art contest sponsored by *Scholastic Magazine.* Submitted block prints to Northwest Printmakers annual exhibition at the Henry Gallery, Seattle.
1932–37	Attended University of Washington School of Art. Studied sculpture with Dudley Pratt, watercolor with Ray Hill, and painting with Walter Isaacs and Ambrose Patterson.
1934	Oil painting accepted in the Northwest Annual sponsored by the Seattle Art Museum. During this time traveled to many sites in the Northwest on painting and sketching trips.
1935–41	Worked as store manager for Tsutakawa Co., the family business Continued to paint and exhibit regularly. Met and associated with Mark Tobey, Morris Graves, Kenneth Callahan, Guy Anderson, Dudley Carter, Bill Gamble, Fay Chong, Kenjiro Nomura, Kamekichi Tokita, and Takuichi Fujii.
1936–52	Studied sculpture with Alexander Archipenko and Paul Bonifas.
1941–45	Inducted into the U.S. Army as infantryman and trained in Arkansas, Texas, and Mississippi. His family was interned; their property was confiscated and was never recovered.
1943–45	Instructor of Japanese language at Fort Snelling, Minnesota, U.S. Army Intelligence Language School. Was made staff sergeant. During this time continued to sketch and paint and had the opportunity to travel widely across the U.S., mostly by train. Visited museums and galleries in New York.

Jefferson Plaza Fountain, 1971. Bronze, 15′ × 8′ × 8′.
Indianapolis, Indiana

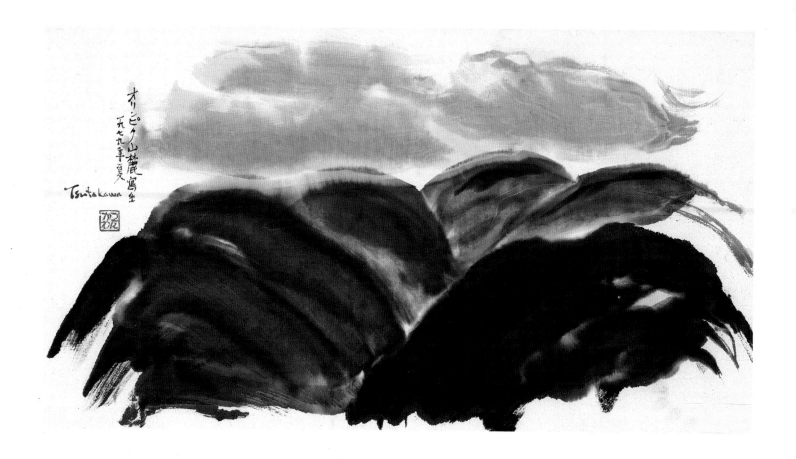

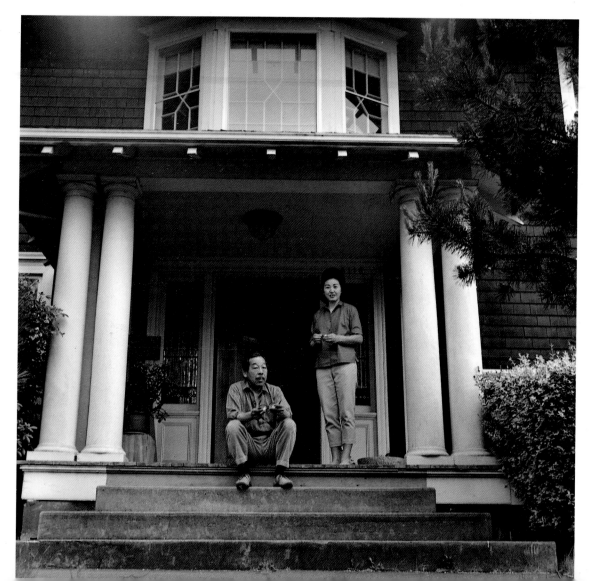

1946	Was honorably discharged and returned to Seattle. Taught Japanese language in Far East Department, University of Washington, for one semester.
1947	Became part-time art instructor, School of Art, University of Washington. Married Ayame Iwasa, whom he had met at Tule Lake internment camp. Became deeply involved in sculpture and also continued to paint. First child, Gerard, born.
1947–48	Became full-time instructor in School of Art, University of Washington. Was reconciled with his father.
1949	Daughter Mayumi born.
1950	Received MFA in sculpture at the University of Washington. Began teaching classes in the School of Architecture. Began association with many prominent Northwest architects.
1952	Son Deems born.
1955	Appointed full professor of art at University of Washington. Son Marcus born.
1956	Read about *obos,* rock piles with ritual significance, in *Beyond the High Himalayas,* by Justice William Douglas. Introduced to Douglas by Johsel Namkung. Began study of Tibetan culture and *obos.* Traveled to Japan for the first time since 1927 (visited Japan again in 1969, then annually from 1979 to 1988).
1957	Created the first *obos* sculpture in wood. Began to work with *sumi* ink, a practice continued throughout his career.
1960	Designed and executed first fountain sculpture, *Fountain of Wisdom,* at Seattle Public Library, assisted by engineer Jack Uchida, who has since been consistently associated with Tsutakawa's fountains. This was the first public sculpture commissioned in Seattle since 1908. Received design award from American Institute of Architects. Presented *Obos No. 7* to Prince Akihito and Princess Michiko of Japan.
1960–90	Completed 60 fountain sculptures in major public sites in the U.S., Canada, and Japan.
1962	Designed Century 21 World's Fair U.S. Commemorative Medal, struck by U.S. Mint in Philadelphia.
1963	Took three-month sabbatical leave to Western Europe with son Gerard. Visited 10 countries and numerous museums and observed many fountains.
1964	Made first trip to Mexico with his family (also traveled to the Yucatan in 1974).
1967	Received Washington State Governor's Award of Commendation
1969	Research travel to Japan, Taiwan, Cambodia, Thailand, Sri Lanka, India, Iran, Turkey, Greece, Italy, France, and England with Ayame. Visited Mark Tobey in Switzerland.
1974	Completed first aluminum fountain sculpture, for Expo '74 site, Spokane. Also designed U.S. Commemorative Medal for Expo '74 World's Fair, struck by U.S. Mint.
1976	Became professor emeritus, ending 30-year teaching association with University of Washington.
1977	Began association with Foster/White Gallery, Seattle. Went on pilgrimage to the foothills of the Himalayas in Nepal and Sikkim; climbed to the elevation of 16,000 feet.
1978	Traveled to Egypt.
1979	*Spirit of the Ancient Warrior,* bronze sculpture, presented to Governor Shiro Nagano of Okayama Perfecture in Japan.
1981	Received Order of Rising Sun Award, Fourth Class, from Emperor of Japan. Also received Washington State Historical Society's Centennial Hall of Honor Award.

Olympic Foothills from Mount Walker, 1979. Sumi, 13⅜″ × 24½″. Collection of the artist. Photo by Paul Macapia

George and Ayame, 1967. *Photo by Mary Randlett*

1983	Completed bronze memorial sculpture for Japanese Americans interned at temporary assembly center in Puyallup, Washington, during World War II.
1984	Received Alumnus Summa Laude Dignatus award from University of Washington Alumni Association. Received honorary lifelong membership award from Seattle Chapter, American Institute of Architects. Received Honor's Award sculpture commission from King County Arts Commission.
1986	Received Honorary Doctorate of Humanities degree from Seattle University and Honorary Doctor of Fine Arts degree from Whitman College, Walla Walla, Washington.
1988	Received Distinguished Alumnus award, Broadway High School Alumni Association, Seattle. Chosen by the Smithsonian Institution Archives of American Art, Western Region, as one of two major artists to be documented in interviews videotaped at artist's studio in Seattle and in various locations in Japan.
1989	Exhibited in "12 Sculptors Exhibit," City of Sendai, for international sculptors featured in the municipal collection, on the occasion of the city's centennial celebration.
1990	Prints, sculpture, oil and watercolor paintings, works in *sumi*, and functional objects from six decades shown in definitive restrospective exhibition at Bellevue Art Museum, Bellevue, Washington.

Olympic Foothills, 1961. Sumi with gansai, 17½″ × 22¼″.
Collection of the artist. Photo by Paul Macapia

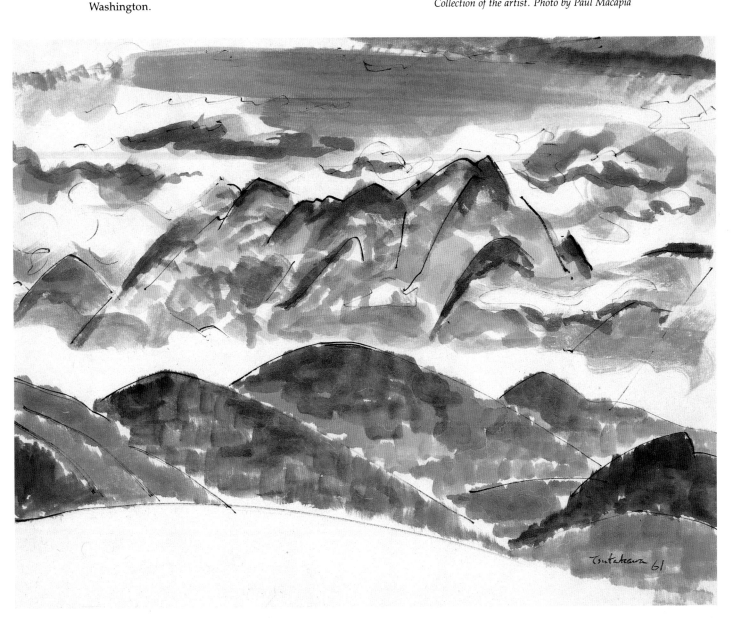

Selected Exhibitions and Commissions

Selected One-Man Exhibitions

1947	Studio Gallery, Seattle
1950	Henry Art Gallery, University of Washington, Seattle (also 1965)
1952	Altman Prechek Gallery, Bellevue, Washington
1953	Zoe Dusanne Gallery, Seattle (also 1958)
1957	Seattle Art Museum
1962	Summer Art Festival, Michigan State University, East Lansing
1964	Kittredge Gallery, University of Puget Sound, Tacoma
1976	Pacific Northwest Arts Center, Seattle Art Museum
1977	Foster/White Gallery, Seattle (also 1978, 1981, 1984, 1988)
1981	Koko-kan Museum, Sendai, Japan
1982	Thomas Burke Memorial Washington State Museum, University of Washington, Seattle
1985	PONCHO Gallery, Seattle Art Museum Pavilion
1986	Port Angeles Art Center inaugural exhibition, Port Angeles, Washington
1987	"George Tsutakawa Fountains," Valley Museum of Northwest Art, LaConner, Washington
1990	"George Tsutakawa," definitive retrospective exhibition, Bellevue Art Museum, Bellevue, Washington

Group Exhibitions

Tsutakawa began exhibiting widely in the 1950s. He showed regularly at the Puyallup Fair Art Exhibition, Pacific Northwest Arts and Crafts Fair, Northwest Annual, Northwest Watercolor Exhibition, and Northwest Printmakers' Annual and was active in Northwest Sculpture Society exhibitions. During these early decades he was invited to many exhibitions including III São Paulo Bienal, 1955; "Northwest Art Today," Century 21 World's Fair, 1962, Expo '70, Osaka; and "Art of the Thirties," Henry Art Gallery, University of Washington, 1972. He won many awards, notably at the 79th Annual, San Francisco Art Museum; the Third Pacific Coast Biennial, Santa Barbara Museum of Art; and the 66th Annual Exhibition of Western Art, Denver Art Museum. Since 1960, when the artist started his longstanding commitment to the creation of fountains, he has continued to exhibit sculpture and painting.

Selected recent group exhibitions include:

1974	"Art of the Pacific Northwest," National Collection of Fine Arts, Smithsonian Institution, Washington, D.C. (traveling exhibition)

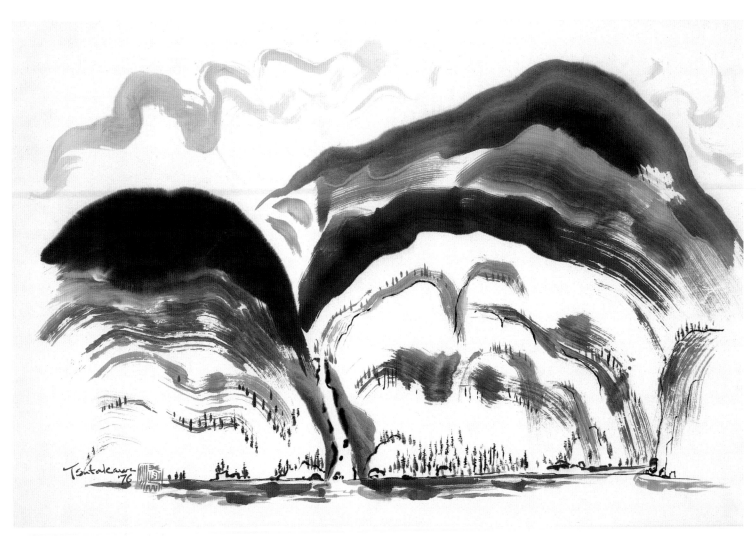

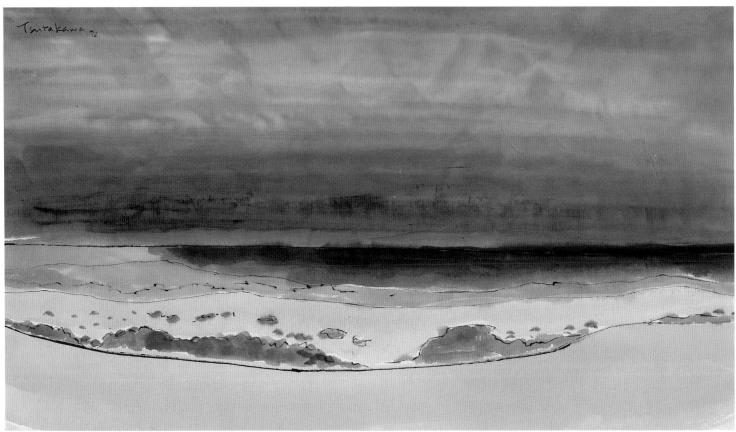

1975	"Northwest Artists Today, Part 2: Painting and Sculpture," Seattle Art Museum
1978	"Governor's Invitational Art Exhibition," State Capitol Museum, Olympia (also 1964, 1966–67, 1973, 1975)
1978	"Northwest Traditions," Seattle Art Museum
1978	"George Tsutakawa and Morris Graves: Painting, Drawings, and Sculpture," Olin Gallery, Whitman College, Walla Walla, Washington
1978	"Invitational Candidacy Exhibition," American Academy and Institute of Arts and Letters, New York (also 1981)
1982	"Pacific Northwest Artists and Japan," National Museum of Art, Osaka, Japan, and Seattle Art Museum
1983	"American Prints of the 1930s and 1940s," Seattle Art Museum
1987	"Seattle Style," Bumbershoot, Seattle Center
1987	"BumberBiennale: Seattle Sculpture 1927–1987," Seattle Center
1987–88	"Seattle Style," *sumi-e* group show (touring exhibit in France including Musée des Beaux-Arts, Carcassonne; Musée Henri de Toulouse-Lautrec, Albi; Musée d'Art Contemporain, Dunkerque)
1988	"Sumi Paintings," Bellevue Art Museum, Bellevue, Washington
1989	"Washington State Centennial Art Exhibition," Tacoma Art Museum

Fountains and Public Sculpture Commissions

Ross Lake, 1976. Sumi with gansai, 18¾″ × 28″. Collection of the artist. Photo by Paul Macapia

1956	Door sculpture, walnut, two panels, 14″ × 30″; Canlis Restaurant, Seattle
1958	*Follow the Leader,* walnut relief, 20″ × 30″; St. Mark's Cathedral, Seattle
1959	*Eskimo Dance,* walnut relief, 55″ × 20″; A. A. Cannon, Anchorage
1960	*Fountain of Wisdom,* bronze, 12′ × 6′ × 6′; Seattle Public Library
	Sculptured fountain, bronze, 7′ × 6′ × 6′; Renton Center, Renton, Washington
1961	Sculptured fountain group, bronze, 7′5″ and 5′ × 8′ × 3′; Lloyd Center, Portland, Oregon
1962	Fountain group, bronze, 7′ × 6′ × 5′; Northgate Shopping Center, Seattle (removed)
1963	Fountain, bronze, 25′ × 12′; Robinson's Department Store, Anaheim, California (site redesigned by client, water eliminated)
1964	*Fountain of Good Life,* bronze, 12′ × 7′; Commerce Tower, sunken plaza, Kansas City, Missouri
	Fountain, bronze, 9′ × 7′; Pacific First Federal Savings Bank, Tacoma, Washington (relocated)
	Obos Fountain, bronze, 12′; *Fountain of Reflection,* bronze, 4′; Civic Mall, Fresno, California
	Fountain, bronze, 5′; Mr. and Mrs. Langdon Simon, Medina, Washington (donated to Seattle Art Museum, 1988)
1965	Fountain for home office, bronze; Charles Luckman Associates, Architects, Los Angeles
1966	Fountain, bronze, 6′ × 3′ × 4′; University YWCA, Seattle
	Waiola Fountain, bronze, 15′; Ala Moana Center, Honolulu
	Joshua Green Fountain, bronze, 6′ × 9′ × 7′; Washington State Ferry Terminal, Pier 41, Seattle

Sand Dunes, Florence, Oregon, 1972. Sumi with gansai, 14¾″ × 26⅜″. Collection of the artist. Photo by Paul Macapia

149

Fountain, bronze, 3'; Northwestern Auto Bank, Sioux Falls, South Dakota

1967 Gates, bronze, 9' × 21'; Lake City Library, Seattle

Fountain of Reflection (Phi Mu Fountain), bronze, 5'; MacKenzie Hall, School of Business, University of Washington, Seattle

Hobart Fountain, bronze, 20'; Hobart Research Center, Troy, Ohio

Naramore Fountain, bronze, 18'; Naramore Park, Seattle

Fountain, bronze, 6'; School of Public Health, University of California, Los Angeles

1968 *East Cloister Garth Fountain*, bronze, 10'; National Cathedral, Washington, D.C.

Fountain sculpture, bronze, 3'; Minor Clinic, Everett, Washington

1969 *Fountain of Pioneers*, bronze, 15' × 8'; Bentall Centre, Vancouver, B.C.

Obos 69 Fountain, bronze, 9' × 6'; Franklin D. Murphy Sculpture Garden, University of California, Los Angeles

Two fountains, bronze, 3½'; Seattle First National Bank Building, Seattle (relocated)

1970 Fountain pair, bronze, 9'; Pompano Fashion Square, Pompano Beach, Florida (removed)

Pacific First Federal Fountain, bronze, 10' × 7' × 4'; Pacific First Federal Savings Bank, Bellevue, Washington

Fountain, bronze, 6'; Group Health Hospital, Seattle

1971 *Moon Song Fountain*, bronze, 6'; *Seattle Post-Intelligencer* Building, Seattle (redesigned for new building)

Jefferson Plaza Fountain, bronze, 15' × 8' × 8'; Indianapolis, Indiana

Baptismal font, bronze; Saint Martin's Abbey Church, Olympia, Washington

1972 *Rain Fountain No. 2*, stainless steel, 6'; Burien Library, Seattle

1973 Fountain sculpture, bronze, 8' × 5' × 5'; Seattle Central Community College, Seattle

Safeco Fountain, bronze, 13' × 9' × 9'; Safeco Plaza, Seattle

Rain Fountain No. 3, stainless steel, 6½'; Design Center Northwest, Seattle

1974 *Fine Arts Court Fountain*, bronze, 8' × 5' × 5'; Pennsylvania State University, University Park

Fountain, bronze, 26' × 7'; Somerset Inn, Troy, Michigan (site redesigned by client; water eliminated)

Expo '74 Fountain, aluminum, 17' × 7' × 7'; Spokane, Washington

1975 Fountain sculpture, bronze, 4' × 3' × 3'; Dr. and Mrs. Thomas Edmondson, Seattle

1976 *Fount Zen*, bronze, 3'; Mr. and Mrs. Doug Fox, Camano Island, Washington

Fountain sculpture, bronze, 8'; Northwest Medical Center, Bellingham, Washington

Bronze gates; University Arboretum, Seattle

1977 *Heaven, Man and Earth*, fountain sculpture, bronze, 10'; City Hall Plaza, Aberdeen, Washington

1978 Sculpture, bronze, 14'; International District, Seattle

1979 Sculpture, bronze, 15'; North Kitsap High School, Silverdale, Washington

Spirit of Ancient Warrior, bronze, 24"; Seattle Okayama Club, Seattle; presented by Governor Shiro Nagano, Okayama Prefecture, Japan

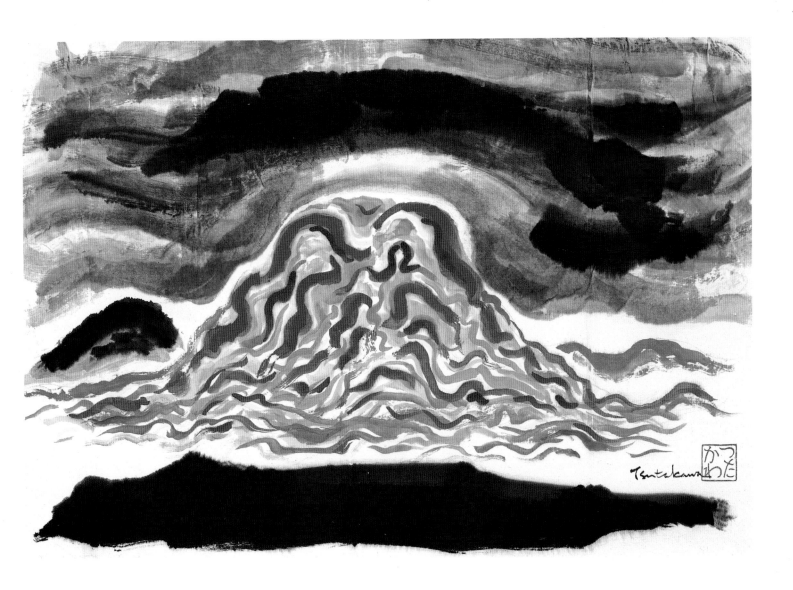

Mount Rainier, 1980. Sumi with gansai, 26" × 36".
Collection of Mr. and Mrs. Marshall Hatch, Seattle.
Photo by Paul Macapia

1981 *Song of the Forest,* fountain, bronze, 20'; Tsutsujigaoka Park,
 City of Sendai, Japan
 Hanging Fountain, stainless steel, 20'; KING Broadcasting
 Corporation, Seattle

1982 *Fountain of Vibrant Spring,* bronze, 15'; Okura Park, Setagaya-ku,
 Tokyo
 Fountain group, bronze, 7' × 3' × 4'; Sheraton Hotel, Seattle

1983 *Chalice Fountain,* bronze, 15' (Minoru Yamasaki, architect);
 Government Center, Toledo, Ohio
 Fountain of Joy, bronze; 15'; Setagaya Park, Setagaya-ku, Tokyo
 Memorial sculpture for West Coast Japanese Americans interned
 during World War II, bronze, 10' × 30" × 30"; Puyallup
 Fairgrounds, Puyallup, Washington
 Fountain for private garden, bronze, 5' × 18" × 16";
 Governor's Mansion, Olympia, Washington
 Fountain, 5' × 3' × 3'; Thomas McCarthy residence, Bellevue,
 Washington

1986	Play sculpture, stainless steel, 12′ × 10′ × 5′; King County Administration Building, Seattle
	Small fountain, bronze, 4′ × 4′ × 4′; Mr. and Mrs. James Pigott residence, Seattle
1987	Small fountain, bronze, 5′; Keiro Nursing Home, Seattle
	Marionwood Fountain, bronze, 20′; Marionwood, Issaquah, Washington
	Fountain of Hope, bronze, 8′; Water Department Building #2, Sapporo, Japan
1988	*Lotus Fountain*, bronze, 6′ × 9′ × 7′; Fukuyama Fine Art Museum, Fukuyama, Japan
1989	*Centennial Fountain*, bronze, 16′; Central Plaza, Seattle University, Seattle

Two Lobsters, 1980. *Sumi* with *gansai*, 24⅜″ × 26⅜″.
Collection of Dr. and Mrs. Charles Gravenkemper, Seattle.
Photo by Paul Macapia

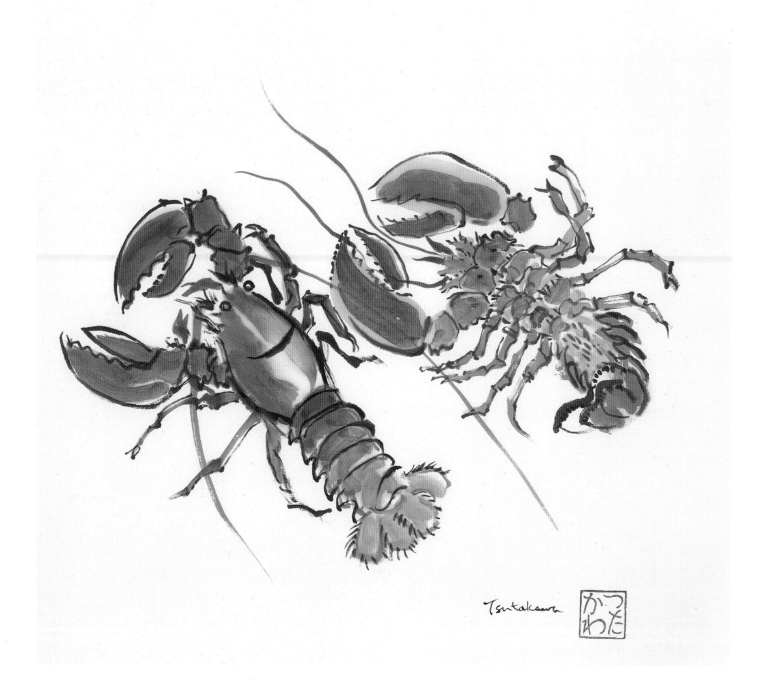

Selected Bibliography

Books and Catalogues

Art Treasures in the West. Menlo Park, Calif.: Sunset Magazine Publications, 1966.

Exhibition of Fountain Sculptures by George Tsutakawa. Sendai, Japan: Contemporary Sculpture Center, 1981.

Fountain Sculptures by George Tsutakawa. Setagaya Ward, Tokyo: Contemporary Sculpture Center, 1982.

Fountains in Contemporary Architecture. New York: American Federation of the Arts, 1965.

Franklin D. Murphy Sculpture Garden: An Annotated Catalog of the Collection. Los Angeles: University of California, 1976.

Franklin D. Murphy Sculpture Garden Catalog No. 2. Los Angeles: University of California, 1984.

George Tsutakawa and Morris Graves. Walla Walla, Wa.: Whitman College, 1978.

Griffin, Rachael, and Martha Kingsbury. *Art of the Pacific Northwest, from the 1930s to the Present.* Washington, D.C.: Smithsonian Institution Press, 1974.

Guenther, Bruce. *50 Northwest Artists.* San Francisco: Chronicle Books, 1983.

Honma, Masayoshi. *Sculpture in the Leafy City: Works by Twelve Artists.* Sendai, Japan: Kodansha, 1989.

Kingsbury, Martha. *Northwest Traditions.* Seattle: Published for the Seattle Art Museum by the University of Washington Press, 1978.

————. *Art of the Thirties: The Pacific Northwest.* Seattle: Published for the Henry Art Gallery by the University of Washington Press, 1972.

Pacific Heritage. Los Angeles: Municipal Art Gallery, 1965.

Pacific Northwest Artists and Japan. Osaka, Japan: National Museum of Art, 1982.

Paintings and Sculptures of the Pacific Northwest: Oregon, Washington, British Columbia. Portland: Portland Art Museum, 1959.

Publicly Owned Art in Fresno, California. Fresno County and City Chamber of Commerce, 1973.

Redstone, Louis. *Art in Architecture.* New York: McGraw Hill, 1964.

Sculpture in Public Places. Contemporary Sculpture Center, Tokyo: Chuokoron-sha, Inc., 1983.

Tsutakawa, Mayumi, and Alan Chong Lau, eds. *Turning Shadows into Light: Art and Culture of the Northwest's Early Asian-Pacific Community.* Seattle: Young Pine Press, 1982.

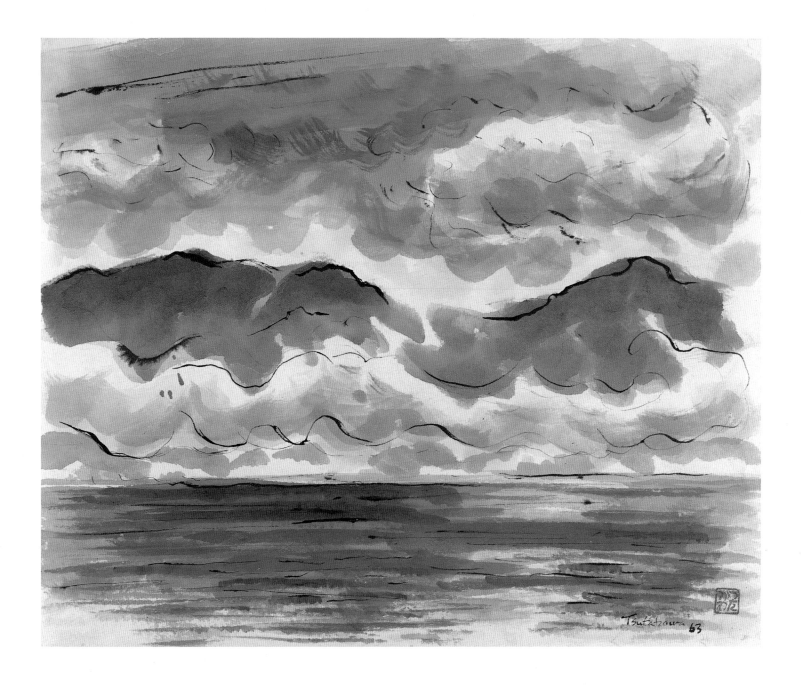

Articles

Abe, Nobuya. "Photo Essays." *Art Handbook* (November, 1958).

Art of Northwest America." *Bijutsu no Mado* (October, 1982).

Baldinger, W. S. "Regional Accent: The Northwest." *Art in America*, vol. 53, no. 1, 1965.

Campbell, R. M. "Sumi Drawings Show a Sculptor's Life View." *Seattle Post-Intelligencer* (January 11, 1984).

Danieli, F. A. "Reviews: Los Angeles." *Art News* (May, 1965).

"Flower of Water That Breathes." *Kateigaho* (September, 1982).

Forgey, Benjamin. "A New Vision: Public Places with Sculpture." *Smithsonian Magazine* (October, 1975).

"Fountains." *Art in America* (December, 1964).

Hood Canal No. 10, 1963. Watercolor, 16½" × 20".
Collection of the artist. Photo by Paul Macapia

Honma, Masayoshi, N. Kakihara, and Ayame Tsutakawa. "Special Issue on George Tsutakawa Fountains." *Bingo Shunju Literature and Art Magazine* (Special Issue, 1988).

Ingle, Schuyler. "The Tsutakawa Tradition." *The Weekly* (Seattle) (August 7, 1985).

Kakihara, Nobuo. "Dedication of the Lotus Fountain by George Tsutakawa." *Bingo Shunju Literature and Art Magazine* (February, 1989).

Kuwabara, Sumio. "Exhilarating Fountain Sculptures of George Tsutakawa." *Asahi Journal* (May, 1982).

———. "Fountain Sculptures by George Tsutakawa." *Lifescape (Japanese Design Quarterly)* (summer, 1982).

Reed, Gervais. "George Tsutakawa: A Conversation on Life and Fountains." *Journal of Ethnic Studies* (spring, 1976).

———. "Fountains of George Tsutakawa." *AIA Journal* (July, 1969).

Robinson, John S. "Seattle, Where Far East and Northwest Meet." *New York Times* (May 15, 1960).

Seldis, Henry J. "Exhibition Preview, Pacific Heritage." *Art in America*, vol. 53, no. 1, 1965.

———. "Pacific Northwest." *Art in America*, vol. 50, no. 1, 1962.

Tarzan, Deloris. "Fluid Art: George Tsutakawa Creator of Fountains." *Seattle Times* (March 18, 1984).

———. "Sculptor Turns to Painting." *Seattle Times* (January 8, 1984).

Uchida, Jack M. "Welding in Modern Metal Sculpture." *Welding Journal* (February, 1966).

Documentary Films and Videotapes

In addition to the items listed below, Tsutakawa has also been featured in numerous news and feature tape clips on KING-TV (NBC), KOMO-TV (ABC), and KIRO-TV (CBS).

Birth of a Fountain: Creation of the Seattle Public Library Fountain by George Tsutakawa. Directed and filmed by Don McQuade. Seattle, 1960. Black and white, 16mm, 30 minutes.

Fountain/Sculpture: The Design and Execution of the Spokane Expo '74 Fountain by George Tsutakawa. Directed and filmed by Ron Carraher, University of Washington School of Art. Seattle, 1974. Color, sound, 16mm, 18 minutes.

George Tsutakawa Interview. Archives of American Art Videotapes. Directed by Ken Levine for the Smithsonian Institution. Seattle, 1987. Color, 20 hours.

Northwest Visionaries. Directed and filmed by Ken Levine. Seattle, 1979. Color, 16mm, 60 minutes. Broadcast nationally on educational television.

Postscripts to Roots, with Dick Carbray and Jacob Lawrence. Videotaped at the Media Center of Educational TV Channel 9. Seattle, 1979. 60 minutes.

Three Northwest Artists: Roethke, Anderson, Tsutakawa. Directed by Jean Walkinshaw and filmed by Wayne Sourbeer for Public TV KCTS/9. Seattle, 1976. Color, sound, 16mm, 45 minutes. Broadcast nationally on PBS.

Song of the Forest, fountain, 1981. Bronze, 20'.
Tsutsujigaoka Park, Sendai, Japan. Photo by Osamu Murai

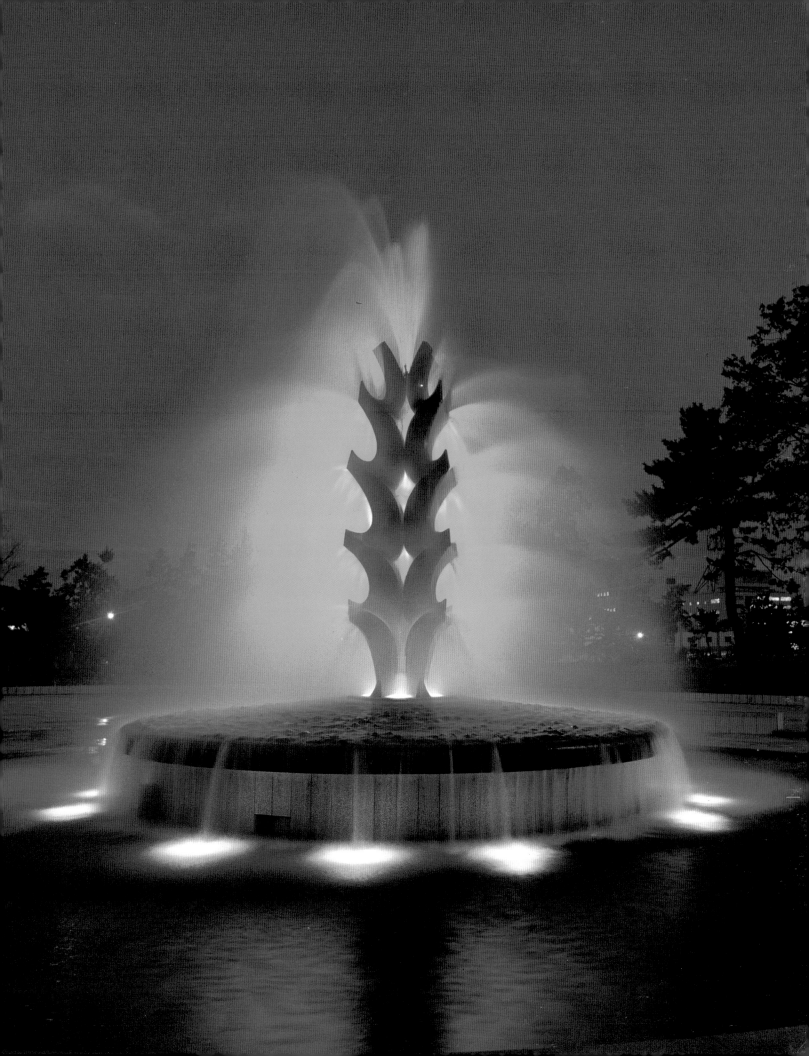

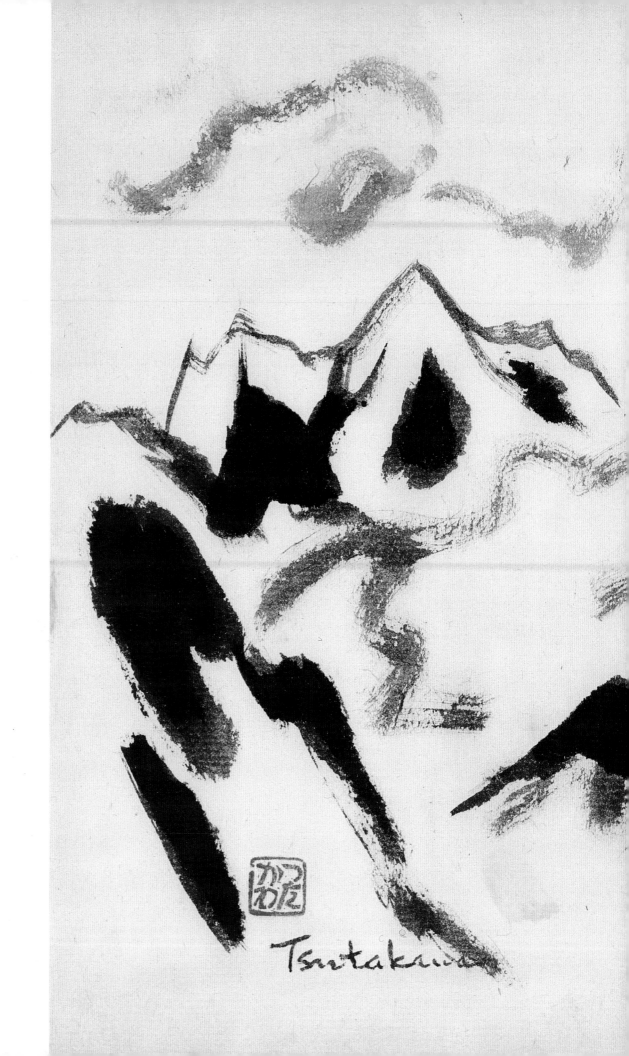

Nepal, Mount Everest, 1977.
Sumi, 12⁷⁄₈" × 17⁷⁄₈".
Collection of the artist.
Photo by Paul Macapia

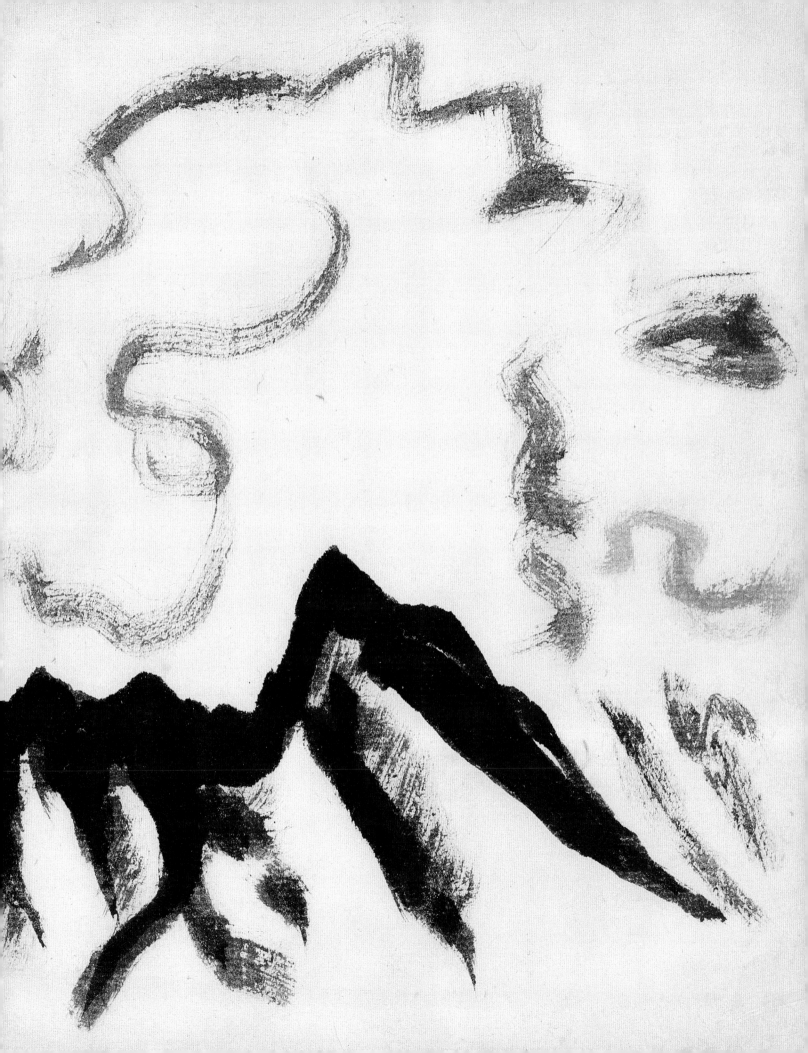